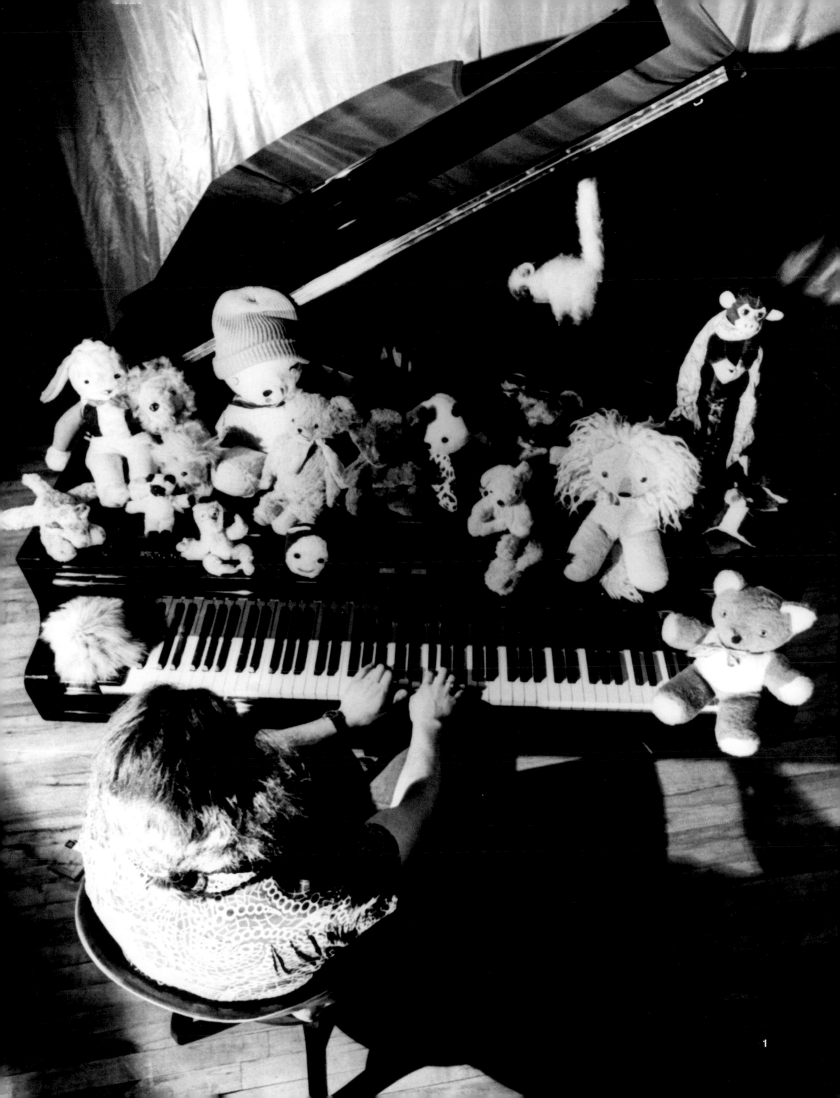

PUBLISHERS
Black Dog Publishing Limited
5 Ravenscroft Street London E2 7SH UK
T 00 44 (0) 20 7613 1922
F 00 44 (0) 20 7613 1944
E sales@bdp.demon.co.uk
www.bdpworld.com

PO Box 20035
Greeley Square Station
New York, NY 10001-0001 USA
T 00 1 212 664 2140
F 00 1 212 684 5583
E pressny@bdpworld.com

**Éditions de l'Aquarium agnostique /
École des Beaux-arts**
8, rue Ferrand (F) 59300 Valenciennes
T 00 33 (0)3 27 22 57 59
F 00 33 (0)3 27 22 57 60
E eba@ville-valenciennes.fr
www.ville-valenciennes.fr/culture/ecole

TRANSLATORS
Robb Beattie
Susan Usher
Antonio Guzman

READERS
Christian Mener
Guy Klucevsek
Catherine Legallais
Rod Stasick
Mai Tran

DOCUMENTATION
The Logos Foundation Logos, Gent
Bérangère Carrière, École des Beaux-arts,
Valenciennes

EDITORIAL SECRETARY
Philippe Perzy, École des Beaux-arts,
Valenciennes

ART DIRECTOR_GRAPHIC DESIGN
Daniel Perrier / per08600@club-internet.fr

MARY THANKS TO
The Wire, London
Galerie Damasquine, Brussels
Torch Gallery, Amsterdam
Galerie Lara Vincy, Paris
Galleria Franco Toselli, Milan

Éditions de l'Aquarium agnostique
c/o École des Beaux-arts de Valenciennes
receives the support of the City of
Valenciennes, the Conseil Général du Nord,
the Conseil Régional du Nord/Pas de Calais,
the Direction Régionale des Affaires
Culturelles.

CHARLEMAGNE PALESTINE IS REPRESENTED
IN HOLLAND BY Torch Gallery
Lauriergracht 94
1016 RN Amsterdam
T (31) 20 62 60 284
F (31) 20 62 38 892
M info@torchgallery.com

IN BELGIUM BY Galerie Damasquine
62, rue de l'Aurore
1000 Bruxelles
T (32) 2 646 31 53
F (32) 2 646 48 52
M damasquine@skynet.be

IN FRANCE BY Galerie Lara Vincy
47 rue de Seine
75006 Paris,
T (01) 43 26 72 51
F (01) 40 51 78 88
M galerielaravincy@wanadoo.fr

IN ITALY BY Galleria Toselli
Via Mario Pagano, 4,
Milan 20145,
T (39) 347 012 42 80,
F (39) 231 80 19 17
M galleriatoselli@digibank.it

© 2003
Black Dog Publishing Limited

Éditions de l'Aquarium agnostique
École des Beaux-arts de Valenciennes

ISBN 1 901033 79 1

Printed in Slovenia by Mladinska knjiga

A French language version of this
publication entitled "Bordel sacré"
is also available from the publisher.

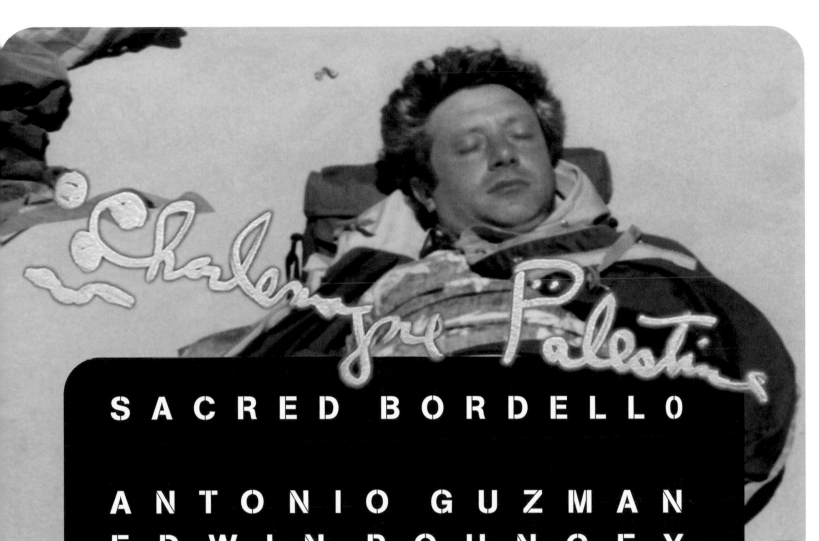

SACRED BORDELLO

ANTONIO GUZMAN
EDWIN POUNCEY
ARNAUD LABELLE-ROJOUX
GUY DE BIÈVRE
DANIEL PERRIER

Edited by

ANTONIO GUZMAN

éditions de l'aquarium agnostique

BLACK DOG PUBLISHING

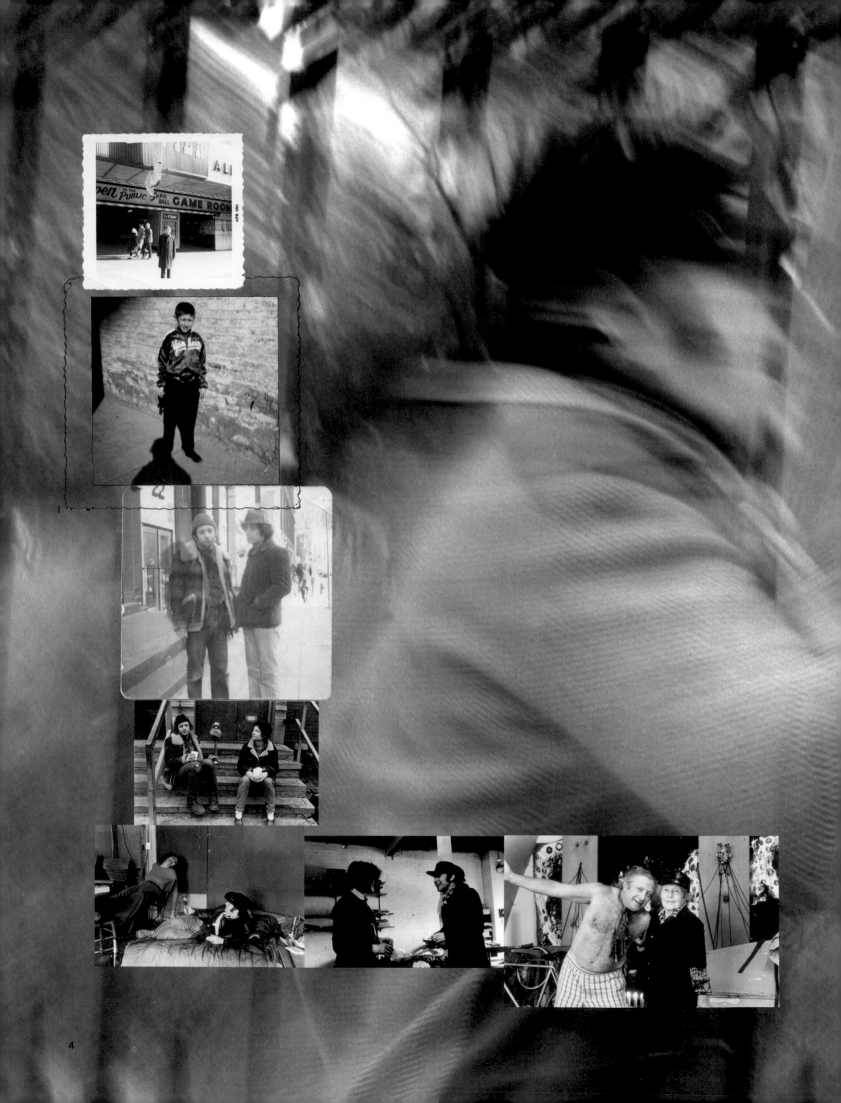

Charlemagne Palestine was born in Brooklyn, New York, in 1947➔1955-1961 sings sacred Jewish music through-
out the United States with the Stanley Sapir Choir. ➔1957 begins studying the accordian and soon after the piano.
➔1959 regularly visits Greenwich Village and becomes a conga and bongo drum player for beat poets, including Alan
Ginsberg, Gregory Corso, Kenneth Anger, among others, in local coffee houses, also for Tiny Tim, the falsetto tunesmith.
➔1960 scholarship to the High School of Music and Art in Manhattan, studies voice, piano, conducting, painting and
sculpture. ➔1962-1969 carilloneur of Saint Thomas Episcopal Church in Manhattan, playing daily at 5 pm and even-
tually composing an on-going work of 15 minutes daily segments for more than five years, a work finally numbering more
than 1,500 segments. ➔1963 assistant to the choreographer Alwyn Nikolais, composing electronic music for his dance
company; creates his first pieces using electronic sound manipulation. ➔1964 attends classes at the Studio School,
the New School for Social Research, Mannes College of Music and New York University, studying music, fine arts, multi-
media and new electronic technology. ➔1968 experiments with Len Lye on sound, light and magnetism as elements
for sculpture, film and sound; sonic and visual installations; the same year, studies vocal production and interpretation
with Pandit Pran Nath. ➔1969 composes music for Tony and Beverly Conrad's film *Coming Attractions*; also composes
for the carillon the theme music for the CBS television documentary film series *Explore*; works on the Buchla synthesizer
at the Intermedia Center, New York University. ➔1970 the composer Mort Subotnick invites him to work at the Music
Department of the California Institute of the Arts in Valencia, California; moves to California; meets the dancer and artist
Simone Forti; works with her on a meditative sound and movement piece entitled *Illuminations*; first performance and
body art works; studies voice and Gamelan music in California and Java with Ki Wasito Dipuro; discovers the
Bösendorfer Imperial piano and begins composing especially for the instrument; develops a new, alternative synthesiz-
er, called The Spectral Continuum Drone Machine. ➔1971-1972 tours Europe with Simone Forti, as musician and
performance artist; concerts, exhibitions and performances in Canada, Italy, France, Holland, Belgium, Germany and
Austria; becomes known in the European art and music scene; in 1972 also works on a video-performance piece, *Body
Music*, that inspires a suite of video work that continues throughout the 1970s; first record commissioned by the
Sonnabend gallery of New York, *Four Manifestations on Six Elements*. ➔1973-1980 returns to New York; creates
sculptural objects such as *Books of Continuity*, abstract expressionistic visual scores without sound; uses a wrinkling
technique as a means of turning two-dimensional objects into three-dimensional ones; during this period, engages the
use of the stuffed animal toys of his performances as the raw material for a genre of sculptural altars, this material
becomes the trademark of his visual art from this time on; a frequent lecturer in numerous American universities (Buffalo,
University of Southern California, New York University); teaches at the Nova Scotia School of Art and Design from 1973
to 1975; regular exhibitions and performances in America, Canada and Europe (Sonnabend Gallery, New York; 39th
Venice Biennale, 10th Paris Biennale); by the end of the 1970s, his desire to develop his visual work overshadows his
concerns for performance and music. ➔1980-1995 rarely appears as a performer, musician or composer; lives
between New York, Hawaii, France and Switzerland (frequent one person exhibitions: Paris, Chicago, Geneva, Zurich,
Montreal, Munich, Milan...; group exhibitions at the Stedelijk Museum, Amsterdam, the Moderna Museet, Stockholm;
1987, participates in Documenta 8 with *God Bear*) and founds the Ethnology Cinema Project in New York, a non-profit
organisation devoted to the collection, restauration, and distribution of early documentary films on disappearing
traditional cultures. ➔1995... lives between Utrecht and Rotterdam, before settling in Brussels; a new generation
of younger musicians and artists persuades him to return to the music scene; begins to compose again; re-releases
his earlier compositions (Felmay of Turin brings out *Strumming Music* in 1995, Barooni of Utrecht reissues *Four
Manifestations on Six Elements, The Lower Depths, Timbral Assault* in 1996-1997); returns to working with video with
the piece *Sacré Asnières*. He continues today to exhibit his sculpture, multi-media installations and videos in Europe,
which has become his home.

BIOGRAPHY

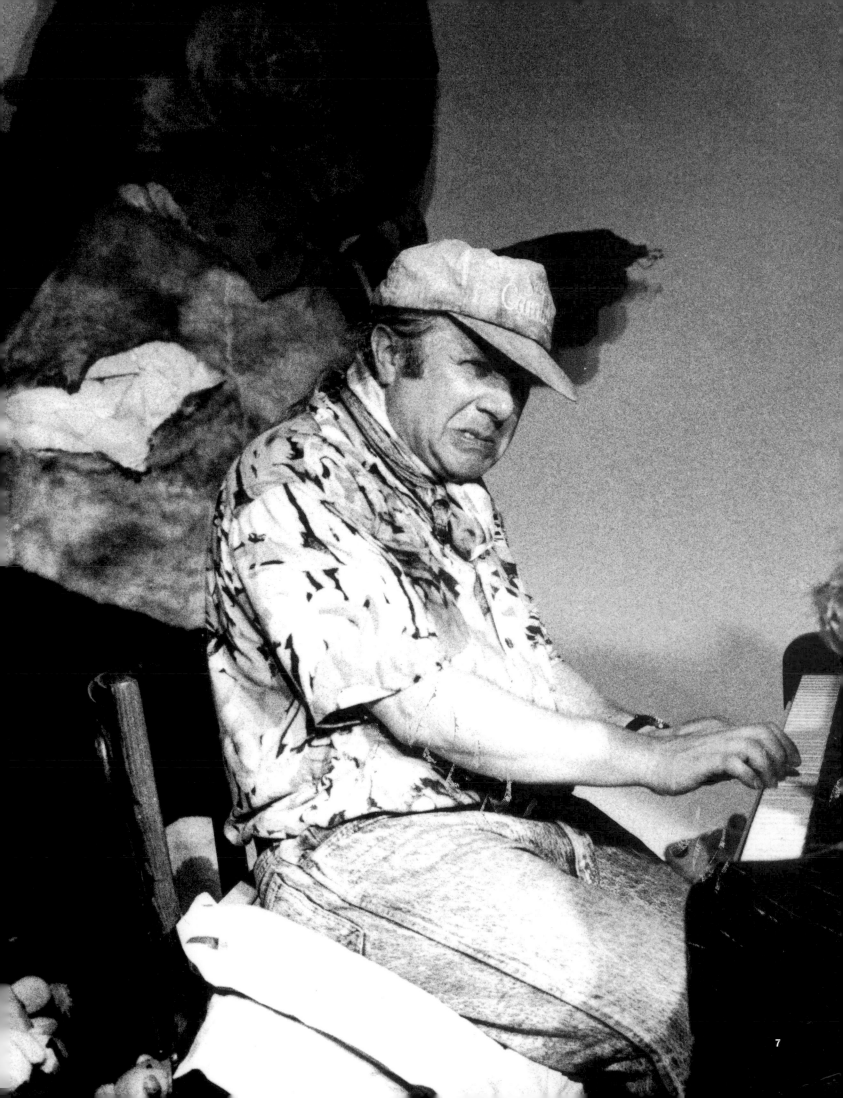

AUG 1956

OST

1000 PLATEAUS

Charlemagne Palestine Ascends

—Tom Johnson, Village Voice

- Solo music—Bösendorfer Imperial Piano
 Harpsichord
 Pipe organ
 Carillon
- Solo vocal music and body works
- Solo sound and/or visual installation
- Theatre monologues
- Ensemble events (commissions only)
- Orchestral events (commissions only)

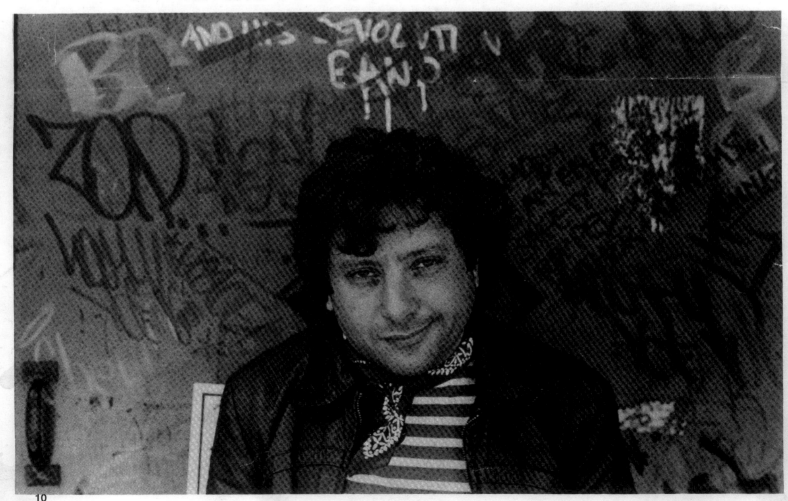

Photo: Betty Beaumont

KLS Management Ltd.

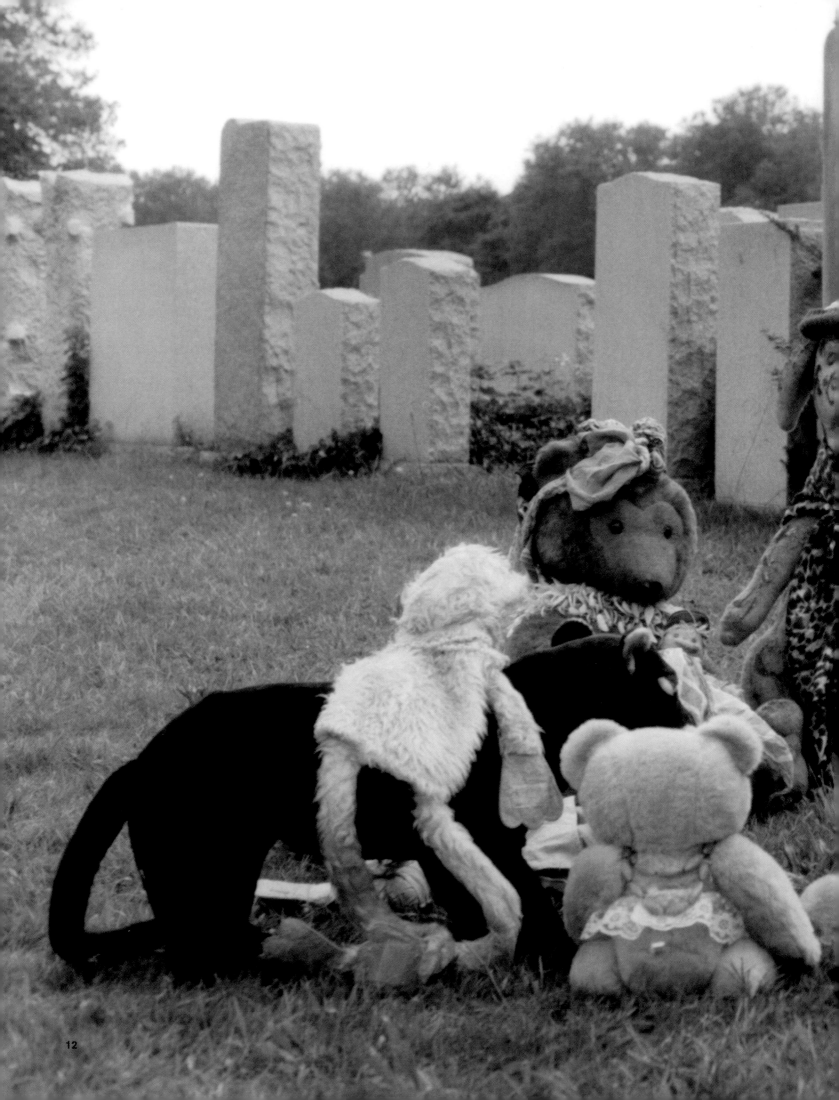

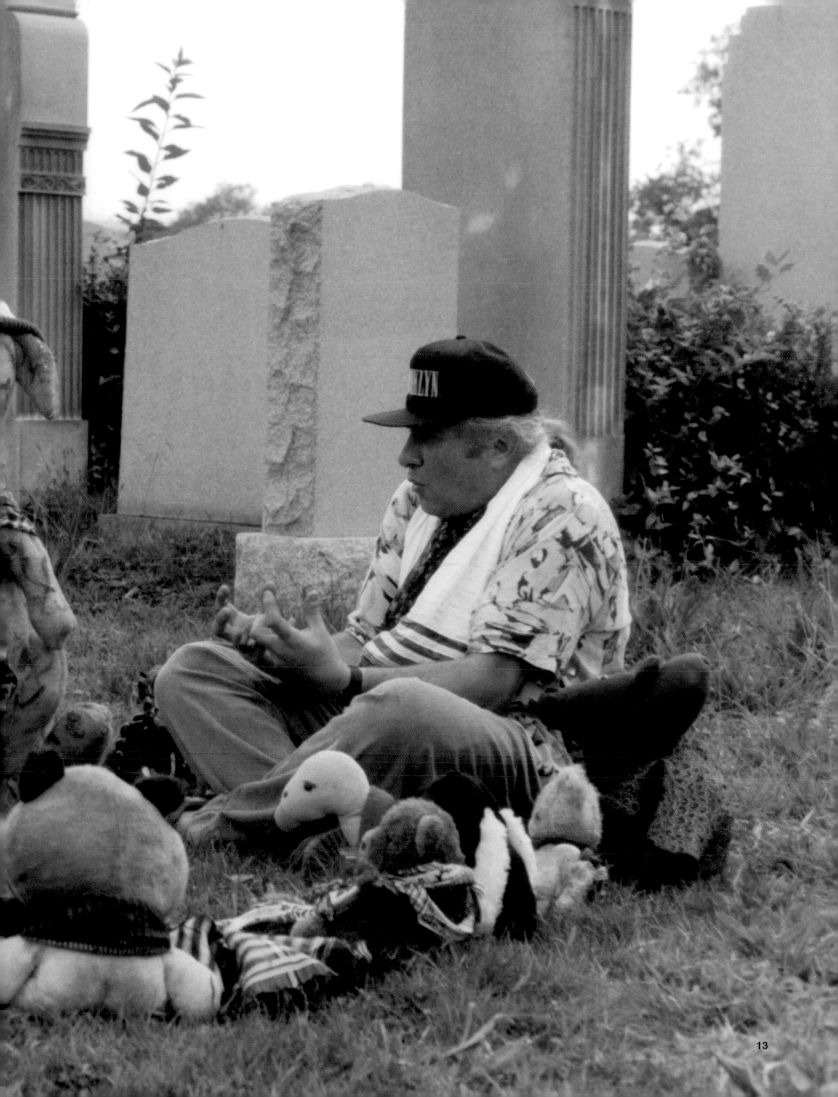

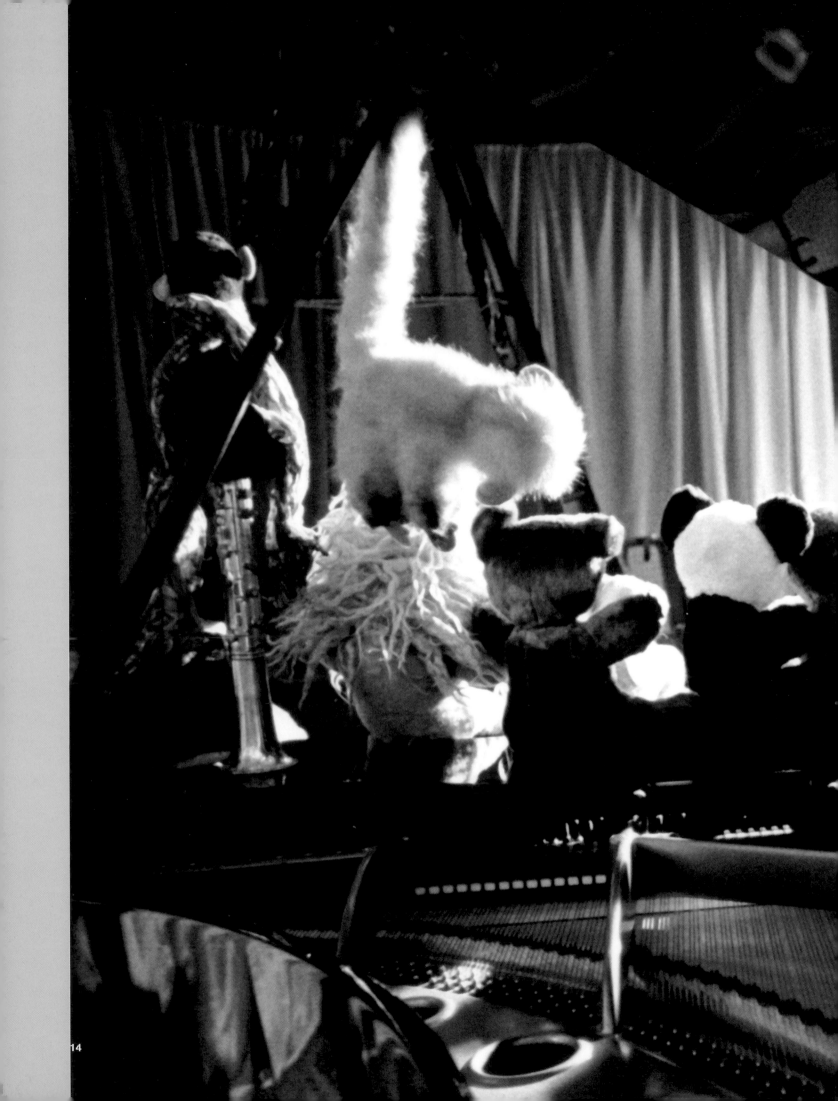

LET ALL THE CHILDREN BOOGIE; BLOOD ON THE KEYBOARDS/ BROOKLYN BOY/ CHOIR BOY GOLDEN BOY/OLD BOY/ BAD BOY: A PREFACE

ANTONIO GUZMAN

TRANSLATED BY ROBB BEATTIE AND SUSAN USHER

16

Charlemagne Palestine's artistic itinerary has been one of intuition, exuberance, rupture, rediscovery and expatriation. For nearly 40 years now, his career has been marked by highs and lows, departures and returns, disavowals and detours, on a road so paved with accidents and incidents that it becomes difficult to follow or even sometimes to discern. It is also a road which has lacked the continuity and discipline that would have made it more comprehensible and yet, perhaps in the end, would have led to the artist being judged as an opportunist or careerist. But the journey has been too bumpy for that, punctuated with satisfaction, success, surprises, compassion, asceticism and ambition, but also disappointment, betrayal, extravagance, excesses and doubt–all running along the three distinct routes of music, performance, and the fine arts.

Palestine's biography has yet to be written; his life is another story. While this monograph contains, here and there, some insights and clues, it does not pretend to present an exact chronology or an exhaustive account. And yet, to evoke the exuberant escapades and excesses of Palestine's journey is not inappropriate. For anyone who knows his oeuvre or hopes to understand it, the starts and lulls of the journey, the vagrant displacements and phases of his life are essential to the fragmentary, unequal, push-pull, divergent quality of his work. On the contrary, Palestine's creativity has mined its longevity, energy and dynamism from a certain nomadism, from one language and homeland to another, following a personal diaspora that has carried him from each concert, performance and exhibition to the next.

Palestine's work is like his itinerary: multifaceted and disparate. It hasn't been a straight road. Linear developmentt and determinism gave way a long time ago to dubious paths that criss-cross and unexpected effects, negotiated via the unforeseen events, the uncertain contingencies and encounters of his life.

This plurality has always been there and has its origins in the three very different forms of artistic expression Palestine employs: music, performance, and installations. More so, he does not fashion equivalencies among the differences, translate a model, or transcribe one form of expression into another. The differences remain divergent; there is no concordance. His music is austere and sober, an asceticism economically abstaining from melody, chords, arrangement and movement. "Monomorphic", Guy de Bièvre calls it. Palestine's gaudy installations, on the other hand, are dense and extravagant debauches charged with an apparent picturesque innocence, while his performance work is again a costly outburst of energy, this time of tension and violence, a catharsis of the body as well as of the soul.

A paradoxical thematic heterogeneity suffuses each of these forms of expression. His work manipulates opposite poles of the sacred and the secular, the mystical and popular, the quick and inanimate. It juxtaposes discrepancies; classicism and kitsch, culture and vulgarity, maturity and childhood, good taste and bad.

The differential becomes even more acute, the angle more slanted and slippery, given the formal diversity with which Palestine expresses himself. He has chosen to work between dramatic and fine arts, between the arts of time and those of space, the dynamic and the static, the successive and the simultaneous, between language and silence.

3

Hubert Damisch's recent study of the distinction between the arts–around a concept he terms *la dénivelée* (literally, "to be out of level")–may be relevant here.[1] In his paradigm, which builds upon the writings of Lessing, Hegel and Schopenhauer, the different artistic disciplines are not hierarchically framed; they just don't function on the same level. In this context, no one form of art employed by Palestine is better or worse than another, they are merely distinct, and the artist exploits the declivity between them to invigorate his work.

In this light, Palestine's creative career can be seen as a passage and a circulation in the intervals between three expressions differing in form, content, and the effects they produce. One expression does not substitute for another, nor supplant it; there is no transfer, exchange or conversion. We can feel the distance that separates his music from his performances and installations. It is in this distance, in this potential divergence, that Palestine finds new possibilities, new stimulants, and conceivably new inspiration.

These distinctions, however, also impose limitations and parameters, when nothing is gained if something is not lost. "Nothing comes from nothing", Epicurus remarked more than two thousand years ago when speaking of measure and proportions, of specificity and difference: "nothing returns to nothingness, nothing is obliterated".[2] That is why Palestine's music starts in silence, moves away from it and then returns. Silence is the point of departure, from which he strays by degrees, from which he wanders in the beginning by progressive stages, and where he returns to in the end. His compositions are atonal and repetitive, ascetic displays of minimalism and constancy that establish identity and maintain stasis through the same chords, the same sound, the same beat. The unwavering repetition is withstood as much by the musician as endured by the audience, united in an unremitting act of audition where there is little change, little movement or progression; it is a matter of lasting. At the same time, harmonics arise and sound on unplayed chords, instilling the sense, in the same duration, not so much of an echo but of a subtext; the unexpected suspicion of another composition from somewhere else, a distant score, far off, in an awareness of time passing that we do not want to end, to stop.

According to the classifications of Lessing and Hegel's genealogy of the arts, considered somewhat orthodox and academic today, Palestine's music operates solely in a temporal dimension. Like all music, it has only time to regret its status and only time in which to work its seductive charms. It is one-dimensional, ephemeral, fugitive, and ethereal, with no material other than sound; it is as free of weight and gravity as the spirit.

Palestine's installations, on the other hand, are derived from sculpture. Like the body, their place is in the three dimensions of empirical space. According to the precepts distinguishing between the arts alluded to above, these works possess an objectivity, are positioned among the objects of the world–albeit to an even more heightened degree given the number of objects with which they themselves are composed. The works are three-dimensional, fixed, material, subject to gravity. In Palestine's practice, the concept of *la dénivelée*, of working on different levels, extends from the arts of memory to those of contemplation, from one to three dimensions,

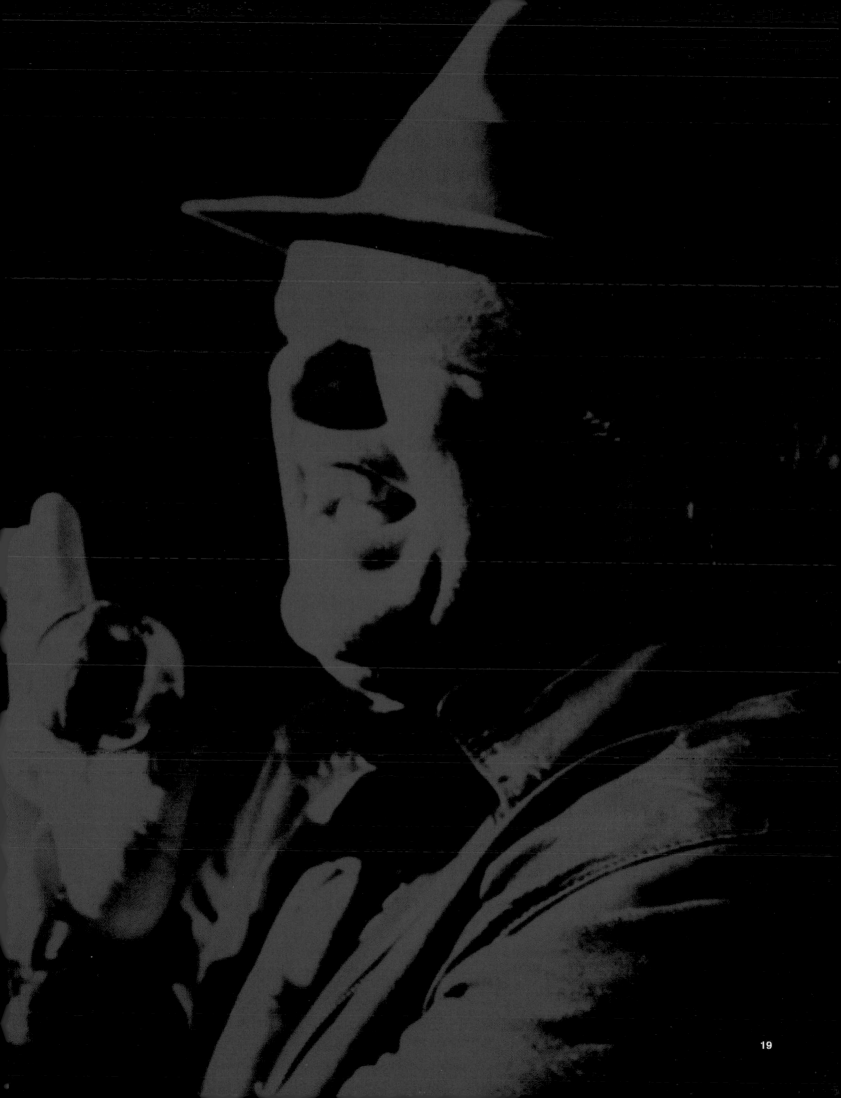

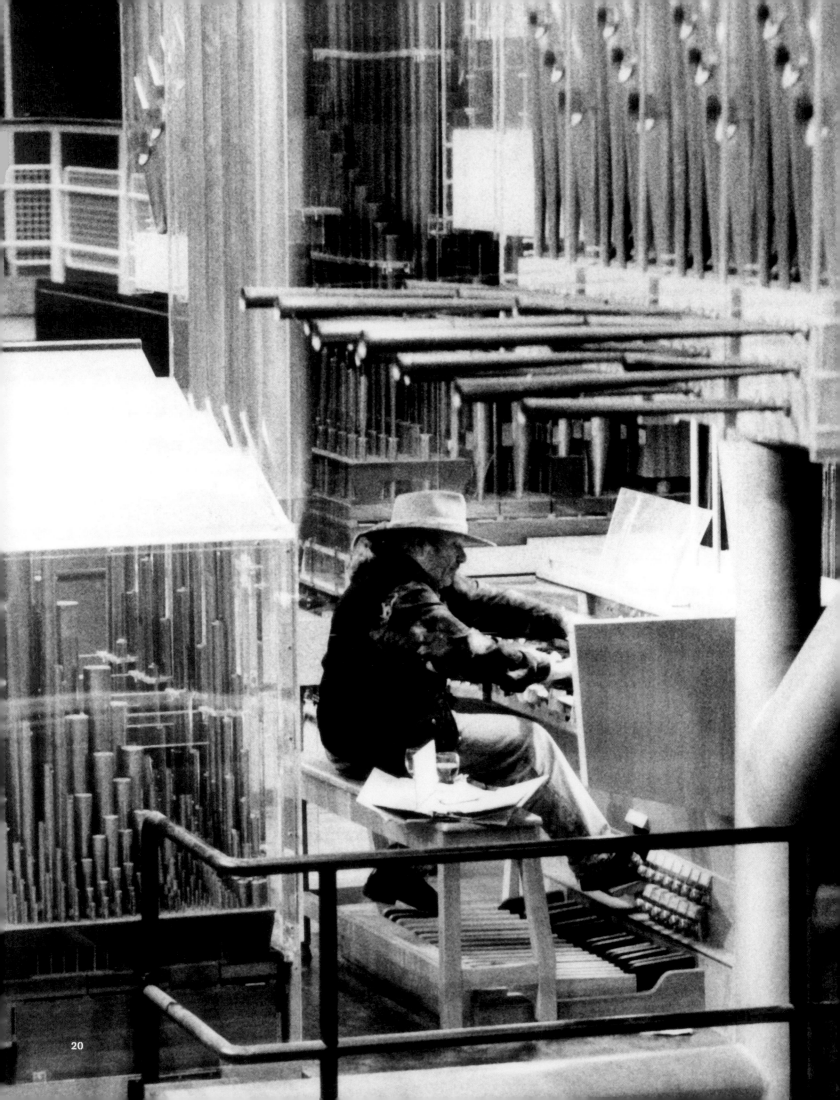

from subjectivity to exteriority, from the interiority of his music to the objectivity accorded to the volume of his installations.

Still according to Damisch, this schema has operational value only, especially as movement traverses time and space and is a constituent element contributing to their definition. Palestine's performances, where he often gives of and pays out with his own person, could be situated just as well on the spiritual as on the corporal plane. The performances are subjective as well as objective, charged with the temporal as well as with the spatial.

The titles Palestine assigns to his installations and exhibitions explicitly reveal the context in which he places them: *Sacred Bordello*, *Plush Toy Temple*, and *Sacred Toys*.[3] Edwin Pouncey's interview refers to this fact, Arnaud Labelle-Rojoux underscores it, and other writers have commented on it—Palestine's realm is specifically that of the sacred and ritual.[4] It is not the terrain of the erudite mythologist or Francophile structural anthropologist, however, but the more modest and mundane landscape of popular animism, a hybrid pantheism infused with a blithe, joyful wisdom.

This is why Guy de Bièvre is right to quote Palestine when he refers to himself as an 'alchemist'. He takes on his artistic endeavours as a quest, between high and low art, in an attempt to transmutate humble materials into treasures, totems, pantheons and altars, where the venal and corruptible are transformed by magic or mysticism into a currency increased in exchange value by its capacity for resolution, the redemption and salvation of our souls. This is the speculative, occult and secretive aspect of the work; an enthusiastic pathos that is tempted by a grand oeuvre of alliance forging an alloy linking man and the universe.

The esoteric and hermeneutic qualities in Palestine's installations are nevertheless neither learned nor scholarly. Disorderly, heteroclite, imbued with inane and childish dimensions, these works properly belong to the domain of pop. It is this which allows them to avoid the realities of aesthetics, the dogmatic pietism of religious paraphernalia, and evoke a barbaric, ecumenical paganism flouting all orthodoxy. Palestine himself becomes a gnostic situated at the atavistic fount of the universal tribe, and must be considered one of our era's kabbalists.

Along the way, what Charlemagne Palestine has done has been to re-imagine himself as a figure, to create a persona with a raucous laugh and a vast collection of scarves and hats. Beyond the intervening and interposed plush toys, beyond the obsessions and the fetishism, the spell of sonorous environments and incantations, Palestine's story is in part the tale of an urban Jewish-American adolescent who at maturity rejected a religion that permitted no idols, who grew up and aged into childhood and acceded to primitivism, reinventing himself as a transatlantic shaman and creating his own divinity, *God Bear*. Occidental fakir and yogi of the New York sidewalk, Palestine tends to blur the lines: Was he born in 1945 or 1947? Where did he get his fabulous name? What is his real name? Why did he put his music aside for so many years? What made him start composing and recording again recently?

Those of us who have followed the torturous course of Palestine's outrageous performances, who have been

swept away by his concerts' nocturnal spirals and accompanied him into the mysteries of Courvoisier-fuelled trances, know that these trips are legends in the making. The anecdotes that result are always recounted with a hefty dose of hyperbole, celebrating both the experience of having been there and the fact of having survived without too much damage. But for all the sulphurous emphasis and exaggeration, this particular legend is no fairy tale.

Despite the sweet softness of the feel of plush and the apparent innocence of his toys, the infantile universe Palestine creates is "uncomfortable" and "deliberately limited in outlook", as Labelle-Rojoux states in his text. It is as if this tender, sometimes silly childishness finds itself incapable of staving off the certainties of anger and deep-seated selfishness, unable to avoid or mitigate a vexatious, trenchant caricature of childhood's gaping maw.

And why should it be otherwise? In point of fact, Palestine employs soft toys to make figures twice removed by delegation and surrogacy. They are two degrees away from us, the distance that separates us from both the infantile and the inert. There is nothing naïve or candid about it, much in the way that adults who take up the transitional objects and clothes of childhood inevitably distort the child they once were, and produce a dissonant travesty of what they no longer are.

Palestine is not the only contemporary artist to turn to the figure of the animal. Nor is he the first. Among the classics, one thinks of Joseph Beuys' 1965 performance *How to explain a painting to a dead hare* or the coyote in *I like America and America likes me* of 1974, or of Annette Messager's stuffed boarder series of 1971-1972, her 1993 *anonymes*, and hearts of 1998-1999. Any such survey of the place of the animal in recent art also has to mention works such as Kounellis' horses, Wegman's canine portraits, the vices and virtues of the hare by Flanagan, and Joan Foncuberta's artificial natural history, *Fauna* of 1985-89 and *Safari* dioramas of 1989-1991. Also included would be Jeff Koons' porcelain statues, his *Puppy* of 1992 and 1997, the hybrid taxidermy of Thomas Grünfeld, the photographed crows of Jean-Luc Mylayne, Damien Hirst's formaldehyde cow and shark, Alain Sechas' cat, Katherina Fritsch's rats at the 1999 Venice Biennale, Carsten Holler and Rosemarie Trockel's pigs at the 1997 Documenta, Xavier Veilhan's penguin, horse and rhinoceros, and the allegorical menageries of Olivier Richon and Karen Knorr, to cite some of the better known examples.

What this superficial look at contemporary art's bestiary does most effectively is highlight how Palestine's use of the animal figure differs from other artists. His menagerie is neither alive nor dead, stuffed, flayed, moulded with resin, suspended in formaldehyde, tied up, photographed or digitised; it is simply inanimate. In the end, the animal figure is not his project. Palestine's work does little more than hint at the zoomorphic and what the French term the *objectile*; his real focus is anthropological, humanist and psychological. The subject is childhood, mediated by the therapeutic toys and role-playing that accompanies that state. Because it is soft, light and cute, Palestine's menagerie is cuddly and furry, but it careens towards the calliope of his roguish, picaresque fairground.

It was with this in mind that Baudelaire wrote, "the child sees everything as *new*; he is always *drunk*", and identified the figure of the artist with the child, aligning the artistic gaze with "a sharp-edged *childish* perception that is magical by force of ingenuity".[5]

This is why Palestine is mistaken, I believe, to compare himself with Mike Kelley or Paul McCarthy, and to have spent so many years claiming recognition for his prior use of stuffed animals. His use of these figures may be

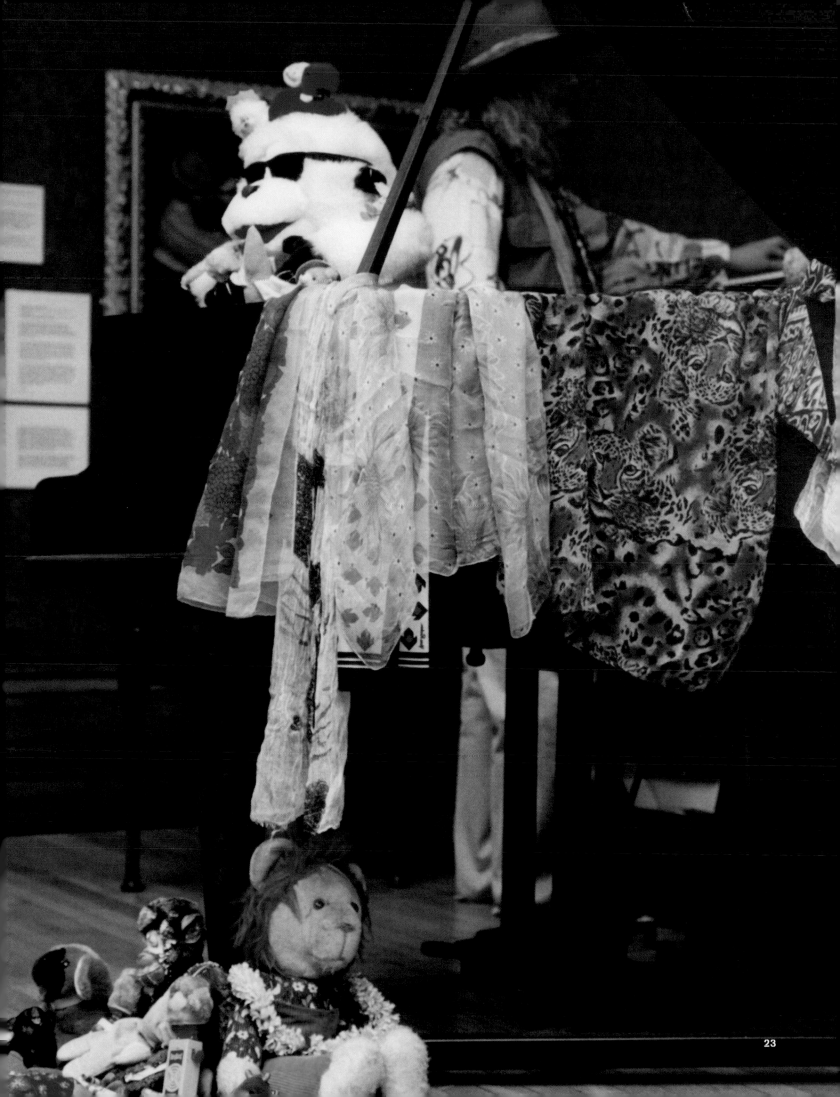

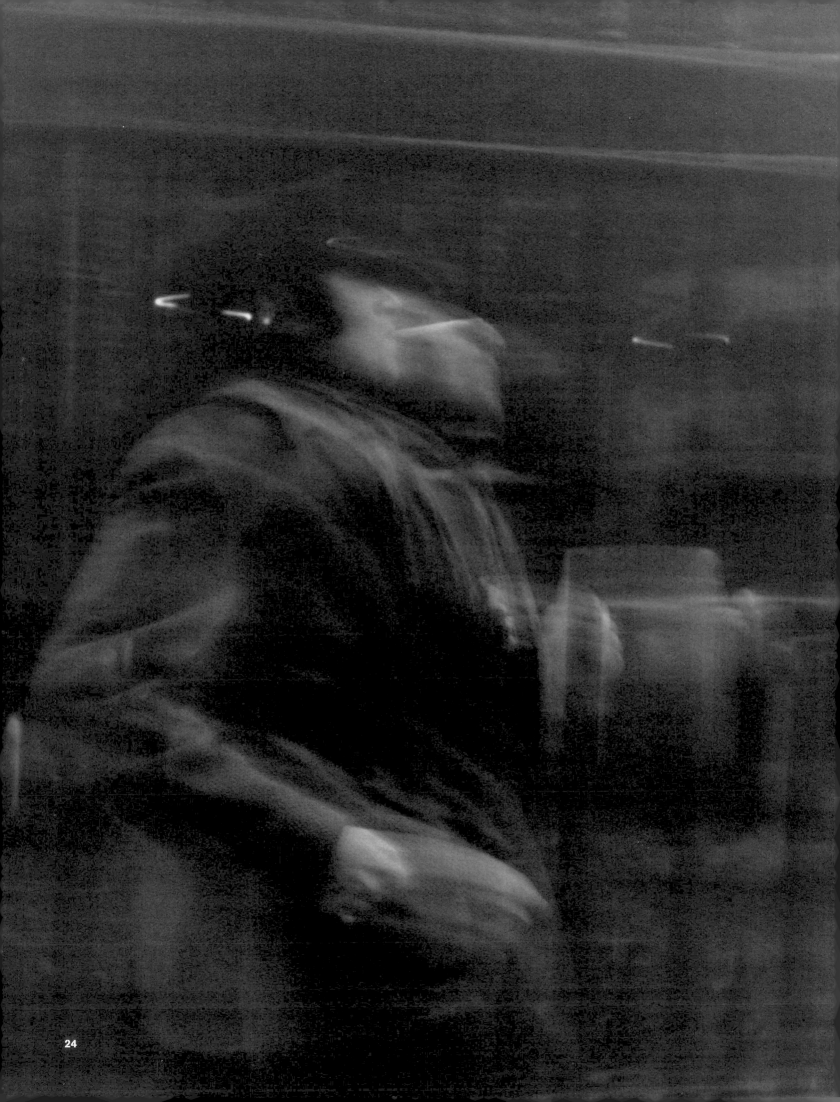

far removed from department store toy shelves and the cradle's moist intimacy, but the work never explores the vagaries of cruelty, violence or parody and never aggressively transgresses taboos in the manner of these two artists. Instead, Palestine's aim is to recover a state of grace and attempt a resolution somehow, somewhere, anywhere, and why not in what childhood might have been before we all lost sight of it. This is why he tries so much to infuse some sense of vital and initiatory breath into his cheap stuffed beasts, something neither Kelley nor McCarthy have ever risked in their own work.

6

It's these concerns which link Palestine's self-invented persona to characters in fables and folklore, as well as to the genre's pervasive sense of ambivalence. While this play of associations may not fit *Cinderella*, *Puss 'n' Boots* or *The Three Little Pigs*, it certainly applies to *Peter Pan* and the *Ratfänger von Hameln* (the Pied Piper of Hamelyn), perhaps because of the traits Palestine and the characters share: music, peculiar garb, the power to lure children, and a sense of the dark side of things, of a 'shadow self'. If you remember, both of these stories start off rather well.

The Pied Piper comes twice to the town of Hamelyn. The first time, in 1284, he arrives dressed in a many-coloured coat when Hamelyn is infested by a plague of vermin; he delivers the town from its plight by playing a flute and luring an ever larger horde of rats and mice to the river where he watches them drown. But the following year, having yet to be paid for his services, he reappears in a marvelous red hat and strips Hamelyn of all its children whom he entrances with the spell of his music.

Peter Pan is another story about a forgetful, enchanting flautist which begins well enough. The children of the Darling family are initially delighted when Peter flits from their dreams to reveal himself after his shadow becomes caught in the bedroom window. They are likewise delighted to learn how to fly and then leave with him for the isle of Never Never Land. There, in a place where it is forbidden to grow up, Peter is captain of the Lost Boys, amnesiac urchins who cannot remember anything before their arrival on the island. In fact, it is so difficult to keep track of time in Never Never Land that Peter himself cannot tell the difference between last year and yesterday. Tragedy and injustice have been a large part of his life, but he has forgotten everything.

At the end of the adventure, all the children, including the Lost Boys, return home by passing through the bedroom window the Darlings left open for them. Peter, with his leafy costume, is left alone in refusing to grow up, to learn to read and write, to grow a beard. He will return to greet an aged, adult, married Wendy who can't help but notice that Peter remains a little boy with baby teeth. She knows that Peter will visit the dreams of her daughter, granddaughter and great granddaughter, and may one day lead one of them out of the window to Neverland, that dystopic utopia. She has forgotten how to fly, but has learned that "only the gay, innocent and heartless take wing".[6]

7

But theory and analysis belong to the stable, peaceful world of Apollonian dream. Their application to work that makes so little claim of them represents yet another paradox, a not insubstantial one at that. In Nietzsche, the arts are presided over by twin aspects of the divine. They are represented as the gods Apollo (accompanied by

muses and idyllic shepherds) and Dionysus (heading a parade of nymphs and satyrs).[7] Apollo steps solemnly and speaks impassively; Dionysus's dance is ardent and he bursts into drunken song; the regulated, soothing music of one inspires eurhythmics, offsetting the other's ecstatic dithyramb and bacchanal.

Palestine's jumbled references, mélange of genres and diverse artistic practices seem ultimately to foreclose any emergence in his work of placid individuation, calm distinction, formal limpidity or clarity. But any consideration of Nietzsche's schema leaves little doubt as to the choices he's made. To realise this, one has to only experience the strange surprise, the primal and primitive epiphany that occurs on first hearing the harmonics appear in *Strumming Music* and float above the persistent score, an advent from the far reaches of nowhere that arrives unexpected and barely understood.

Beyond the reveries and revelry, the lures and lugubriousness, the temerity and aesthetic enthusiasm (used here in the antique etymological sense of 'union with the divine'), Charlemagne Palestine's work, when he gets it right, redeems something confusedly oriental and orphically modern. It engages something of the impasses and mysteries of abstraction, a place where the spirit is not a pallid, feeble double of the body, but instead is ultimately one part earth and one part sky–a celestial soul for an earthly body.

1. Hubert Damisch, *La Dénivelée: à l'épreuve de la photographie*, Seuil: Paris, 2001; as well as *La Peinture en écharpe: Delacroix, la photographie*, Brussels: Yves Geveart, 2001; and Lessing's *Laocoon*, 1766, especially Chapter XVII; Hegel, *Cours d'Esthétique*, Hotho ed., vol. III, 1835; Arthur Schopenhauer, *Esthétique et métaphysique du beau* in *Parerga et paralipomena*, 1851.

2. Lucrece, *De natura rerum*, chant 1, verse 155 and verse 216.

3. Respectively, exhibitions in Valenciennes in 1997, Montpellier and Amsterdam in 1990; also *You should never forget the jungle*, performance-video, 1975; *Retour à nos racines* and *Let's go back to the caves–to hell with white walls* exhibitions in 1989; *The preservation of old souls at the end of a forgetful century*, exhibition and video in 1989; *Transmutation des reliquaires sonores*, exhibition in 1997.

4. Including Hendel Teicher, "Qui a peur de Charlemagne Palestine?", in *Sacred Toys–Preservation of Old Souls*, Amsterdam: Torch Galllery, and Geneva: Eric Franck Gallery, 1990; Josselyne Naef, in *Charlemagne Palestine*, Saint Fons: Centre des Arts Plastiques, 1992; Catherine Legallais, "Bordel sacré", in *Acquisitions recentes*, Dunkirk: Frac Nord-Pas de Calais, 1998.

5. Charles Baudelaire, *L'Artiste, homme du monde, homme des foules et enfant*, in *Le peintre de la vie moderne*, 1863.

6. James Matthew Barrie, *Peter Pan*, 1904.

7. Friedrich Nietzsche, *The Birth of Tragedy*, 1871.

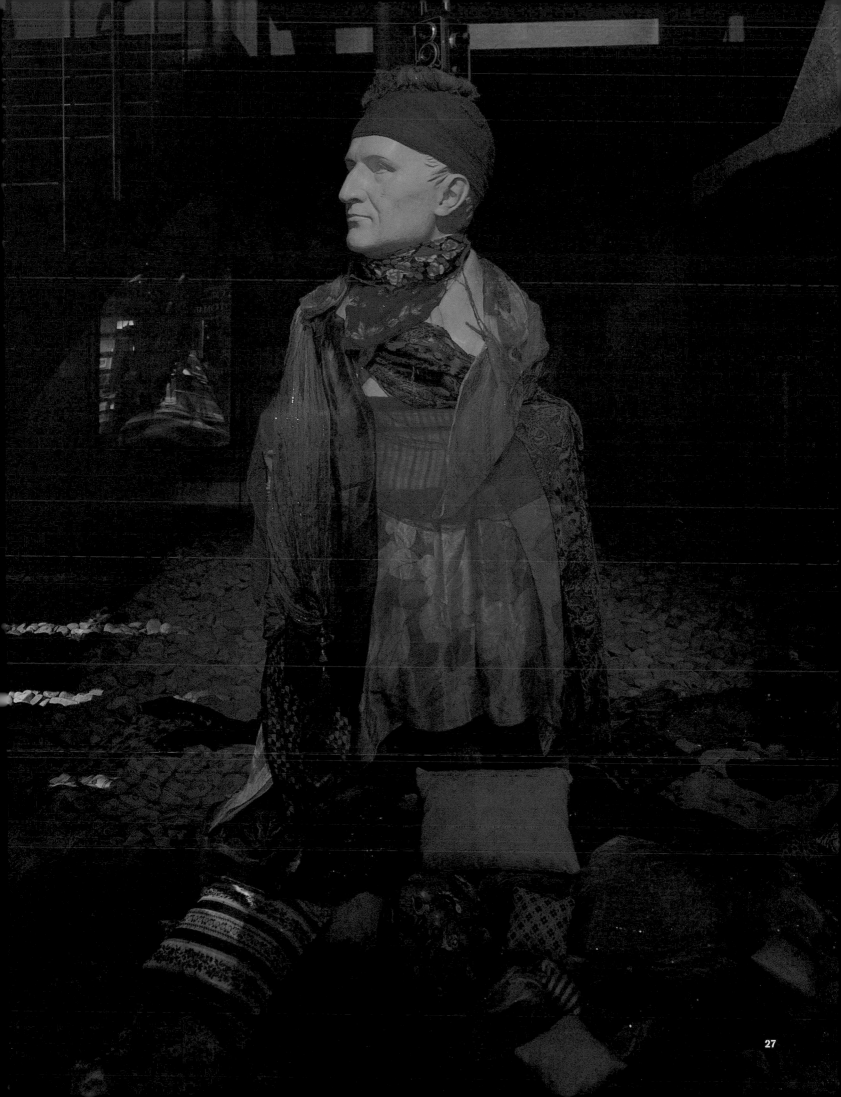

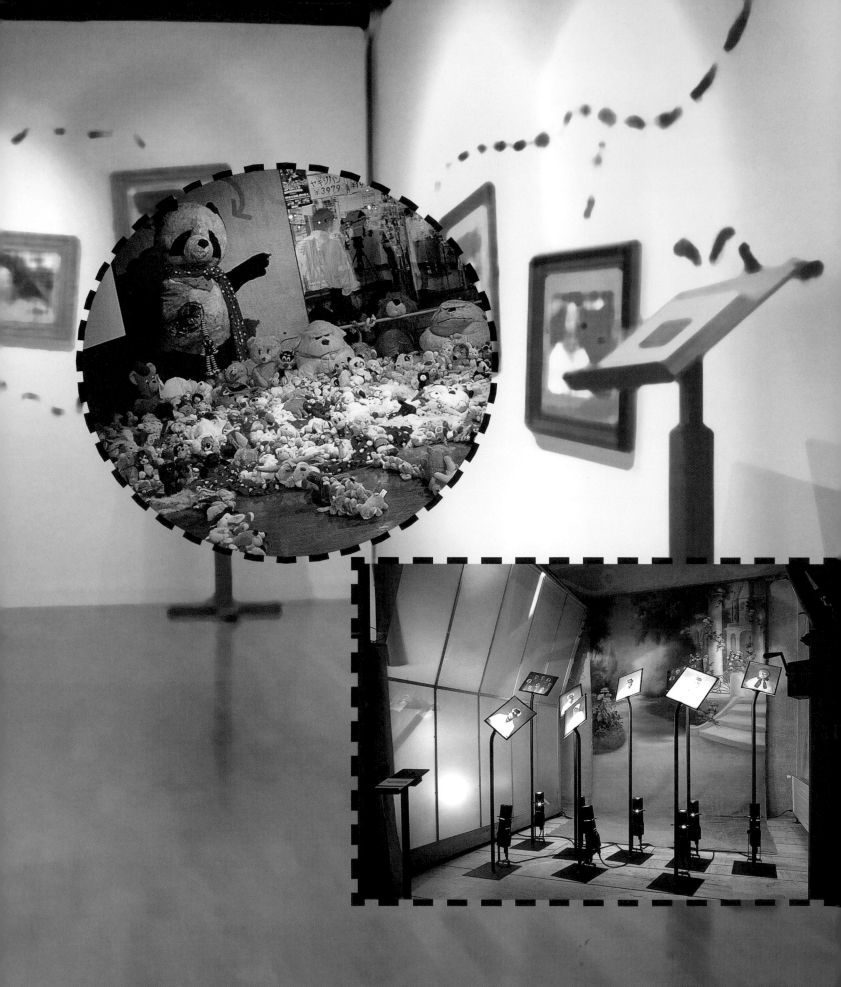

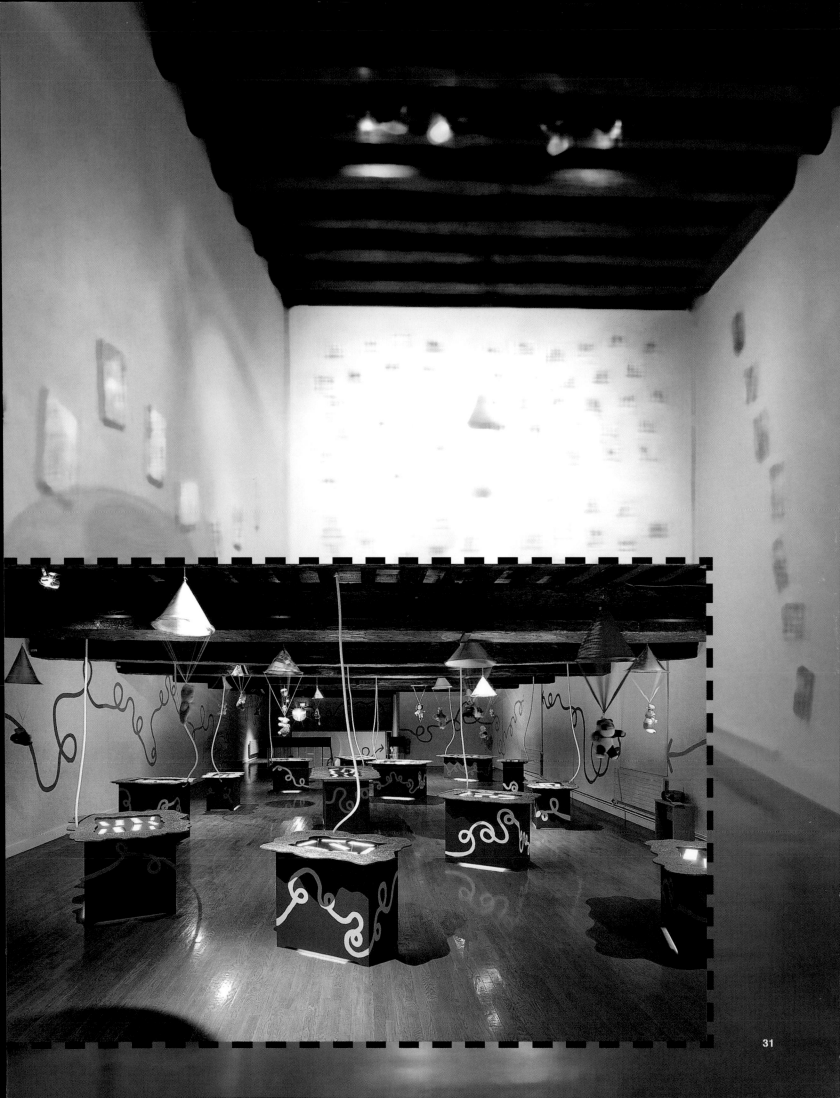

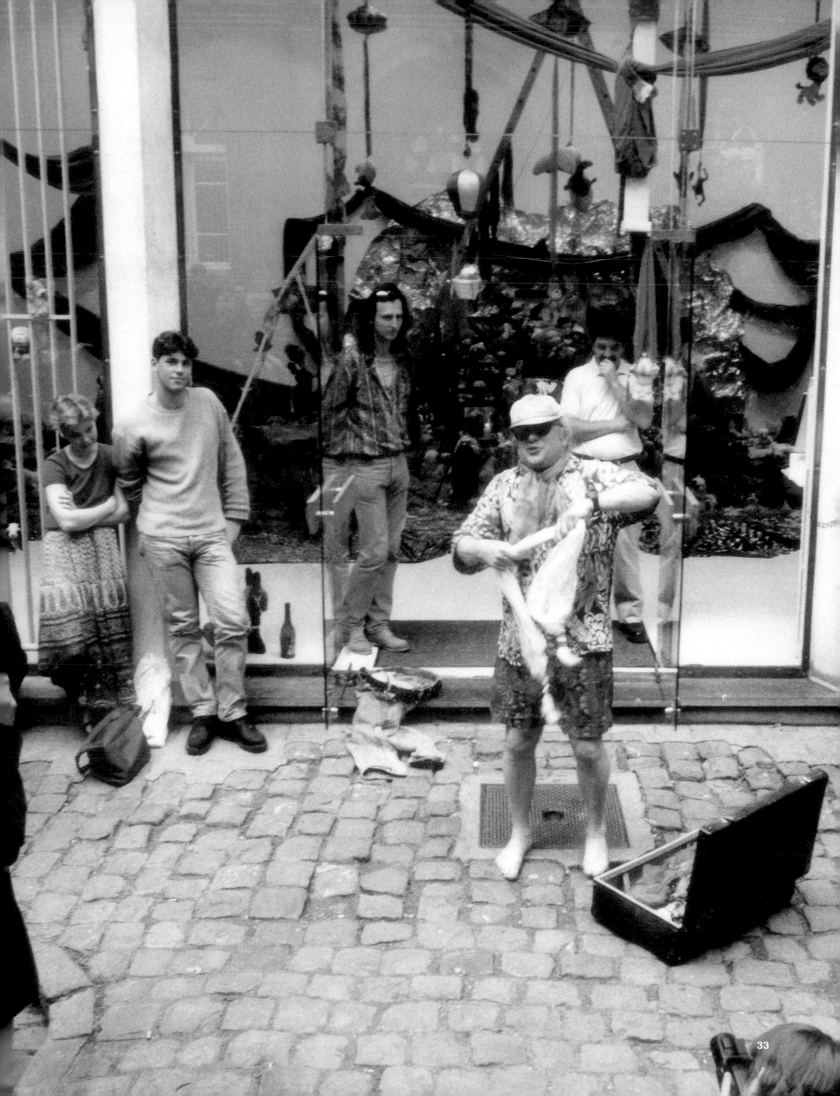

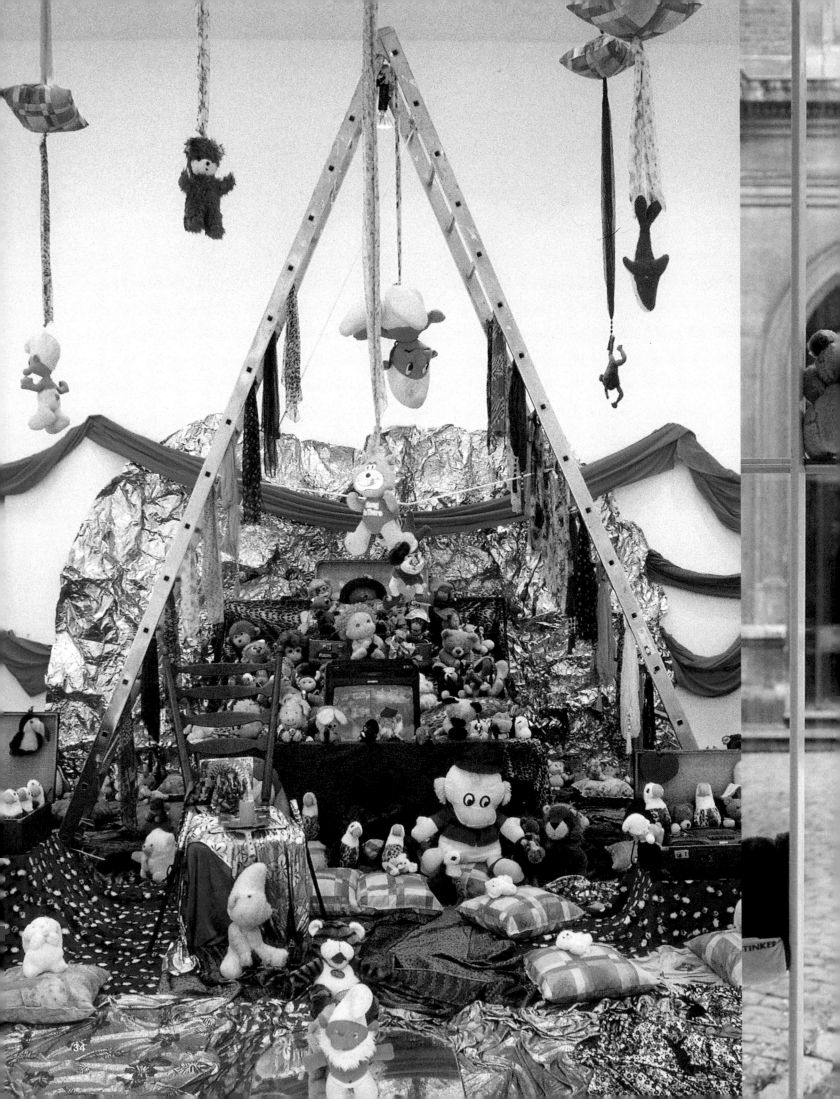

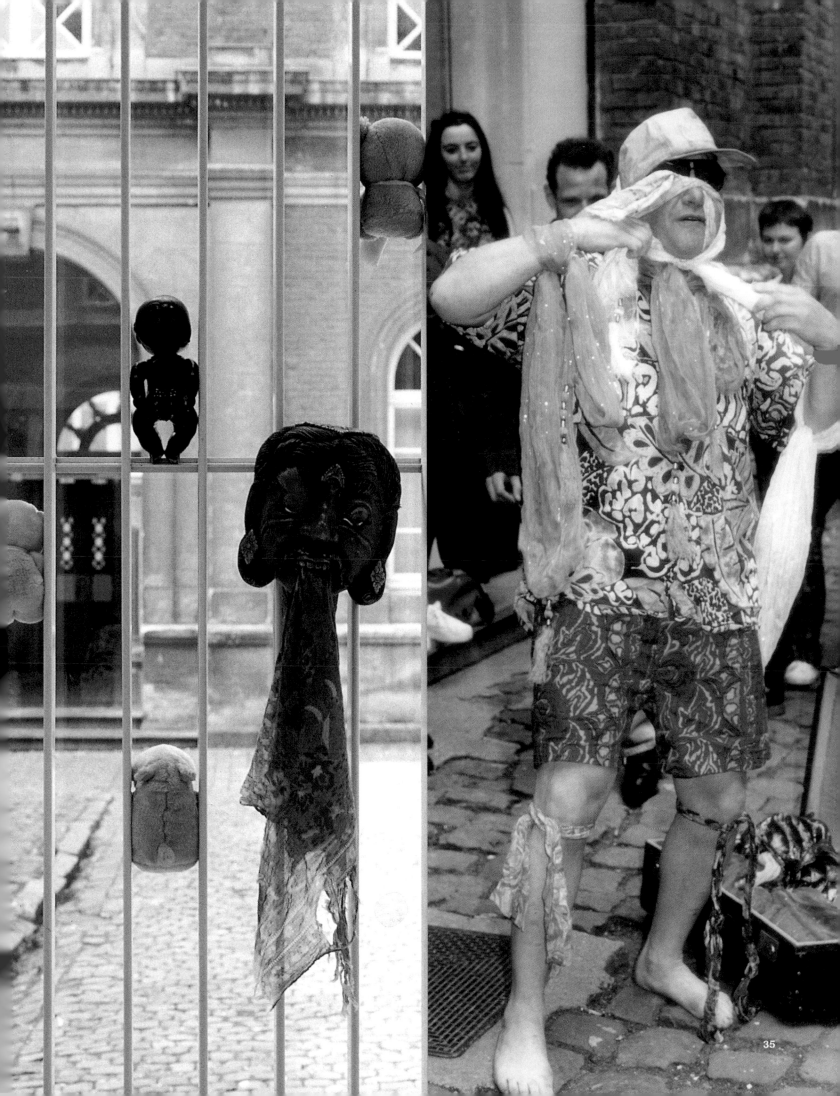

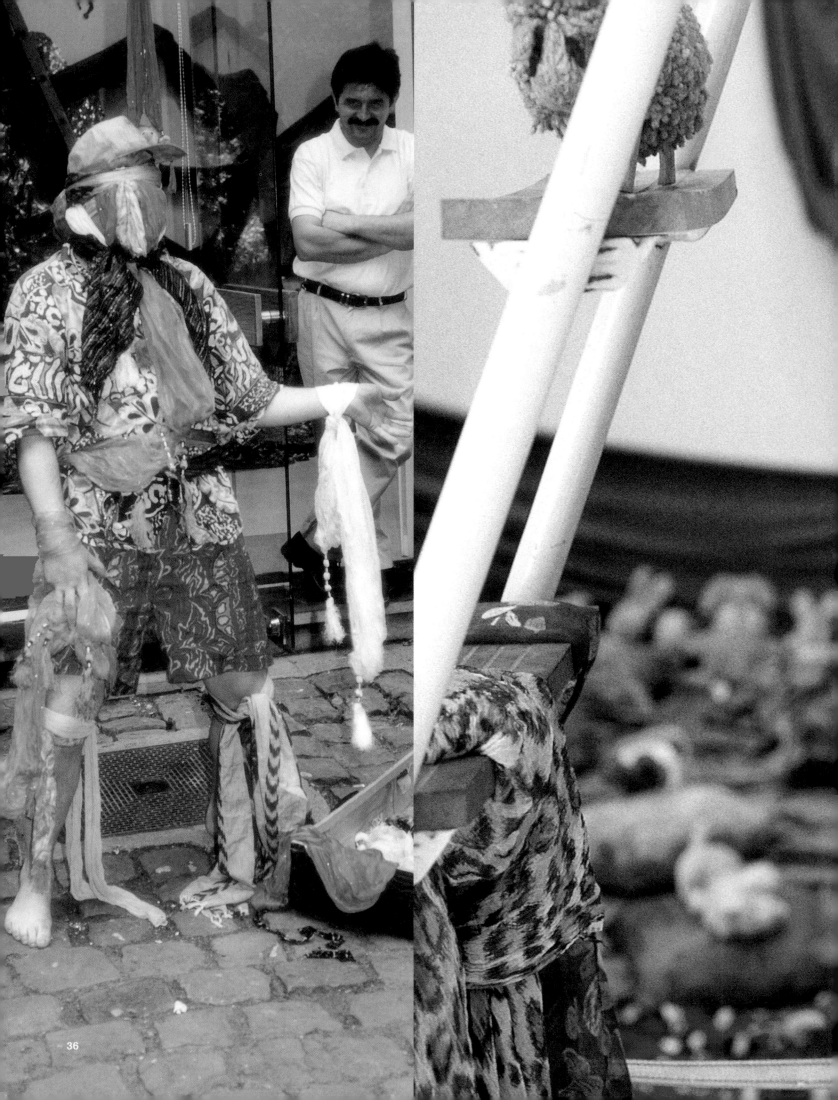

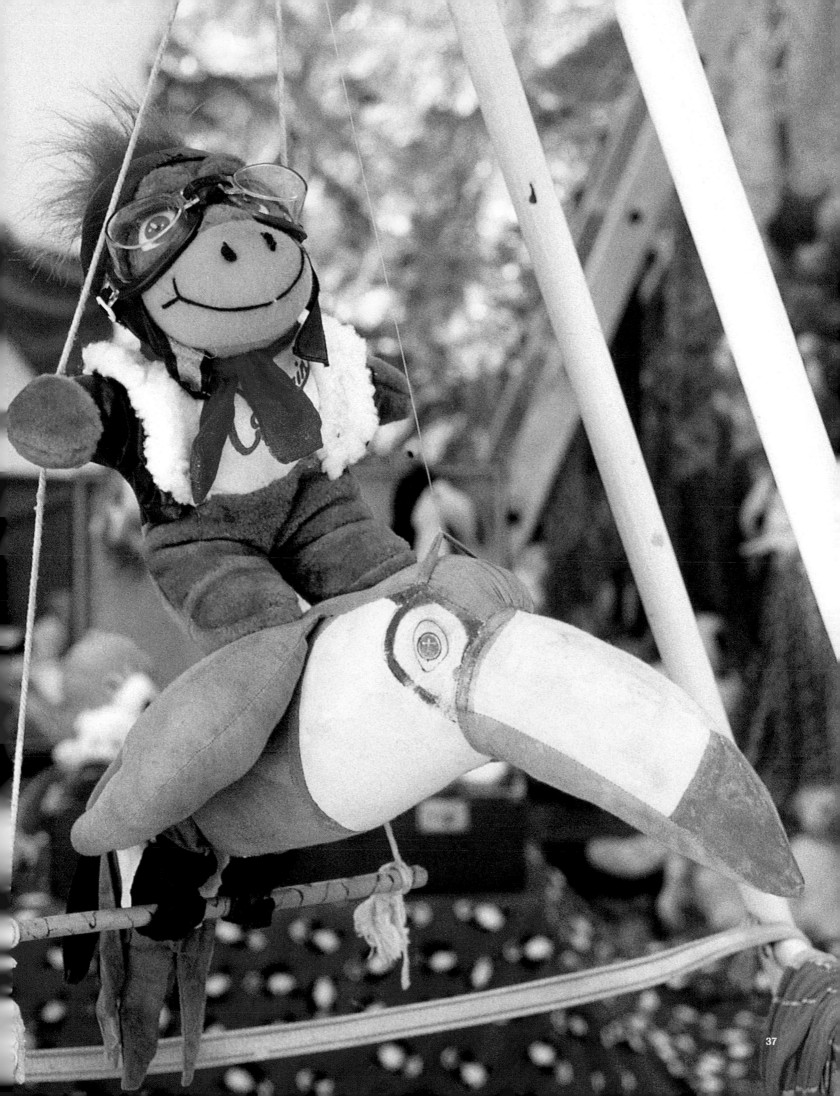

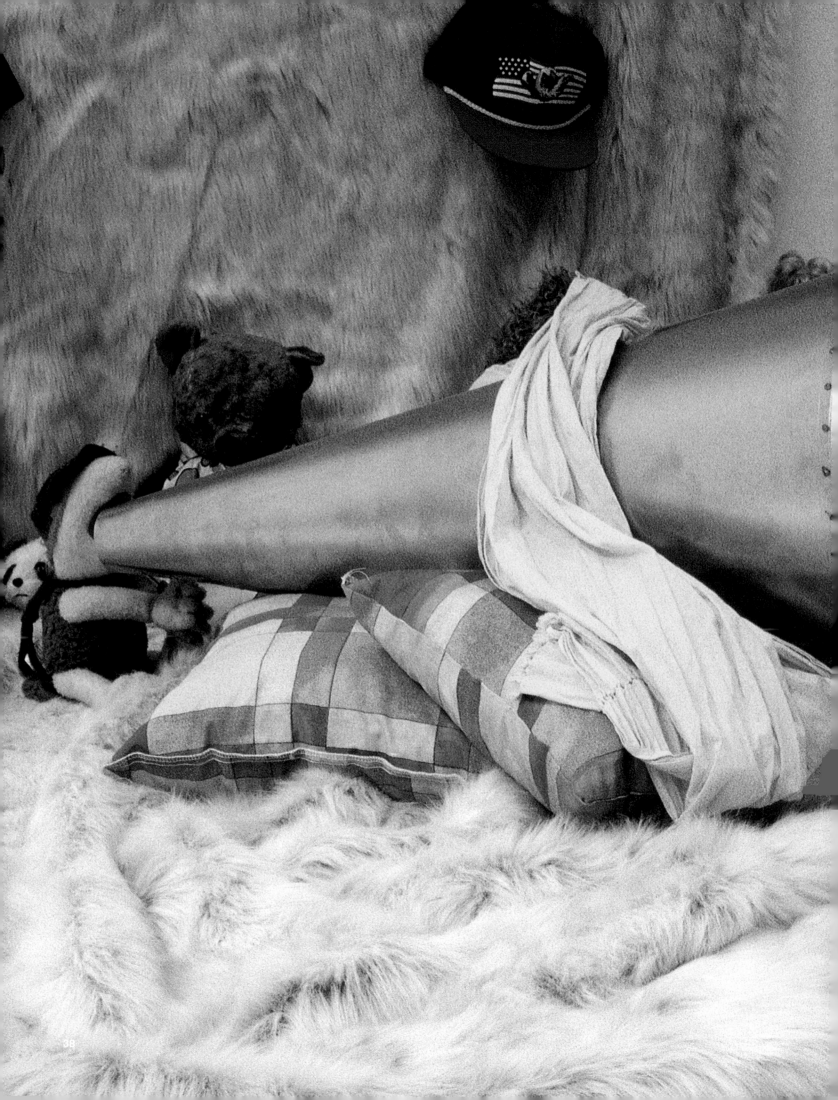

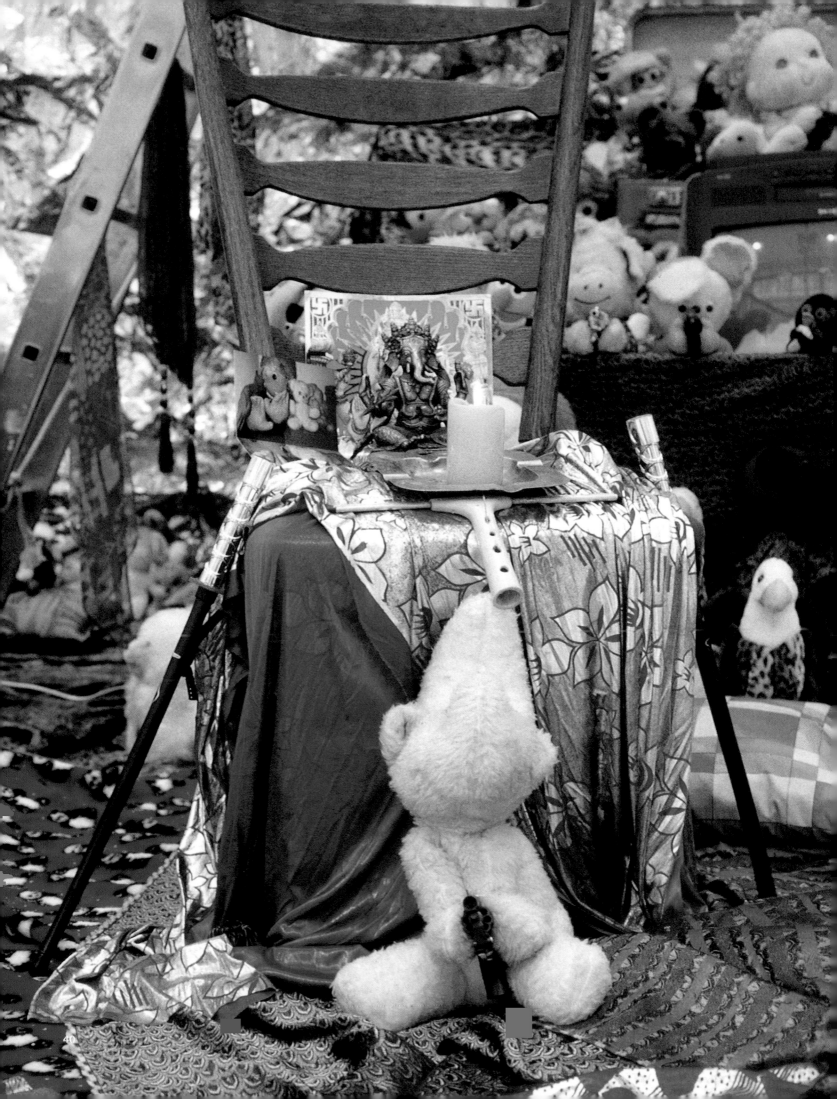

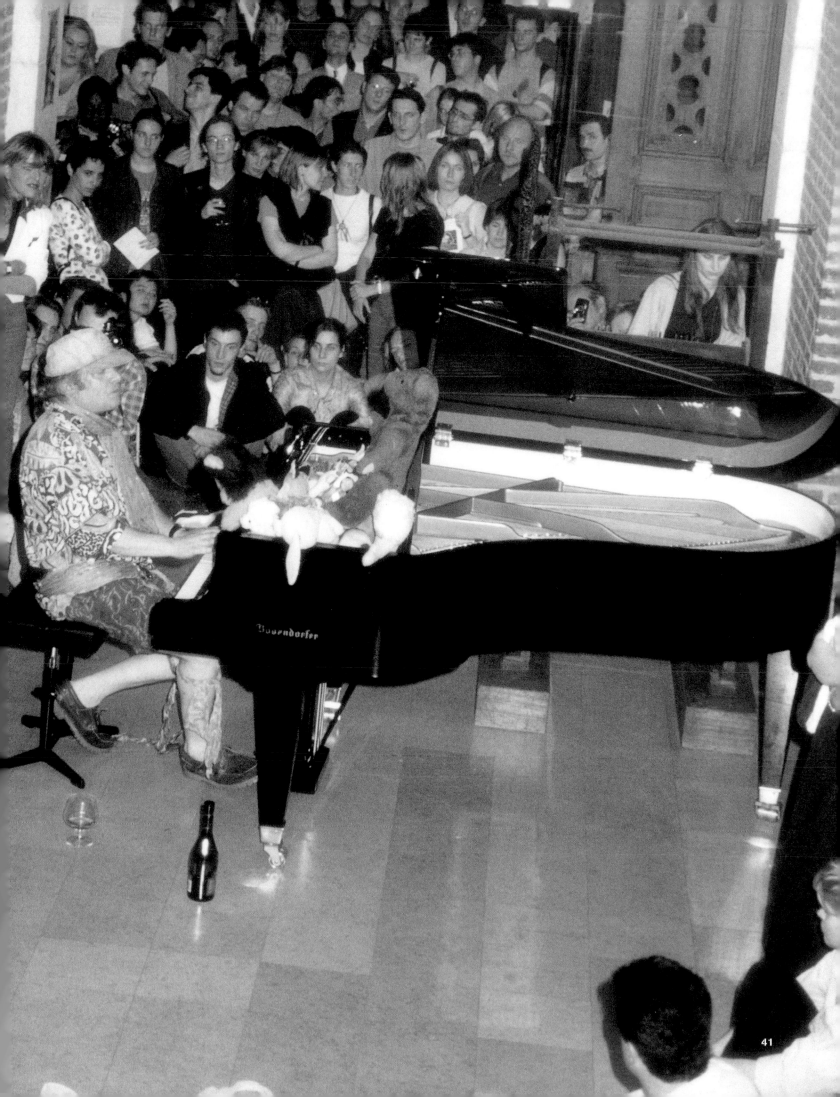

DIVINE INSURRECTION

EDWIN PONCEY

42

THE NAME CHARLEMAGNE PALESTINE IS NOT ONE THAT READILY DRIPS FROM THE PEN OF MOST MODERN AMERICAN MUSIC SCHOLARS, DESPITE THE FACT THAT HE WAS PARTLY INSTRUMENTAL IN THE FORMATION OF THE 1960S AMERICAN MINIMALIST MUSIC MOVEMENT, ALONGSIDE SUCH KEY FIGURES AS LA MONTE YOUNG, TERRY RILEY, STEVE REICH AND PHILIP GLASS. UNLIKE HIS CONTEMPORARIES, HOWEVER, PALESTINE CHOSE TO GO DOWN HIS OWN ROAD OF UNCONVENTIONAL INNER EXPLORATION, A ROUTE THAT WOULD ULTIMATELY LEAD TO SELF-MUTILATION, NEAR NERVOUS BREAKDOWN, AND EVENTUAL PERSONAL ENLIGHTENMENT. TO ACHIEVE THIS HE WOULD HAVE TO TRAVEL AROUND THE WORLD IN ORDER TO STUDY ANCIENT TRIBAL CUSTOMS AND COMMUNE WITH HIS INNER DEMONS, A SEARCHING OF THE SOUL THAT HE READILY ADMITS IS STILL HIS MAIN REASON FOR MAKING MUSIC, CREATING SCULPTURE AND STAYING ALIVE.

My musical career began more in Europe than it did in America. Europeans immediately saw this relationship between the work that physical artists and sound artists like myself were making in the 60s. I was little more than 20 years old and I'd never been to Europe, but from the first time I arrived it became my second home, my salvation.

SACRED CHANTS AND RESONATION

Charlemagne Palestine's natural home is Brooklyn, New York where he was born in 1947 and brought up in a Jewish household that was situated a mere stone's throw away from where the American version of the teddy bear was invented in 1902 (a coincidence that would play an important part in his development as an artist and musician during the 70s). At the age of seven he was urged by his parents to join the choir at his local synagogue and it was through this that the young Charlemagne learnt the basic endurance training for the physically demanding music he would in later life be shocking audiences with.

I started at a very young age, singing certain Hebrew texts which often lasted many hours. In traditional Jewish orthodox music a woman is not permitted to sing, so boys take the role of singing in the highest voice and that was my job until my voice changed at 13. I already had this sense of the synagogue being a sacred, resonant place. There's a lot of wood, they usually have enormous, high ceilings and occasionally a dome. You sang and everything would resonate. Even then I wasn't a religious Jew; I found that it was not easy to mix traditional life with normal Western life. I was still searching for a connection with that ancient consciousness and tradition, but I was a modern kid in America who loved TV and synthesizers and gadgets. It was just incompatible.

SOAP OPERA IN A BELL TOWER

At the age of 13 he auditioned and was accepted into New York's High School of Music and Art where he offered up his life to the creation of art and music. His search for the ideal instrument on which to play the music that was building up inside him was rewarded three years later when he took a job as carillonneur at Saint Thomas, a Protestant Episcopal church that was located next to the Museum of Modern Art.

They had a carillon with a traditional clavier and for me it was like a continuation of my singing in the synagogue, it was something I had to do every day. There are these oak levers and pedals which you have to play very physically; you smash your fists on the levers which move clappers with counterweights that hit the bells above your head. I played twice on Sunday and for six years, until I was 22, I never missed a day.

Although he was obliged to play traditional hymns and Christmas tunes on the carillon bells Palestine was also allowed to perform some of his own experimental music, first in the spirit of such composers as Cage, Stockhausen, Berio and Xenakis, but later this shifted into his own style which began to attract a daily audience.

I made something that became a kind of musical soap opera where I would play a series of chords and elements which would last for 15 minutes. The next day I would continue exactly where I had left off and it evolved into quite an elaborate thing. I was playing in a bell tower that was right down the street from Saint Patrick's cathedral which was like playing in your Piccadilly Circus; thousands of people heard it every day.

One of the thousands who heard and responded to Palestine's musical soap opera was to have an important influence on the budding composer's career, fellow experimental musician and filmmaker Tony Conrad.

I was playing this episode of my daily soap opera one day and all of a sudden I hear this guy screaming

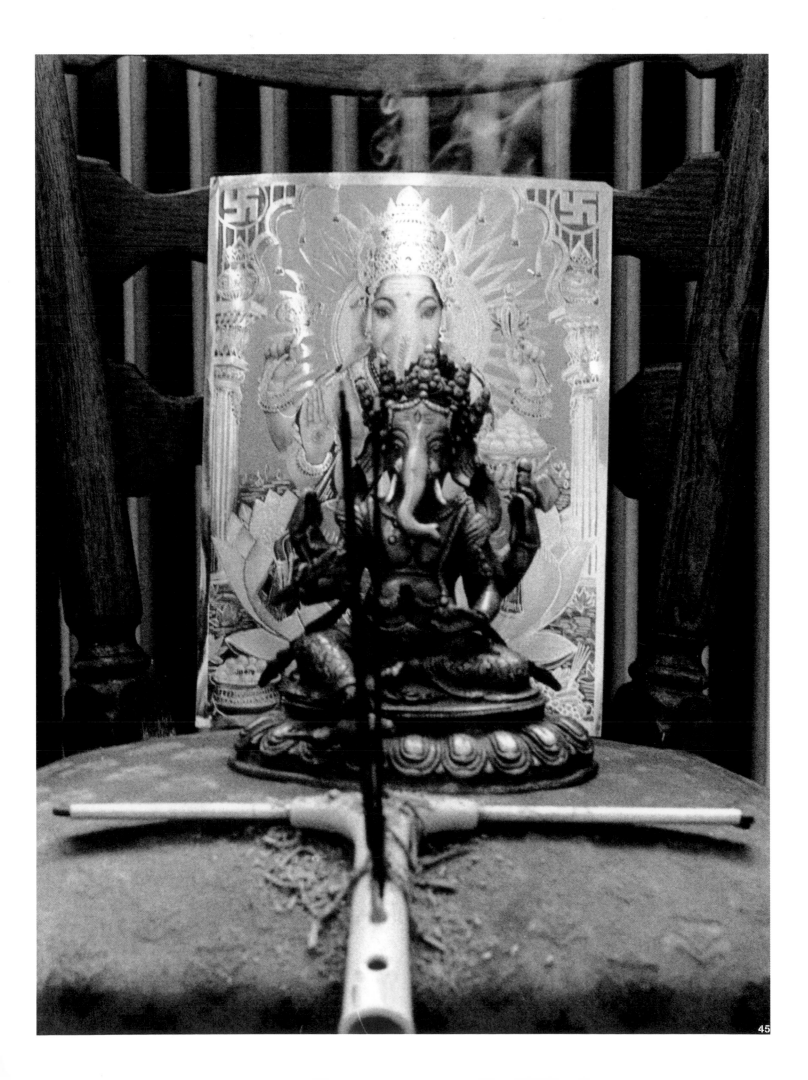

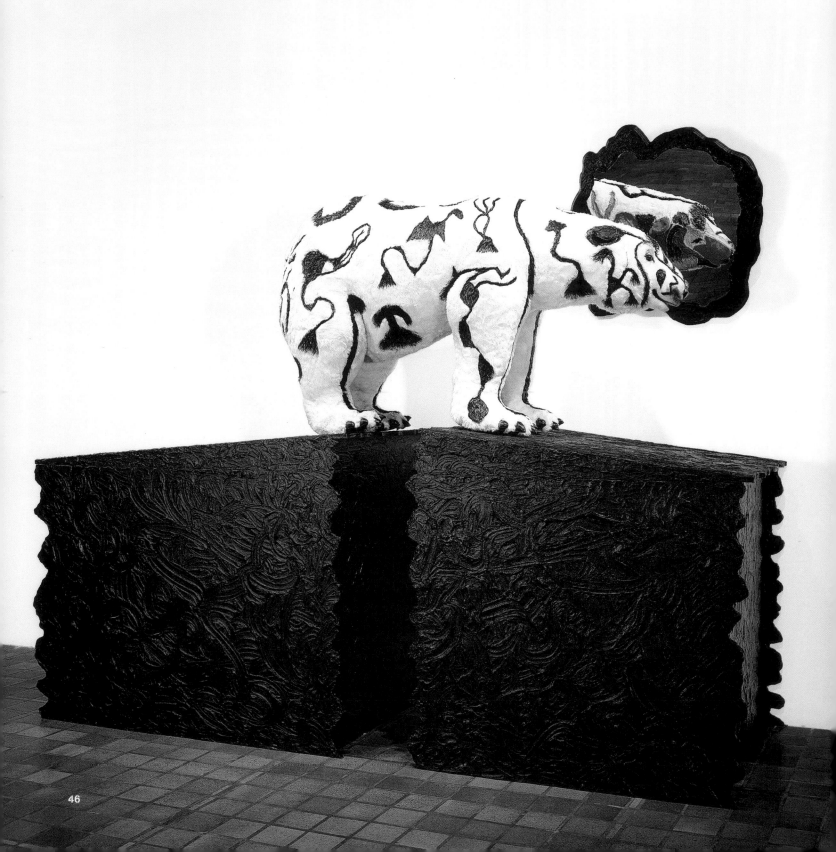

"INCREDIBLE! OH FANTASTIC! THIS IS INCREDIBLE!" up the stairway of the bell tower. I just kept playing and by the time he made it to the top I had finished my piece. It turned out that he was Tony Conrad and he had been experimenting change ringing with a set of Russian bells while he was a student at Harvard University. I later found out that he was the creator of one of the first Minimal films called *The Flicker* and at the time I met him he was working with his wife on a totally different idea called *Coming Attractions* which was a film about everybody and everything in his life.

MEETING THE MINIMALISTS

When Palestine came into contact with Conrad a whole new world of discovery and invention was opened up to him. In the late 60s, when their meeting took place, New York was a hotbed of artistic activity where no idea was too obscure, outrageous or unacceptable. Through Conrad, Palestine was introduced to some of the core members of New York's avant-garde, a diverse crowd of painters, performance artists, dancers, sculptors and musicians, some of whom were to become comrades during his personal dream quest to discover the pure, sacred music which he craved to create and make his own.

Tony had commissioned six composer friends of his to provide the music for *Coming Attractions*, some of whom were already known like La Monte Young, Marian Zazeela, Terry Riley and John Cale who he had played violin with [as part of La Monte Young's Theater of Eternal Music] back then. He asked me to play bells for the film because he was still stunned by my soap opera. I met everybody at Tony Conrad's apartment, as 24 hours a day somebody famous was up there. Taylor Mead, Gerard Malanga, the entire Andy Warhol entourage and even Valerie Solanas [who would later shoot Warhol] were there.

PANDIT PRAN NATH

In 1969 Palestine was soon to move to California at the invitation of Morton Subotnick who he had met while working with synthesizers in search of his "golden sound" at the Intermedia Center at New York University. Subotnick was then the head of the Centre and when he was offered the deanship of the California Institute of the Arts (Cal Arts) he was asked to select students to accompany him. Subotnick invited American composer Ingram Marshall and Palestine, both of whom agreed to make the move to California. Before he left New York, however, he composed a drone piece for church organ which he called *The Spectral Continuum Drones* and came into contact with Indian teacher and classical singer Pandit Pran Nath; both events would add to Charlemagne's development as a musician and strengthen his endurance as a performance artist.

I began to study with the legendary Indian singer Pandit Pran Nath who I met through Timothy Leary's assistant Baba Ram Dass (né Richard Alpert). Alpert had experimented with psychedelic drugs with Leary at Columbia University where he saw the magic of God when he was on a trip and became a student of the great Indian masters. He studied with Pran Nath, but more on the religious than the vocal

training side. I had this pothead neighbour who went to these meetings and one day he came back saying, "Charlemagne you've got to see this Ram Dass guy who's fantastic and he's with this Indian singer who will blow you away." So I went to hear Pandit Pran Nath who sang this slow, evolving drupad where the intonation changed over a very short period of time. I had never heard anything so incredible and I became his student. This was a couple of years before La Monte Young and Terry Riley studied under him and by that time I had left for California. It was like the synagogue, he wanted me to give up my life for him and I wasn't willing to do that.

CALIFORNIA DRONING

Once in California Charlemagne continued to work with synthesizers where he was encouraged by Subotnick and Donald Buchla, both of whom were working alongside Robert Moog on the early stages of synthesizer technology. I built an electronic instrument which I called the *Drone Machine* that made the sound of the Indian tambura or the sruti box, only much more controlled. There weren't many synthesizers that could do what it did. It used no voltage control and it had 15 switches fitted so that I could change the beat between tones by one percent. I later toured with the *Drone Machine* and on the *Four Manifestations* record the two electronic pieces were made using it.

For a while he considered trying to market his invention, but as there was no room for the *Drone Machine* in the practical world of modern synthesizer technology this idea was abandoned. It was at Cal Arts, however, where he initially came into contact with his first Bösendorfer Imperial grand piano, the instrument he had been unknowingly searching for and the one that would completely change both his life and his musical vision.

One day I wandered into this room and sat down in front of this enormous, beautiful looking piano. I started playing and while the tone continued I could hear all the detail of the overtone system as clearly as I could when playing my *Drone Machine*. That's when I decided to make piano music, but for this make of piano alone, and that's when I started to get obsessed with that instrument. It turned out to be the thing I had been looking for, but I had no preconceptions about it. I had left the piano behind.

STRUMMING MUSIC

After this important and influential discovery Palestine temporarily returned to a version of *The Spectral Continuum Drones* music he had worked on in New York using a church organ and transferred it to the keyboard of his now beloved Bösendorfer piano. This would evolve into a technique (and eventually a piece) called *Strumming Music*, Palestine's most famous work which was performed in countless versions during the 1970s.

It started on middle E and followed on with the octave below, then the octave below that in a kind of strumming fashion. I gradually brought out all the overtone system to create a single piece that lasted up to five hours. It was very impressionistic. It wasn't quite what would turn into *Strumming Music*, but it had all the elements.

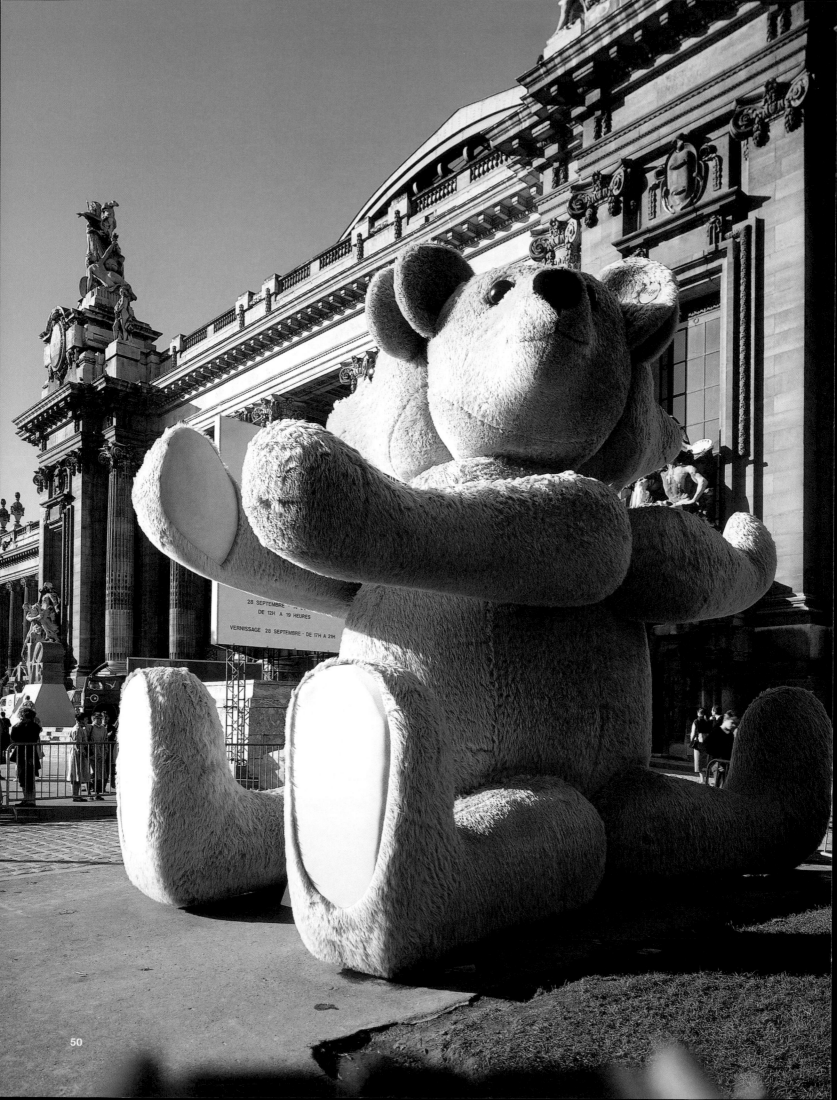

As the late 60s toppled into the early 70s, Charlemagne was asked to perform at a festival in Rome by Simone Forti, a dancer at New York's famous Judson Dance Theater who had also studied with Pandit Pran Nath. She knew a guy called Fabio Sargentini who was one of the first guys to show an interest in Minimal music and dance. She was invited to perform at this festival he was organising and because I was working with her on this piece-a sound piece which involved my voice and body-I was invited along as well. When I got to Rome there were La Monte Young, Terry Riley, the famous dancers of the time, Steve Reich and Philip Glass. That's when I first became a part of that whole Minimal music movement.

NYC SLIGHT RETURN/THE LOWER DEPTHS

In 1973 Charlemagne Palestine returned to his home city where he would make some of the most physically demanding, challenging and shocking work of his career. On his return and with no base he was befriended by, among others, Philip Glass, whose career was in the ascendant. Palestine had begun to make a series of psycho-dramatic videos which he describes as "sonic investigations" where physical, vocal (and sometimes mechanical) rituals were acted out using the camera as an extension of the body. Such works prompted the Sonnabend Gallery in New York to ask Palestine if he would record *Four Manifestations on Six Elements* for them, a commission that included two electronic and two keyboard works where he was assisted in the recording studio by Glass's engineer Kurt Munkacsi.

As the 70s wore on the extended drones of *Strumming Music* gave way to a more flamboyant, mystical and violent performance, one in which Charlemagne's childhood endurance training at the synagogue and his later bell ringing energies were put to the test.

When I returned to New York the music began to change and the strumming technique became more like an aggressive flamenco. I no longer felt that laid back energy I experienced when I was living in California. Eventually I was doing something called *Timbral Assault* and another, more strenuous piece called *The Lower Depths* that took over two hours to perform, where I would go down to my 'lower depths'.

To reach there he would first ritually prepare himself for the physically and mentally draining performance ceremony that lay ahead:

I would drink Napoleon cognac which was an important stimulant for me when I played. I would chain smoke Indonesian Kretek cigarettes made from cloves, because cloves are a mild anaesthetic. I would anaesthetise myself until I was in a trance-like state, then I would sit down at the piano in this dark, red-lit room and start on this journey. I would have all my stuffed animals arranged around me that I would look at. I was only with them and myself and we went off to another world.

At the end of these 'journeys' Palestine would emerge dazed, confused and bleeding. His hands resembled pulped lumps of red meat, broken strings shook like thin silver snakes from inside his damaged piano while the remains of his audience looked on in shocked amazement.

My performance was compared somewhere between that of Chris Burden and Iggy Pop but I personally felt that I was going too far. I was drinking heavily, burning my candle at both ends and inventing this playing style that was a big influence on the New Wave rock musicians, but I didn't know what

the fuck I was doing to tell you the truth. I was getting ecstatic reviews but I couldn't even make a living. I was broke, I was taking myself to the limit and I was near to having a nervous breakdown. I couldn't pay the rent so I had to think of something else.

THE BLIND MONKEY

That something else was to transfer his devotion from music to sculpture. He was particularly interested in channelling his energies into making the stuffed toy animals he shared his piano and emotions with real and decided to create a personal divinity mythology that would exist in a secret realm called *Charleworld*. On the front of the Barooni CD version of *Four Manifestations* crouches *The Blind Monkey*, one of Charlemagne's divinities which he considers being an important inspiration.

All my animals are autobiographical. Several days ago in Belgium I saw the original vinyl version of *Four Manifestations* which was issued in a blank cover. Now 22 years later and *Four Manifestations* is reissued on CD and *The Blind Monkey* is on the cover and that's me. It's like Odysseus after his journey. I could have taken a smoother road, it was all handed to me 22 years ago and I could have had anything I wanted. Instead I chose the rougher road and I'm still looking, but that would seem to be my destiny. Here I am 49 years later and these things I created all that time ago are coming back and for the first time they feel right to me now.

Edited extracts from an article that originally appeared in *The Wire*,
London, issue no. 154, December, 1996.
Reproduced by permission.

52

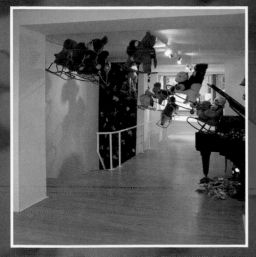

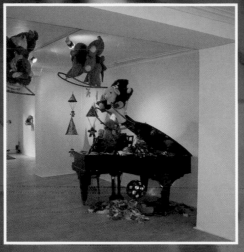

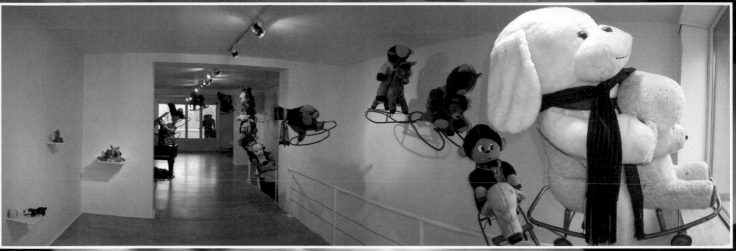

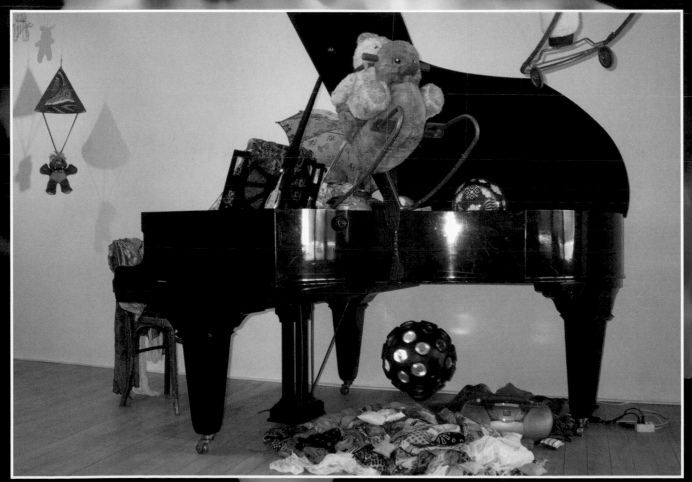

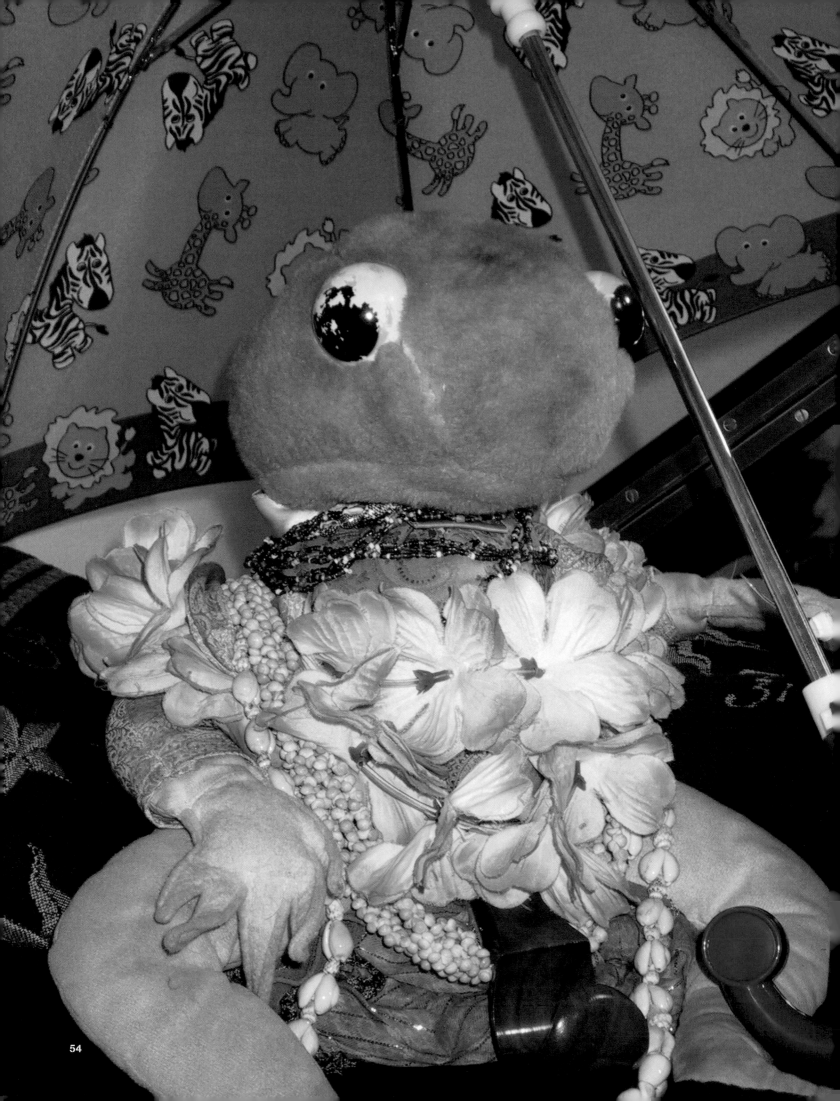

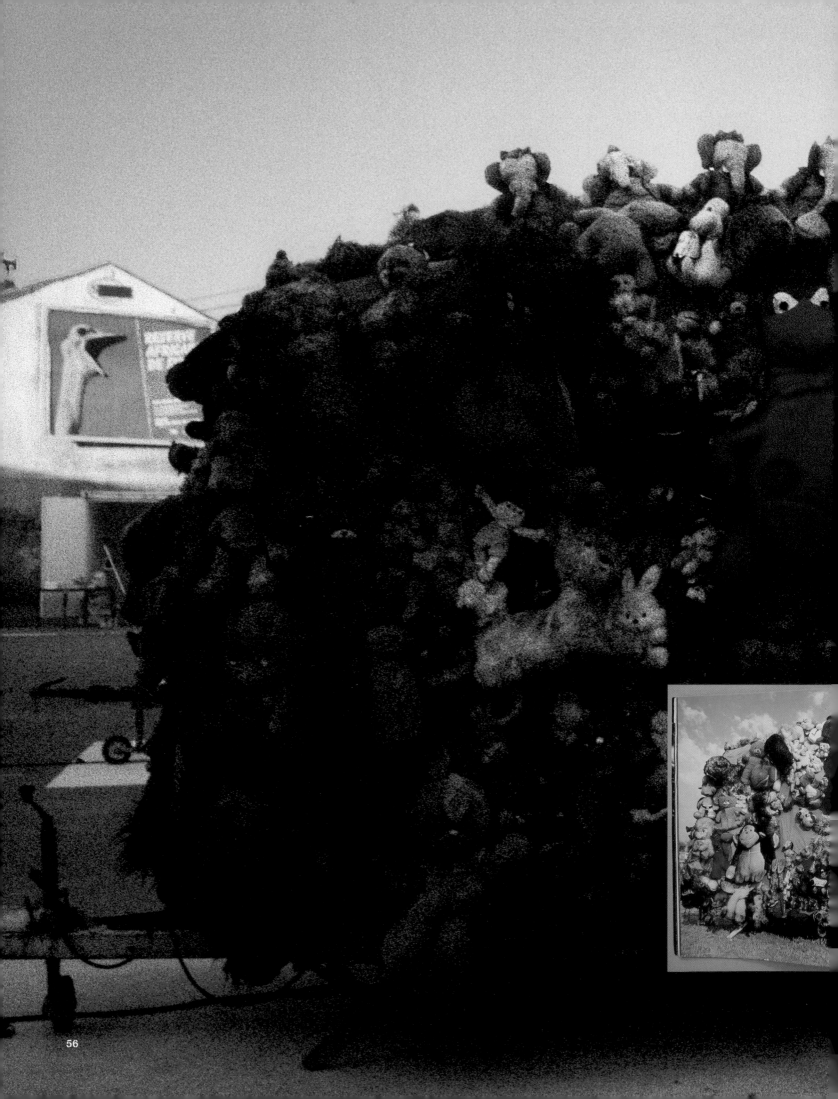

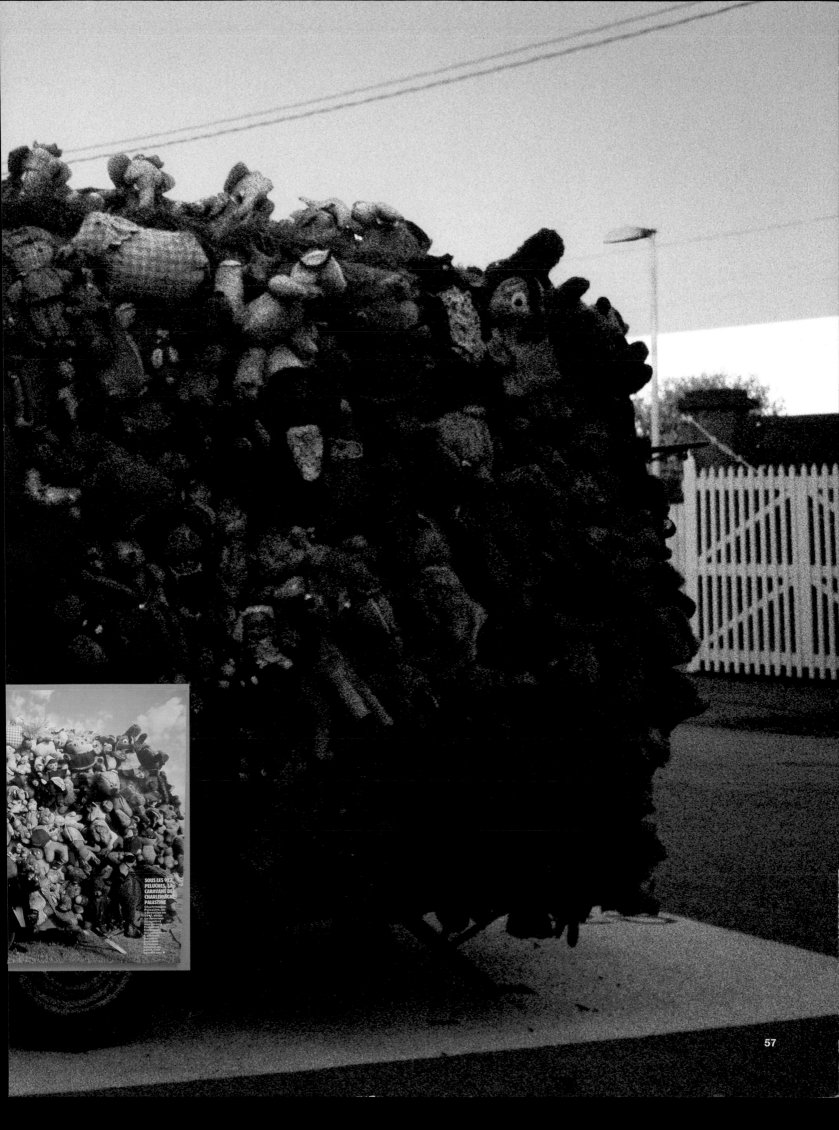

SOUS LES 92X
PELUCHES, LA
CARAVANE DE
CHARLEMAGNE
PALESTINE

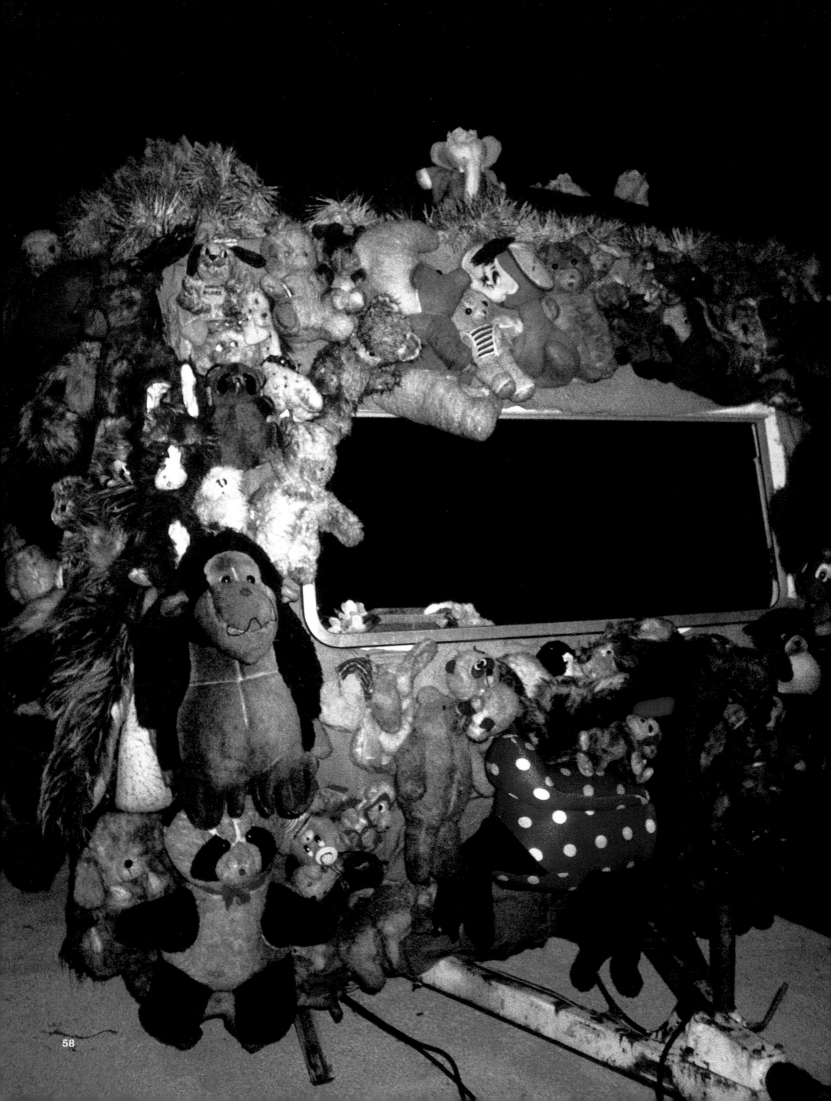

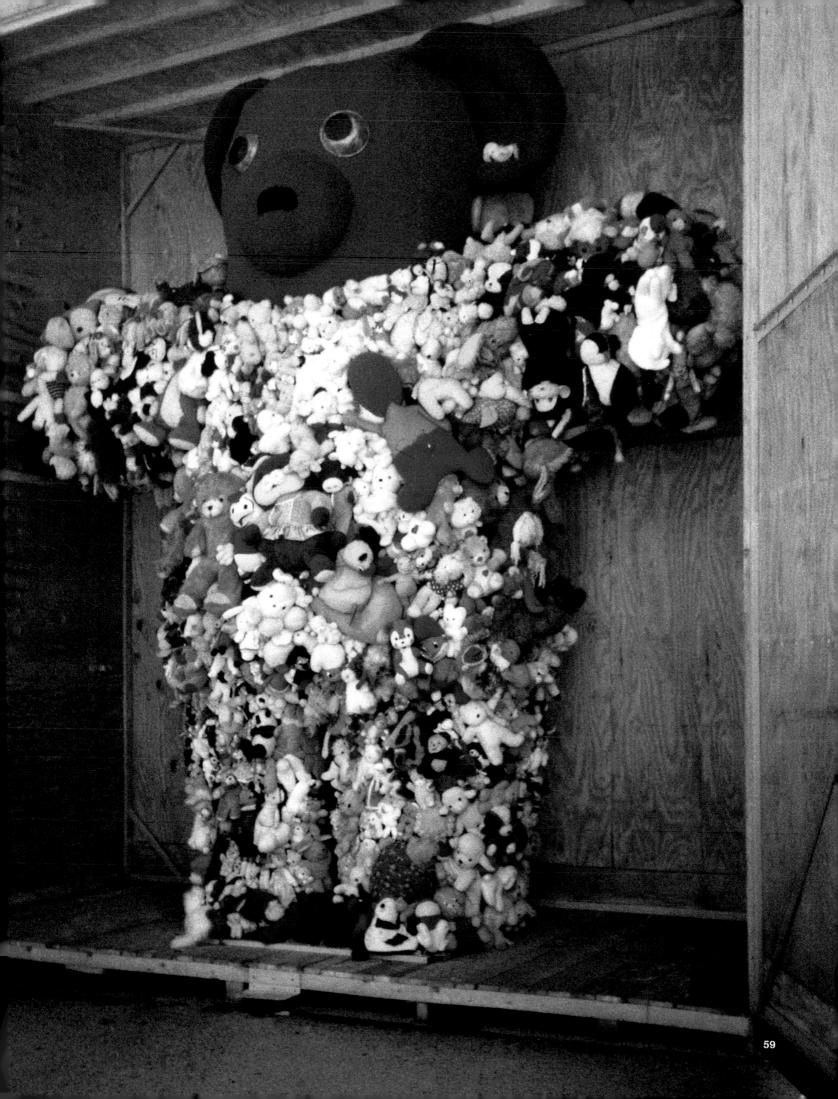

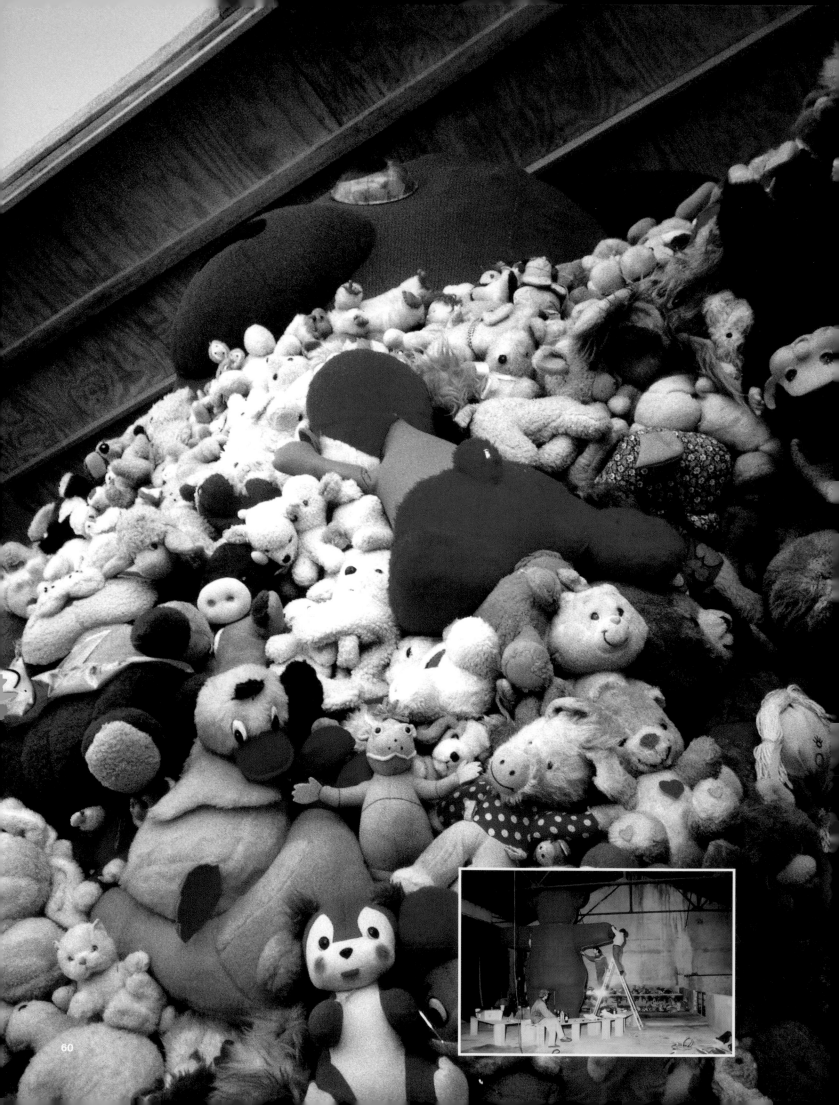

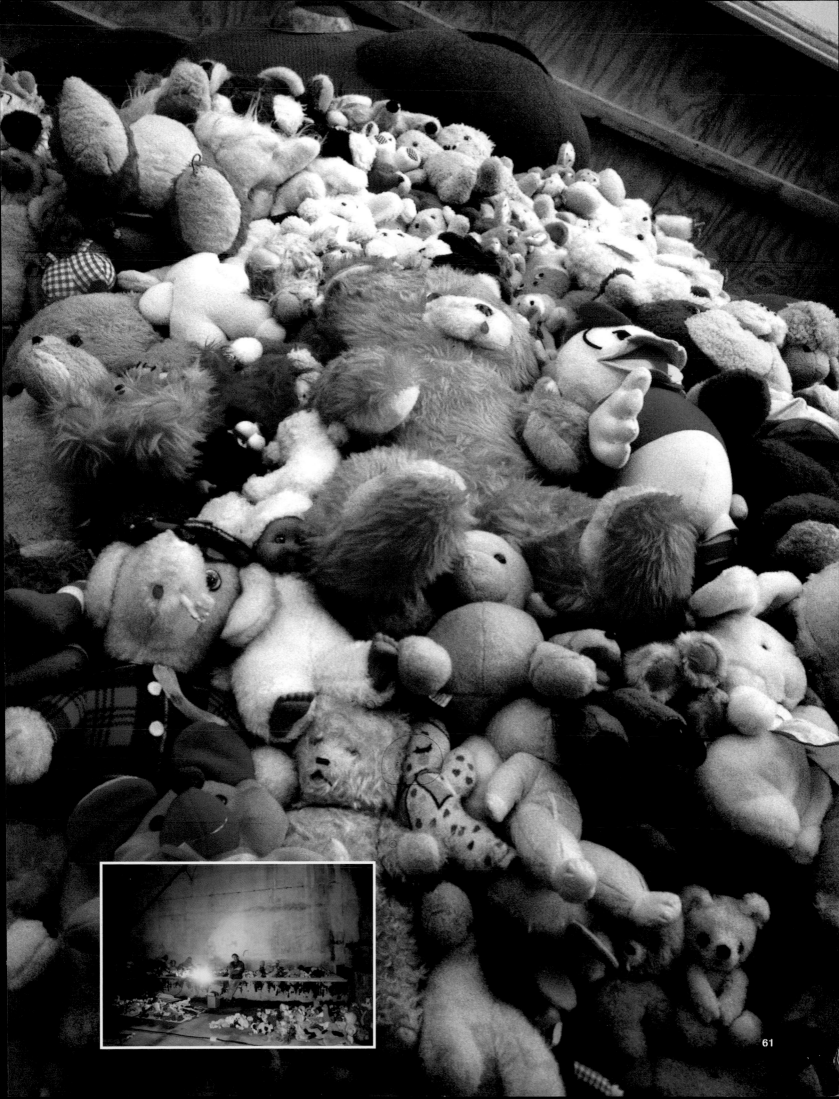

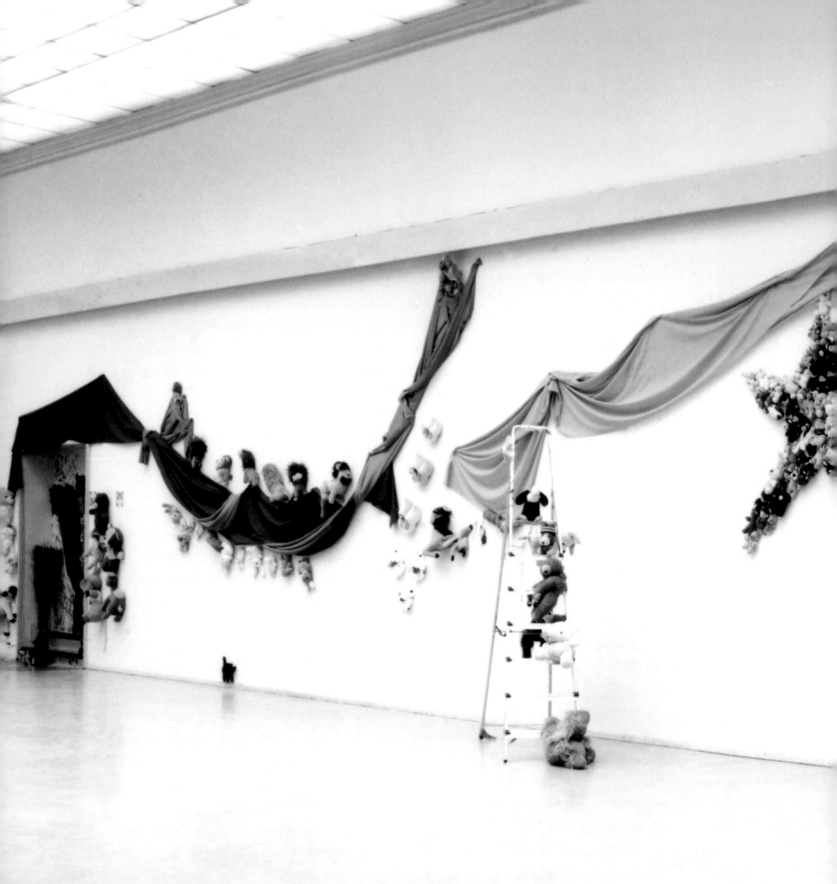

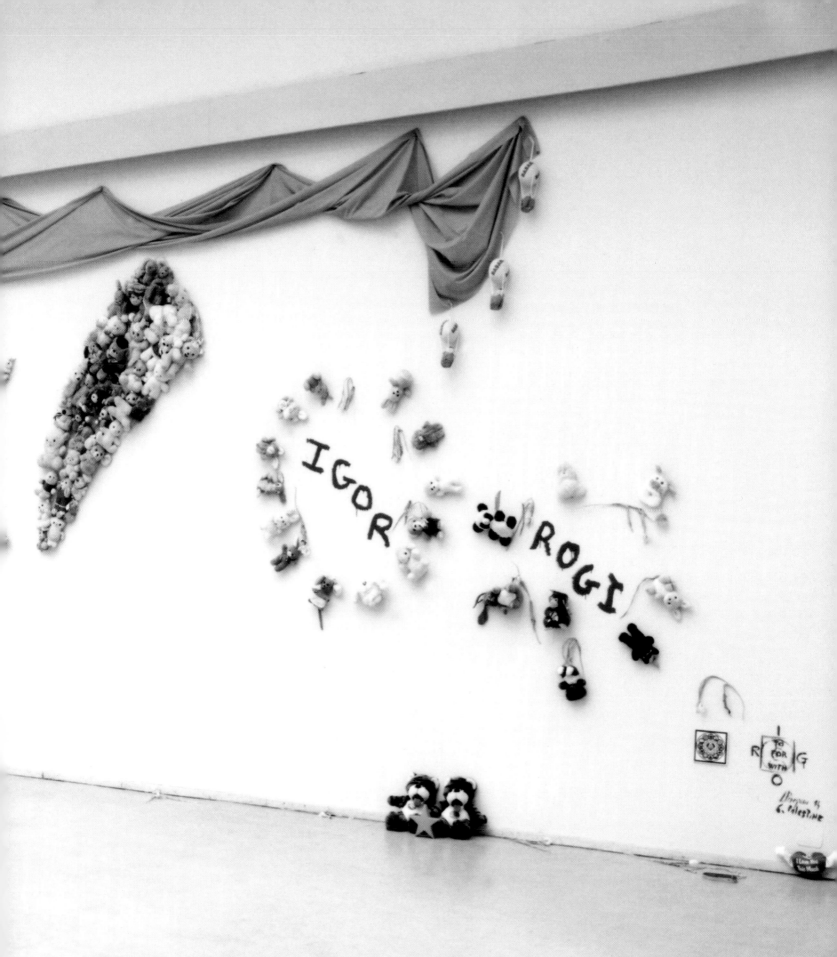

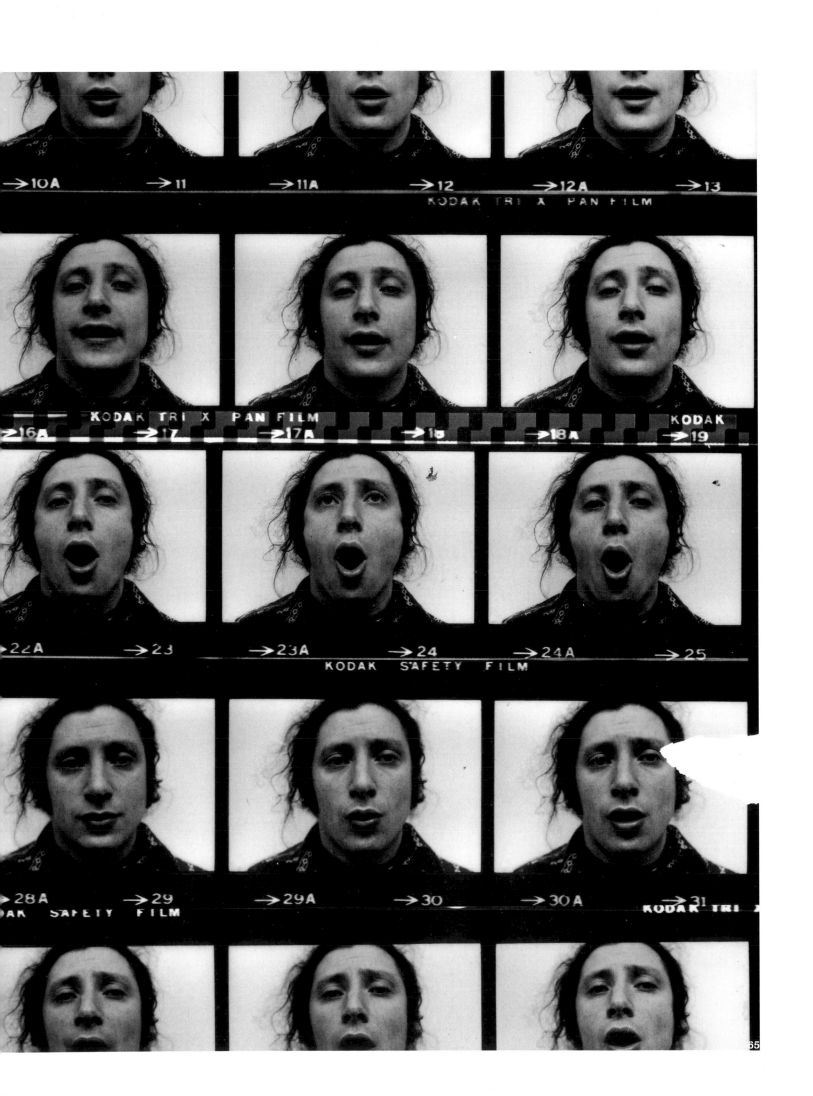

→10A →11 →11A →12 →12A →13

KODAK TRI X PAN FILM

KODAK TRI X PAN FILM KODAK

→16A →17 →17A →18 →18A →19

→22A →23 →23A →24 →24A →25

KODAK SAFETY FILM

→28A →29 →29A →30 →30A →31

OAK SAFETY FILM KODAK TRI X

65

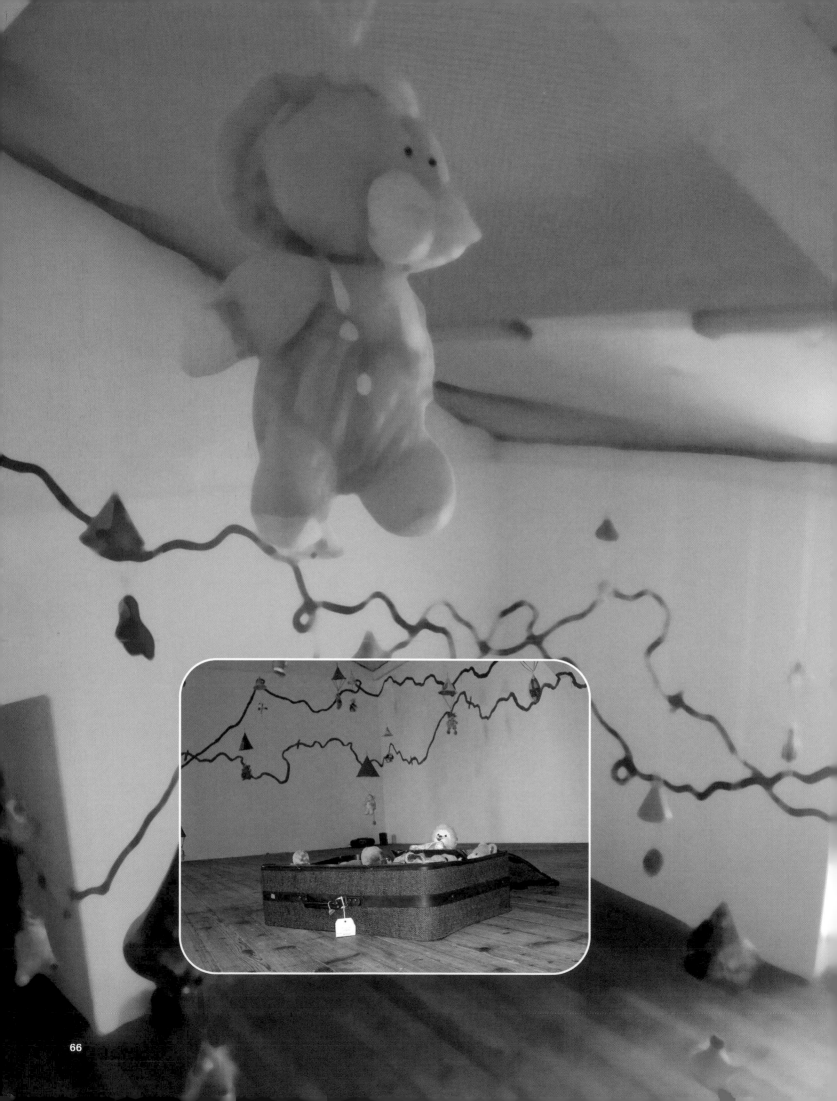

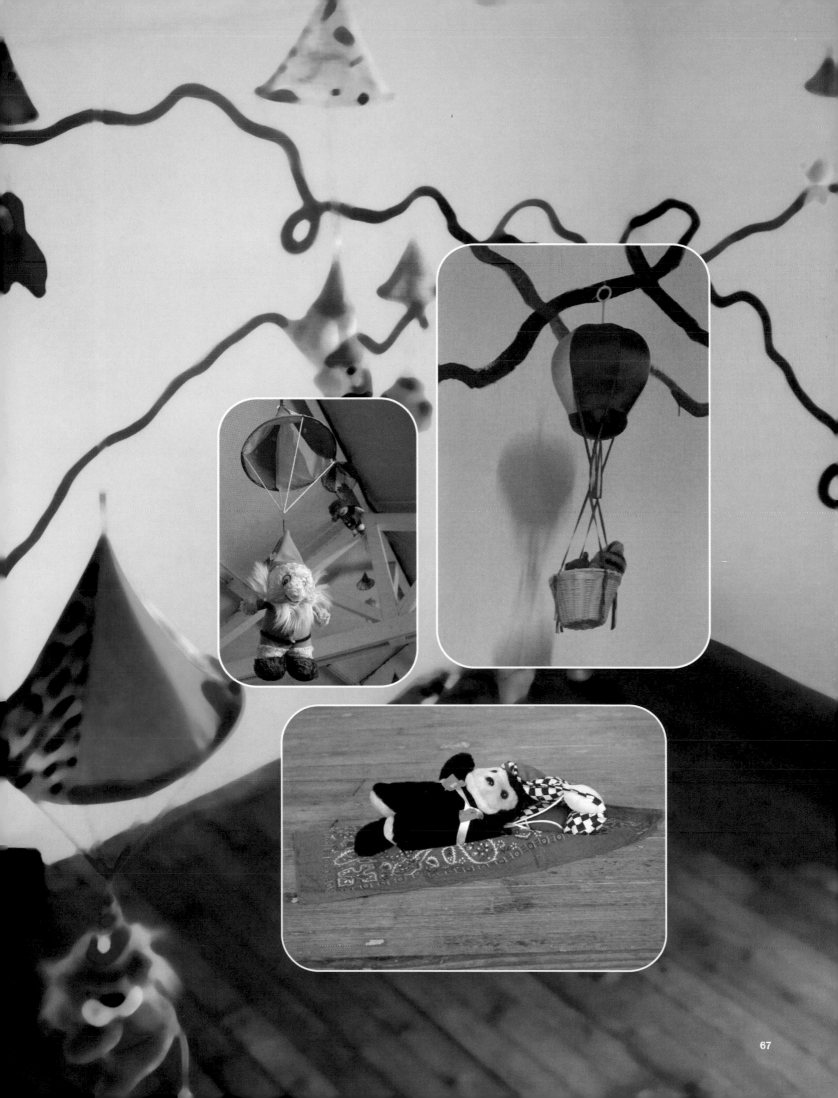

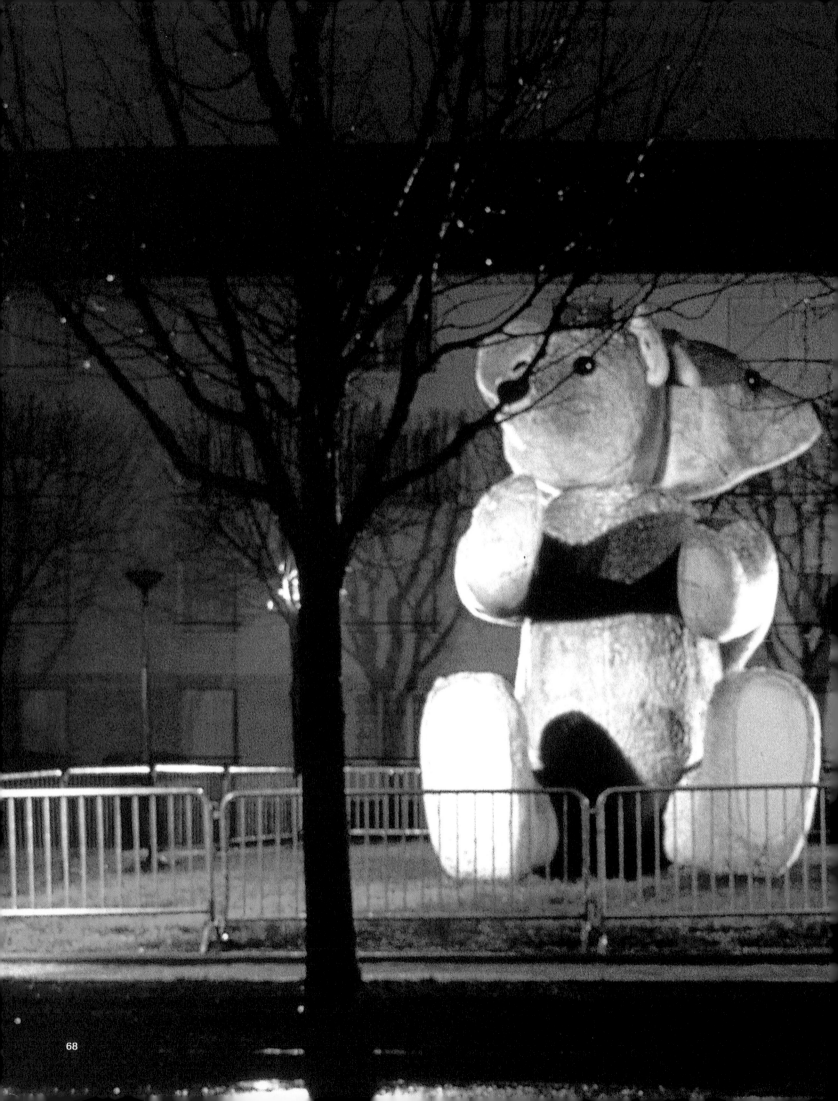

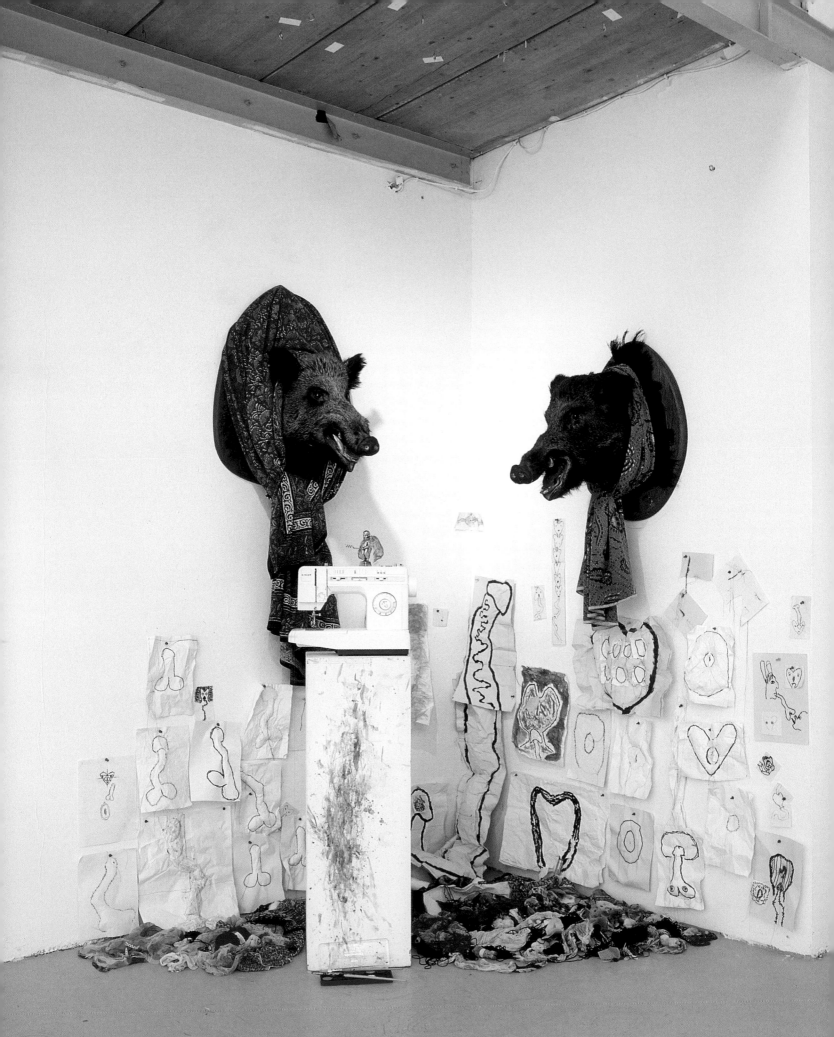

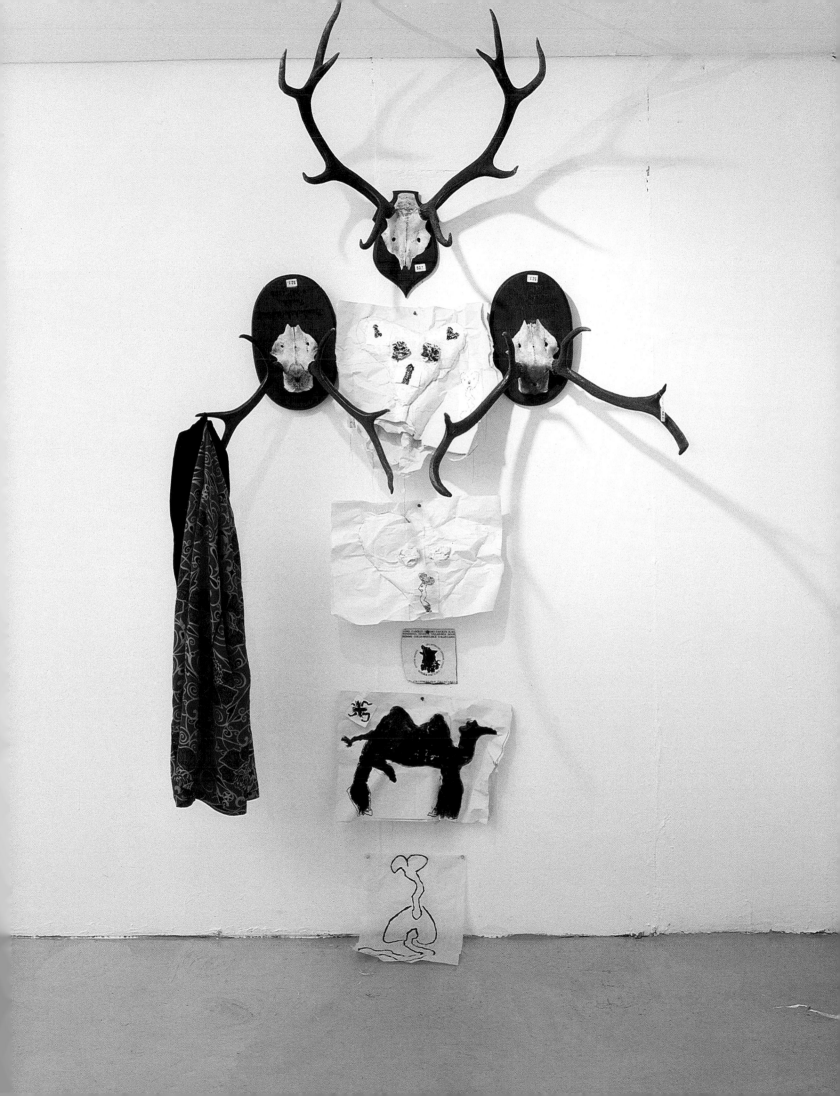

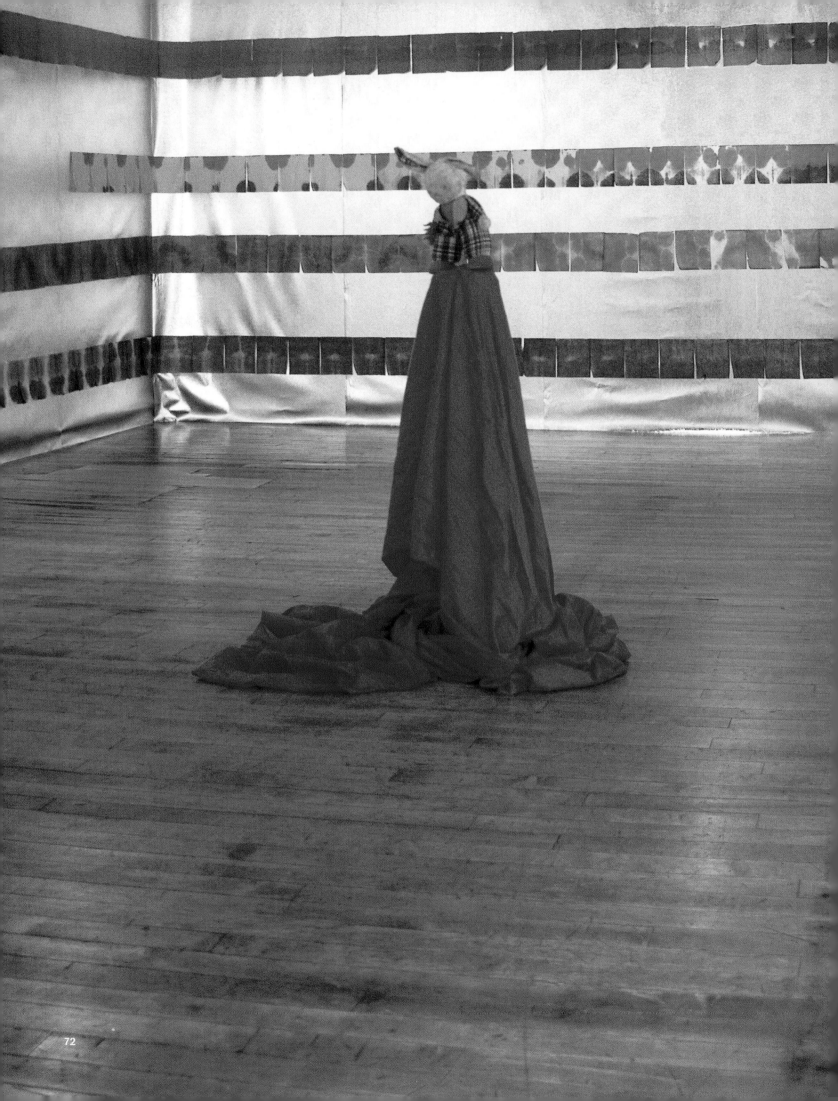

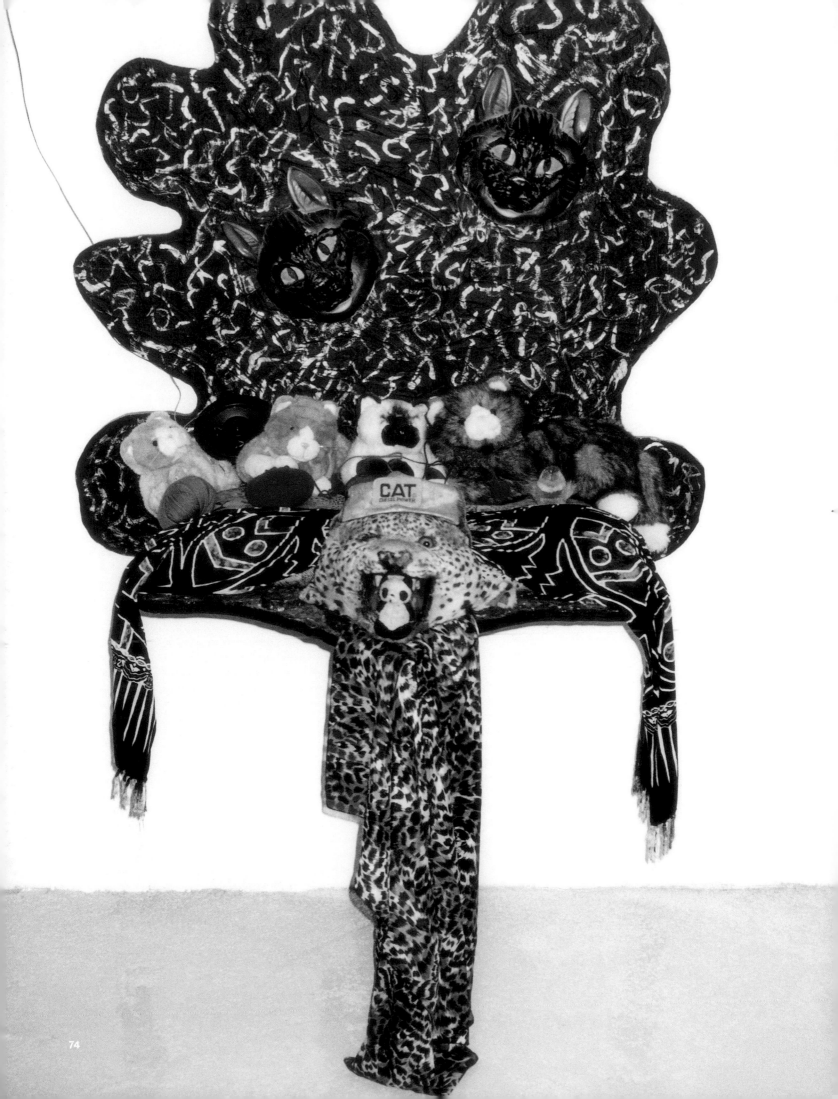

"Finalmente è ritornato a suonare, 1999
il Gentile Charlemagne Palestine,
dopo tanti anni di Silenzio per insofferenza sociale
Andai, pregandolo di risuonare, in pellegrinaggio
a Brooklyn, nella casa studio, ready made ambientale,
ricovero ricreativo d'orsacchiotti orfani,
quelli che sempre lo accompagnano in viaggio,
uscendo dalla valigia, invadendo il pianoforte,
testimoni anche al palazzo delle Esposizioni,
fra la tribù dei fedelissimi,
al curatore Sargentini,
nella città' eternamente assente...,... ROMA"

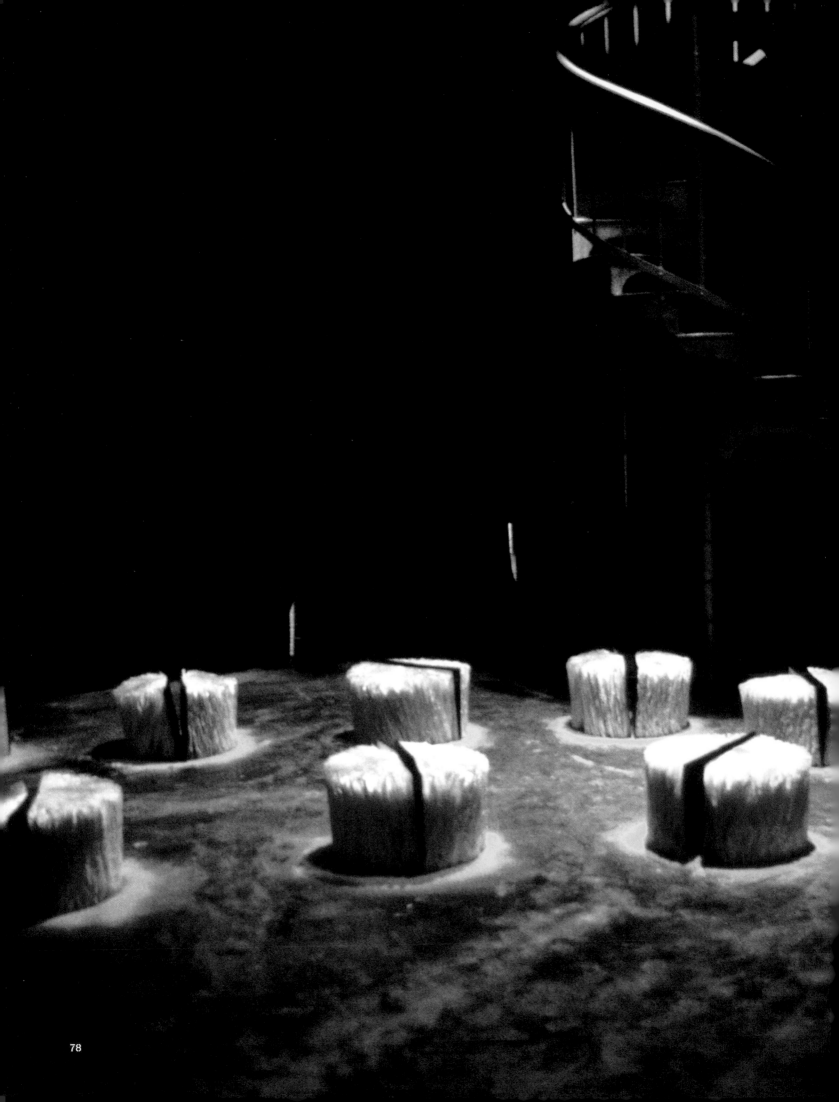

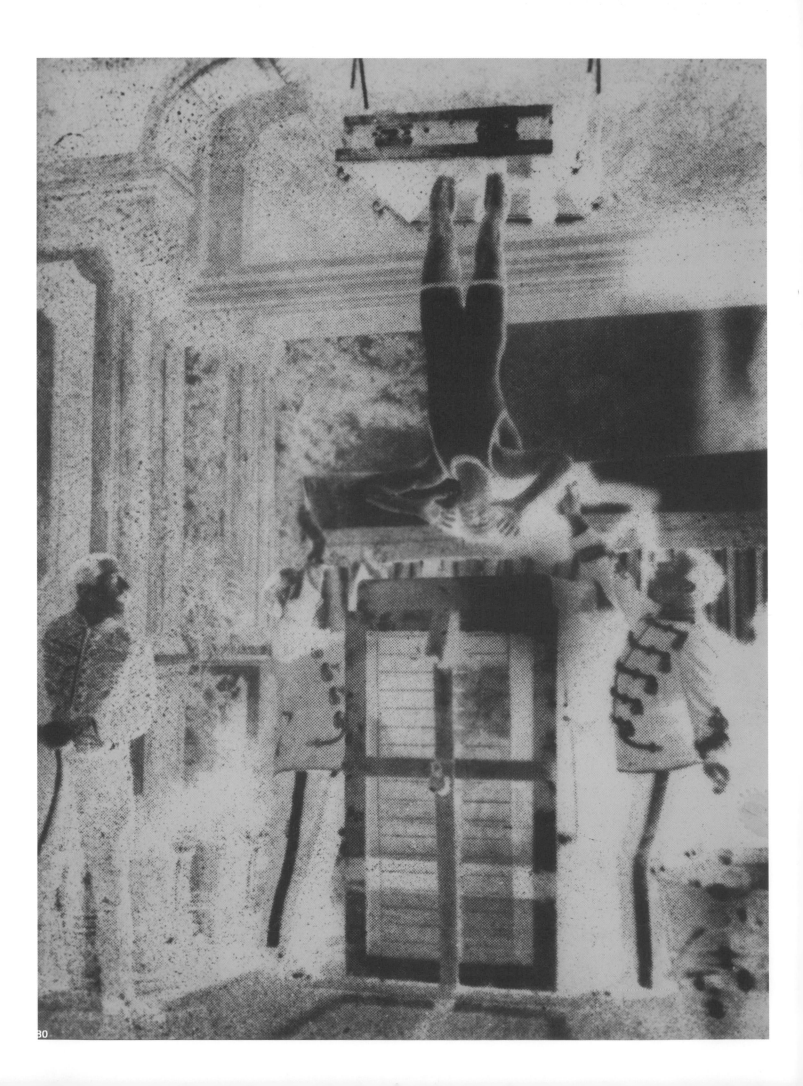

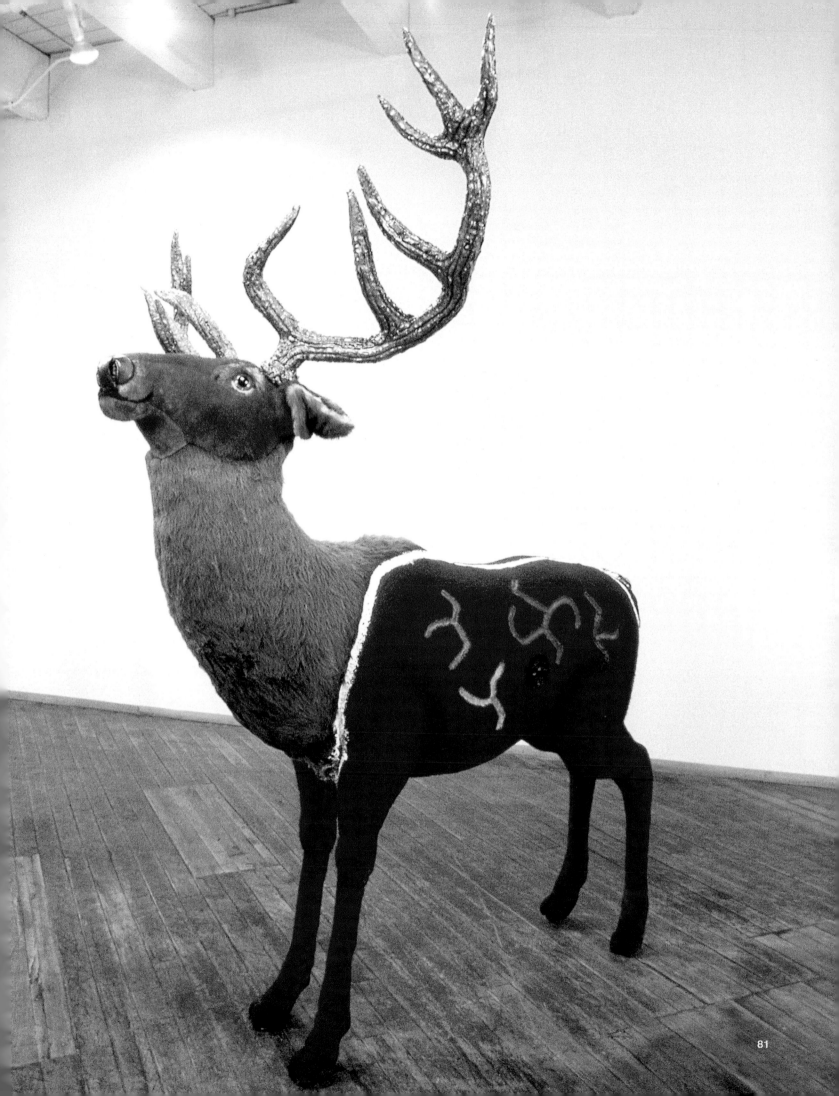

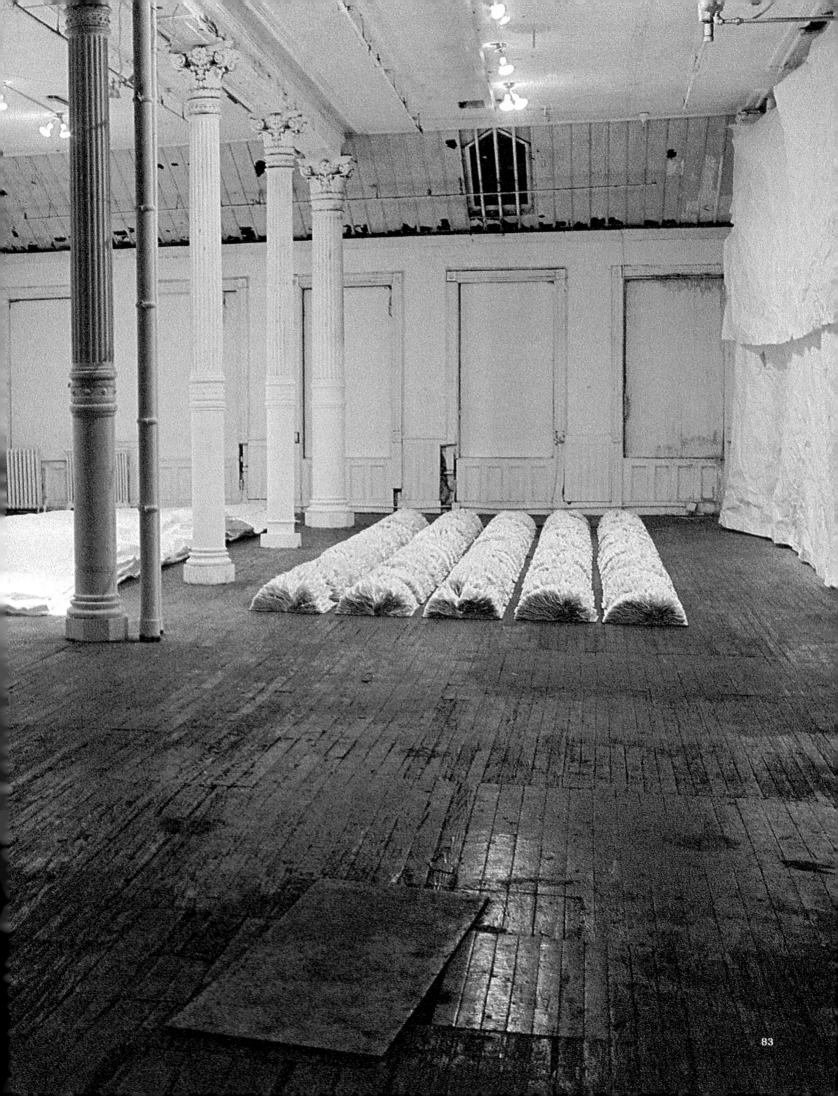

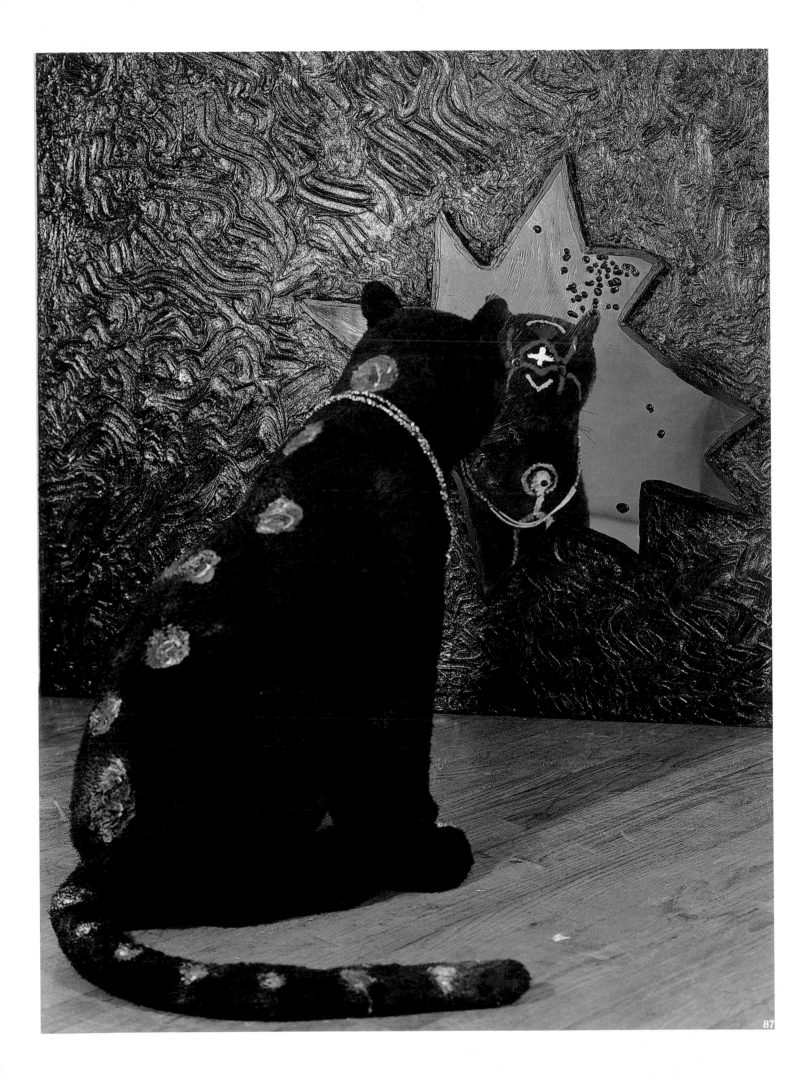

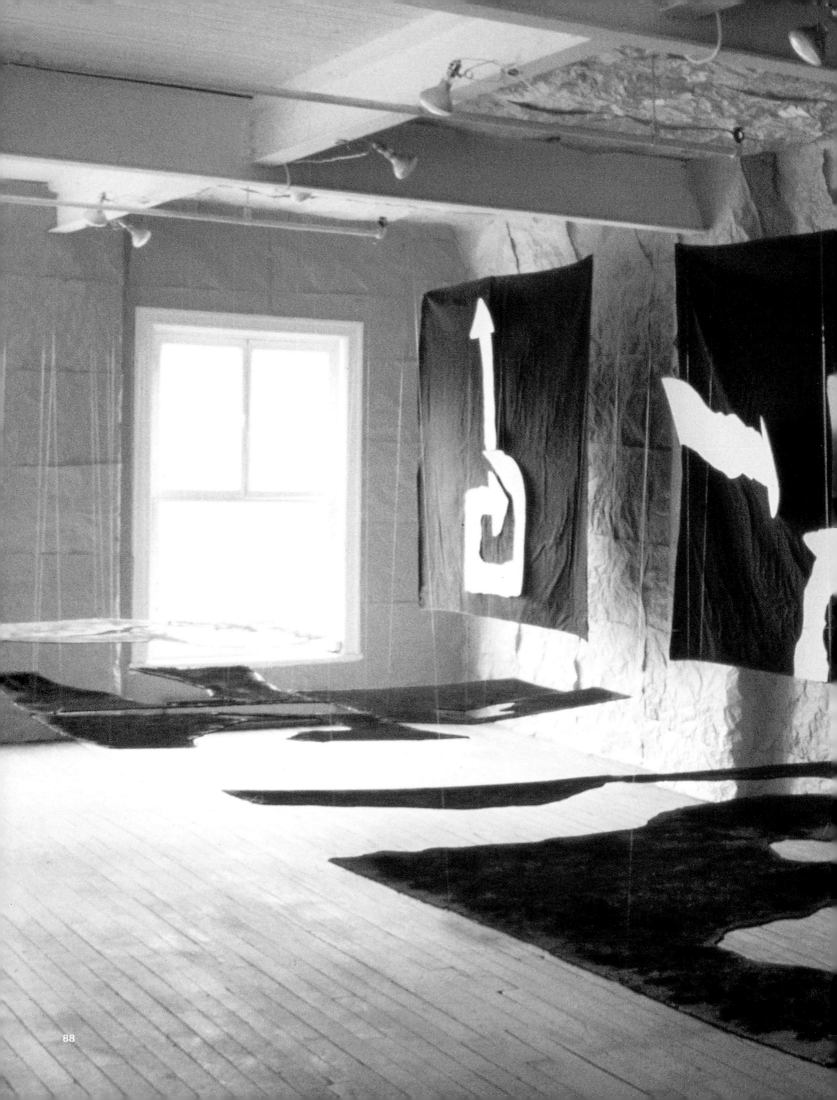

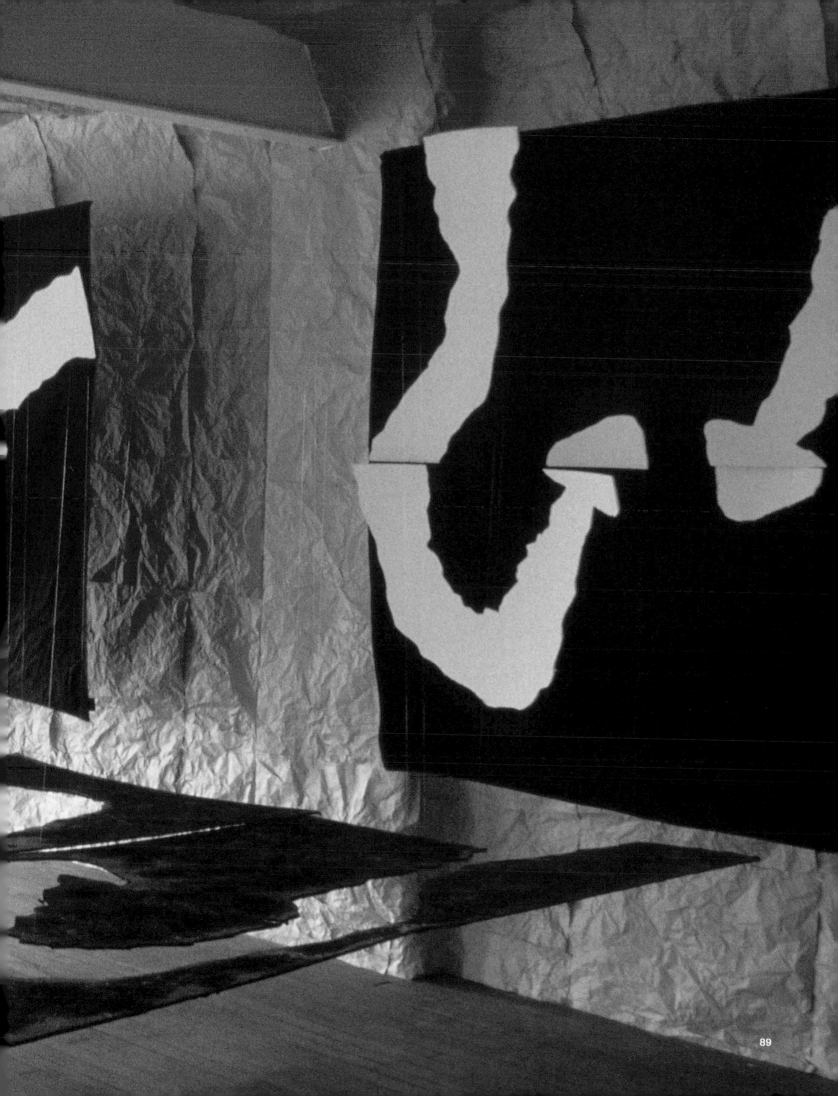

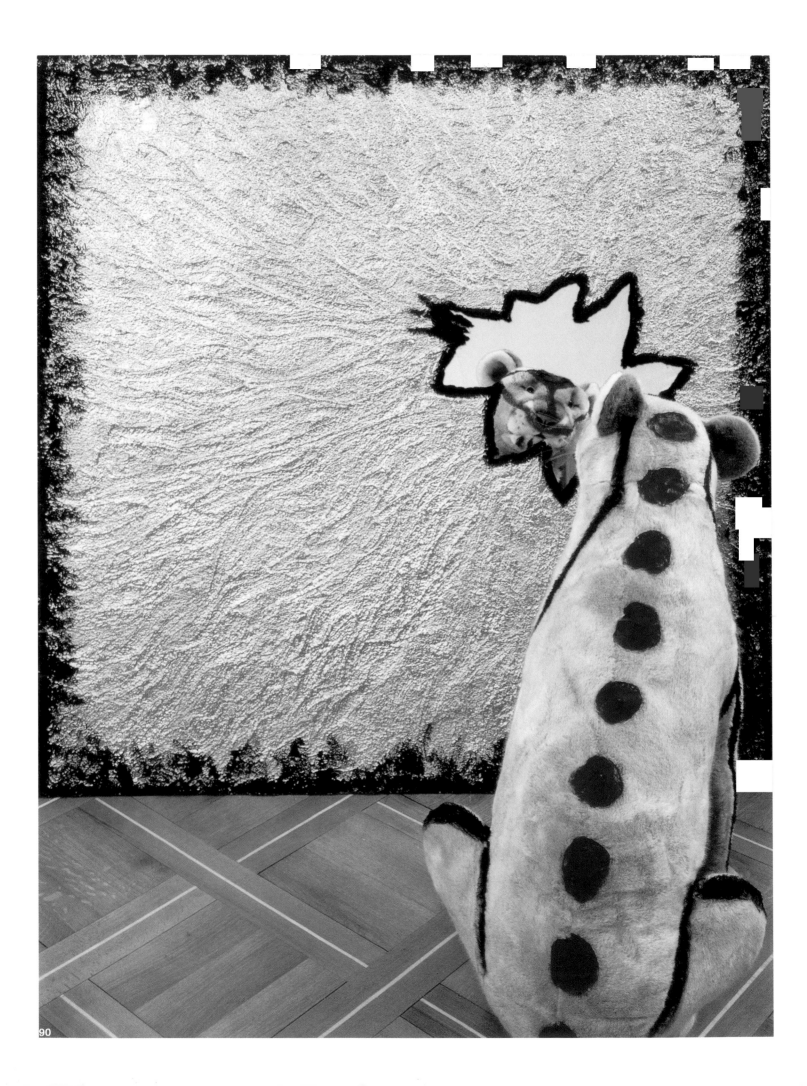

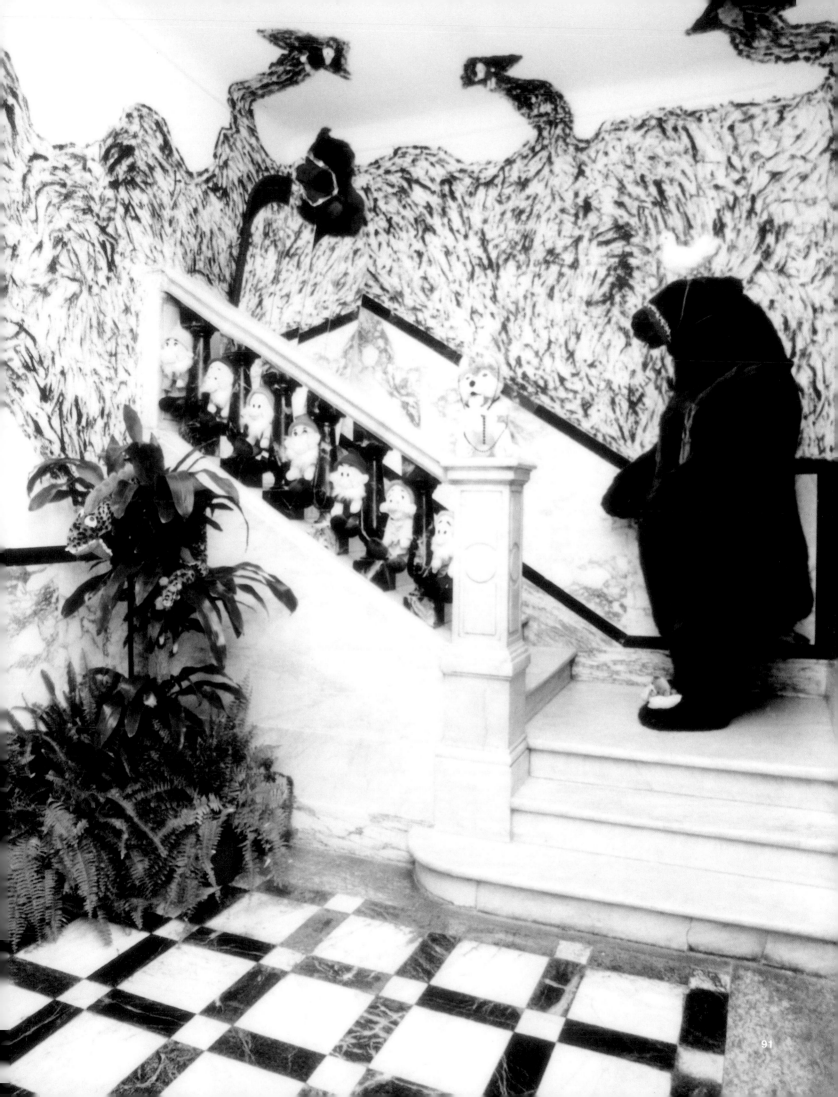

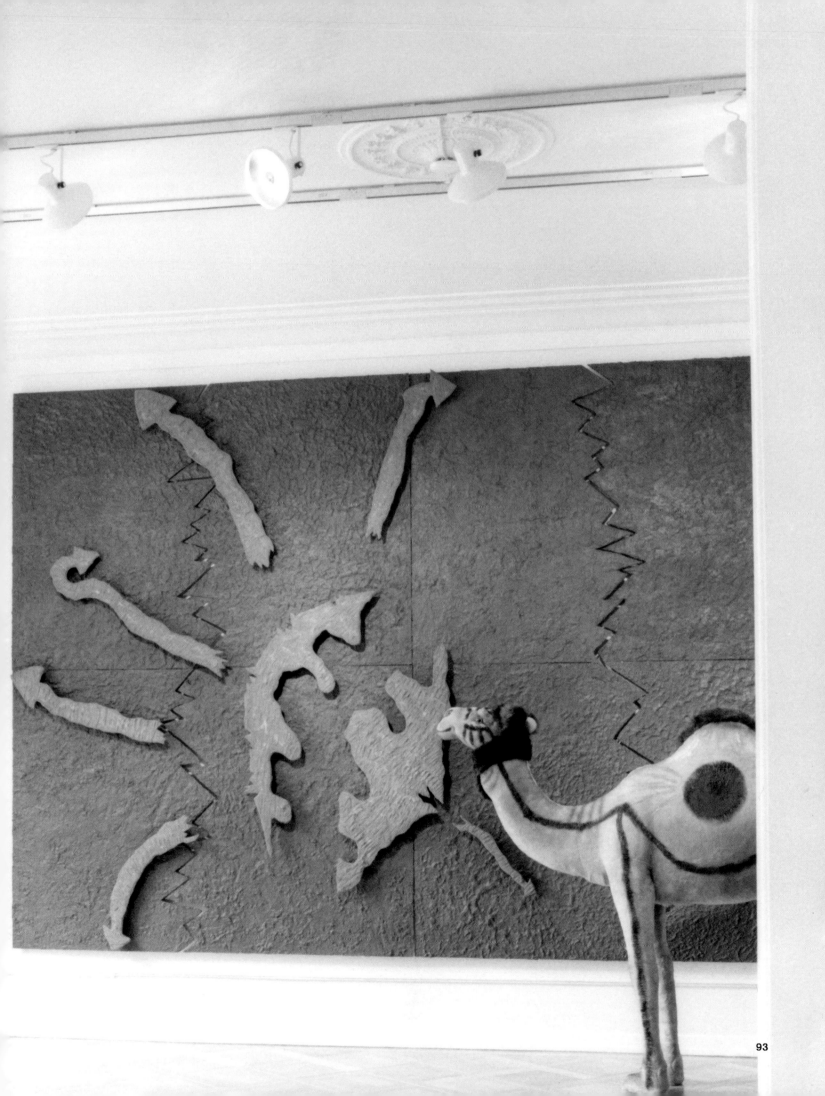

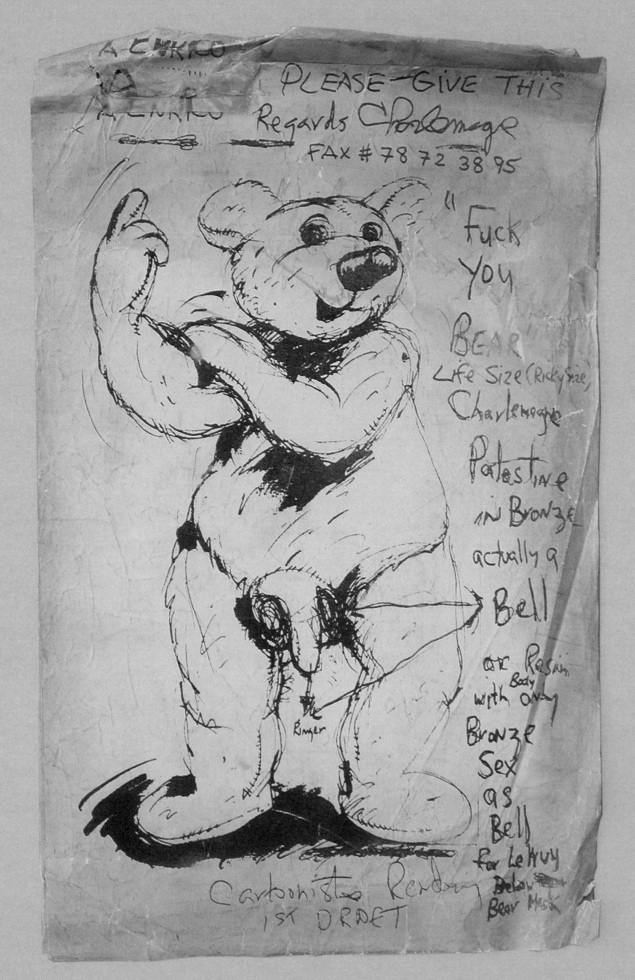

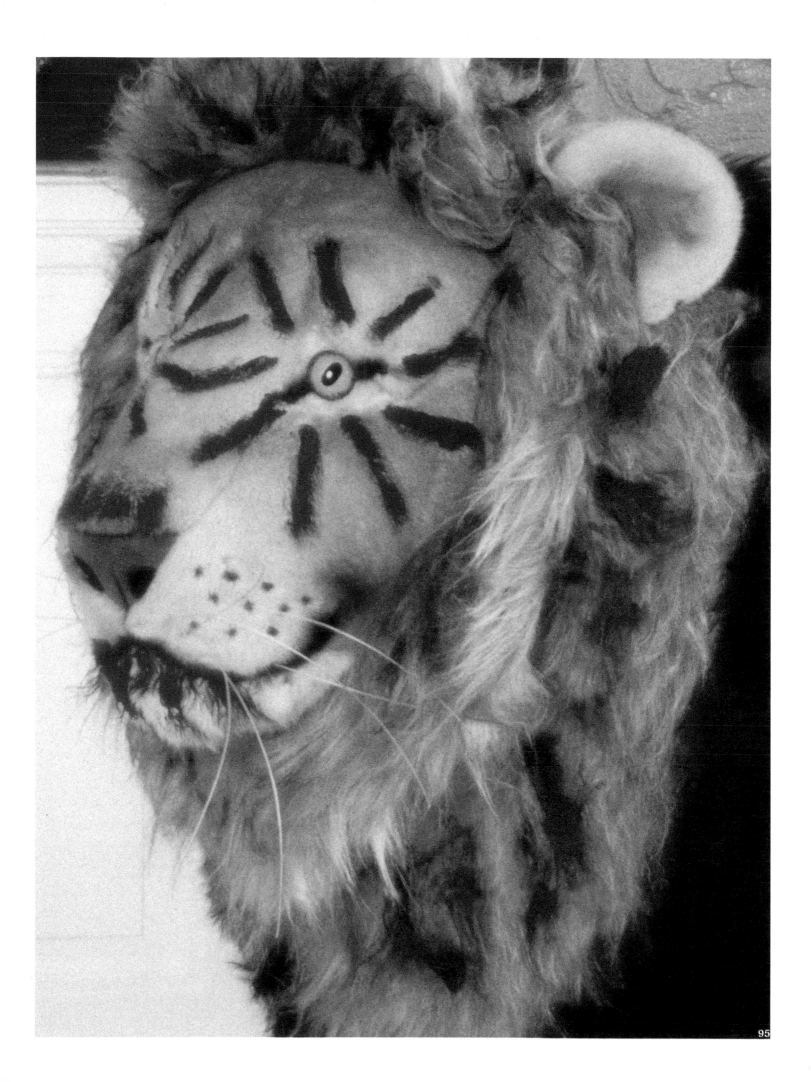

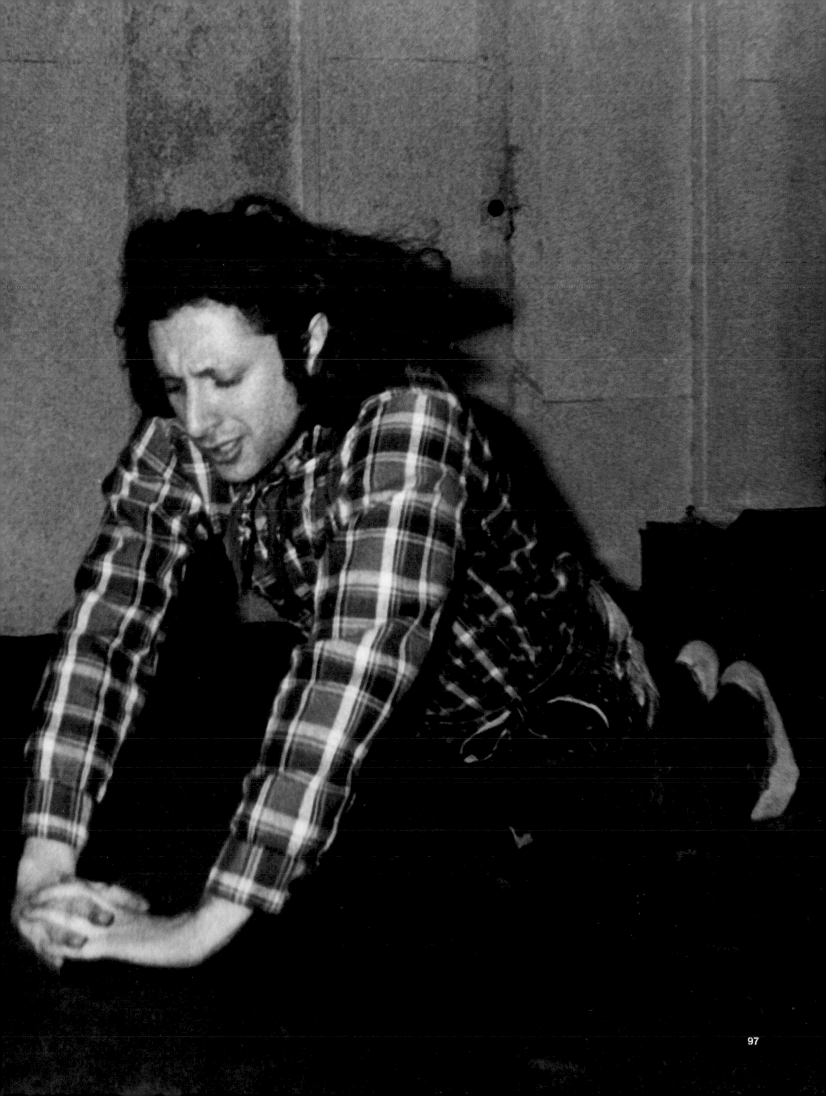

SACRÉ SACRÉ SACRÉ CHAR

98

SACRÉ, SACRÉ, SACRÉ CHARLEMAGNE!

ARNAUD LABELLE-ROJOUX

TRANSLATED BY ROBB BEATTIE AND SUSAN USHER

As
far as music is concerned,
I am surrounded
by animals and beasts.

W A Mozart

Teddy bear,
lovely teddy bear,
You are the confidant of my dreams.

France Gall

It is perhaps fitting that I begin an appraisal of Charlemagne Palestine considering both divine providence and the profane. A few hours ago a die of sorts (good, bad; how to know?) was mysteriously thrown (by Charlemagne himself no less?) across this text, inextricably altering its contents. I had seated myself at the computer to finish my writing after several weeks' interruption, and was suddenly horrified to discover that all of my work had vanished from the hard drive, lost forever in the chasm of some megabyte abyss. What was I to do? Reassemble the original text in its entirety? Making the changes and additions it had needed was an impossibility in any event, and even attempting a resurrection seemed a perilous endeavour that would likely be in vain. Better, it seemed to me, to begin again and forget even the anecdotes that acted as little white stones marking my path. The one that served as a preamble is especially dear to me: my first encounter with Charlemagne Palestine.

It was

the early 1980s. Bathed in the surreal orange light of the Sorbonne Chapel, I was one spectator among many at the annual Autumn Festival. Charlemagne was on stage playing two Bösendorfer pianos simultaneously, facing the audience with a hand on each keyboard as he hammered away at his composition *Strumming Music* with an impressive, escalating remorselessness. The crowd was rapt and the atmosphere was becoming incredibly charged; a palpable tension ran through the room. From that time on, it seemed obvious to me—and I would imagine to others in the audience—that something sacred, for want of a better word, inhabited Palestine's music. (I was still assimilating the already very mannered and purring minimalist music of the time.) But was this the case? The music spoke to a sense of dislocated sacredness, inadequate and bizarre, that was far removed from religion of a more conventional coin (the God solution, the meaning of life in a mystical kit, the rewards from on high...). As well, a kind of floating discomfort doubled the high that you got from listening. Incarnating this discomfort was the fascinating presence of Charlemagne as he sat between two pianos, frantically hitting their keys to produce a sound that resonated and oscillated continuously.

This sense of the sacred stamped with discomfort has not dissipated over time or with the evolution of Charlemagne's work. It sticks to his person—powerful, contradictory, disturbing—but most of all to his work, which during the 80s expanded from music to art installations populated by a slew of stuffed animals. And always there was the same extraordinary, affecting emotion.

GANESH IS GOOD FOR YOU!

Nothing

is more tempting (and it has been done often enough) than to compare Palestine's use of these now fetishised stuffed animals with the work of Joseph Beuys, ritualising the obscurities of a life story through the convocation of an entire symbolic bestiary. But the comparison soon reveals itself to be non-operational—in my opinion at least—even if the term "shaman" is frequently used by commentators to describe Beuys and Palestine alike. Palestine has a profoundly American side, no less sacred (in the way that Roger Caillois understands the word, which underlines its ambiguous nature), that is far removed from Beuys' recourse to myths (and their reactivation).[1] Palestine is never afraid of sentimental kitsch, or religious paraphernalia (his altars evoke small Chinese prayer temples

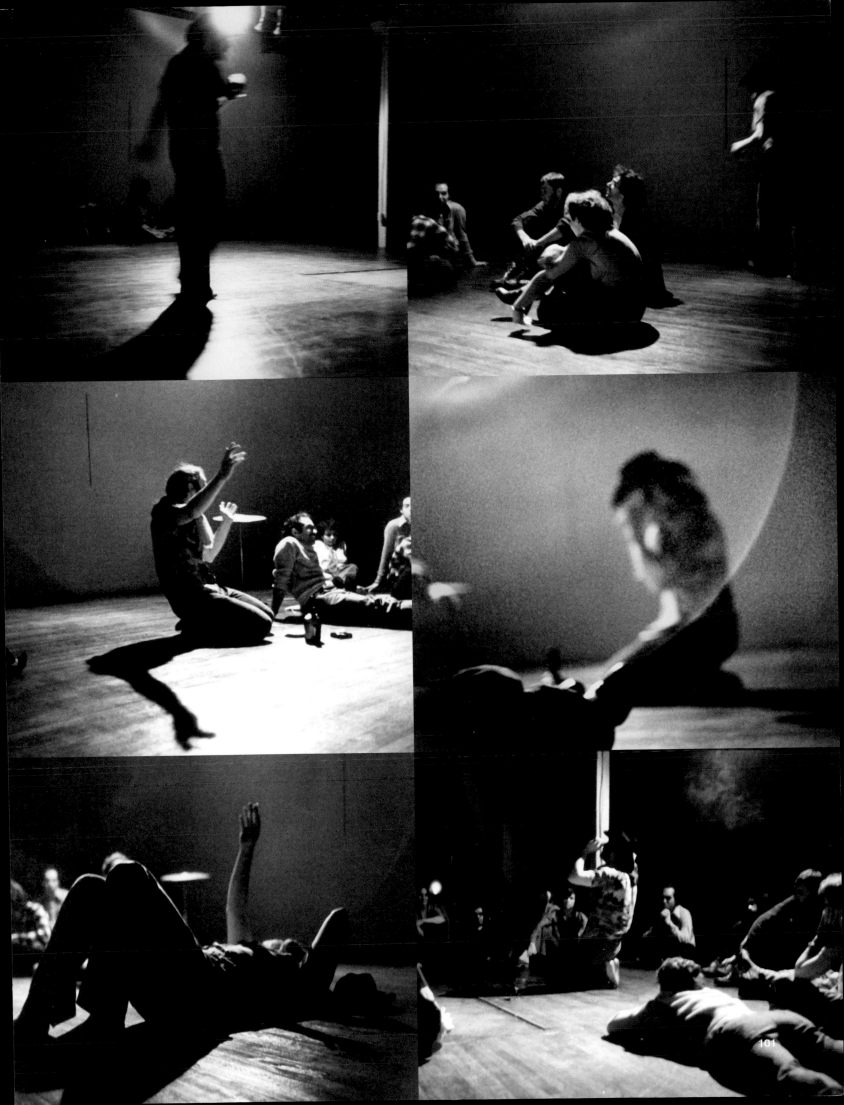

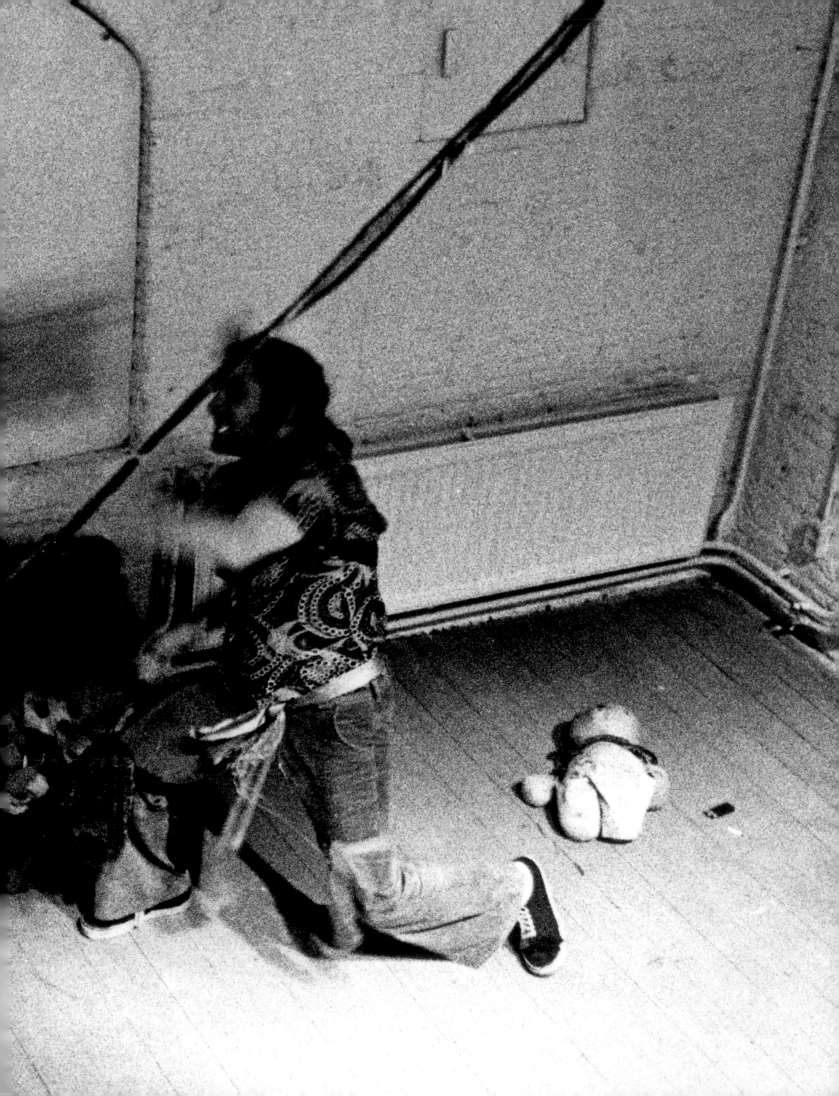

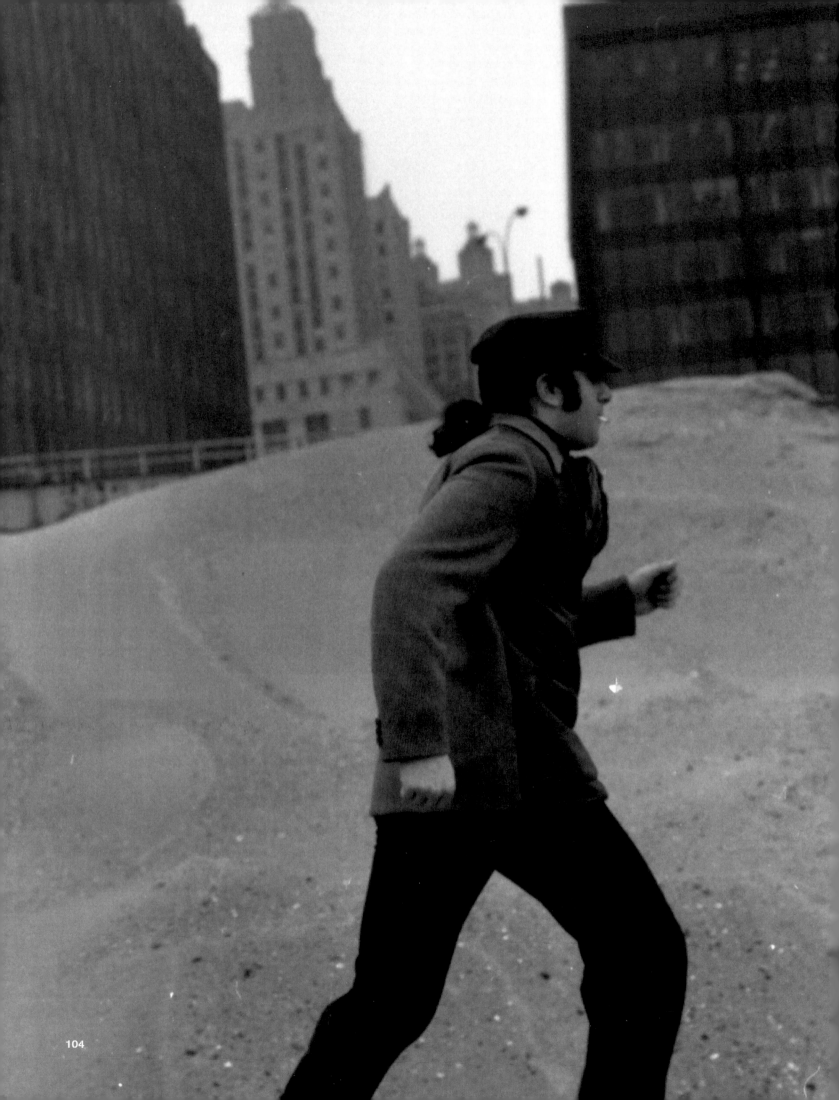

as much as they do the piled up religious trinkets of Lourdes), nor the cultural melting pot.

It seems more fitting—if we must compare him to someone—to liken him to Sun Ra (whom I like a great deal, especially since I had the chance to see him in concert in the 1970s). Musically, Sun Ra is very different from Palestine, but he also draws on a personal cosmography that is deliriously singular and universally identifiable, while fitting very obviously into American culture (Sun Ra's inspirations were the Bible, popular and science-fiction magazines, and a childhood fascination with ancient Egypt and the kingdoms of Africa). David Troop saw it clearly, situating Sun Ra, in his *Ocean of Sound*, within "an America spangled with psychedelic visionaries and eccentrics" where he was "the autodidactic prophet assembling an extravagant patch-work of deep wisdom, nonsense, and inspired gibberish" to fight in "a story of the future... for the souls of his people, against the heritage of slavery and segregation, drugs, alcohol, apathy, and the powers of capitalism." But Palestine isn't comparable, you say: he's a white artist born in Brooklyn to Russian Jewish parents, a man whose work offers no lessons, even in judgment, who doesn't cavort with an improbable crown on his head, clothed in an ample gold toga and channeling poetry from the stars while exhorting the brilliant sun....

But

are there really no similarities? Sun Ra came to attention as an 'eccentric's eccentric' amid the hordes of psyche-delic visionaries and neo-prophets that exist in such numbers in the United States. While he is certainly all that, he is primarily a singularly unique and important African-American artist, personifying all that is most deeply creative about America's over-abundance of oppositions and obsession with origins. In the same way, Charlemagne Palestine—the name alone is incandescent!—incarnates another version of America that is neither country nor continent, but a sort of 'non-place' that is contradictory (and not just multi-cultural), indefinable and almost invisible. ("Everyone has his own America; along with the pieces of an imaginary America we think are there, but can't see."—Andy Warhol[2]) As his universe references child-hood, it inscribes itself in this "non-space" as surely as Sun Ra's flying saucers. Charlemagne's swarm of coloured stuffed animals does not conjure up a childhood idealised by memory, but instead evokes childhood's residence in the *present*, populated by the soft caresses, irrational fears, secret pleasures and incommunicable thoughts of the distanced, repressed world of adults: an animal carnival, far from ordinary socialised life....

But I was talking about America. The presence of childhood does not belong exclusively to America, no more than do plush toy fetishes; to the contrary, it is in an examination of Walt Disney, Steven Spielberg,

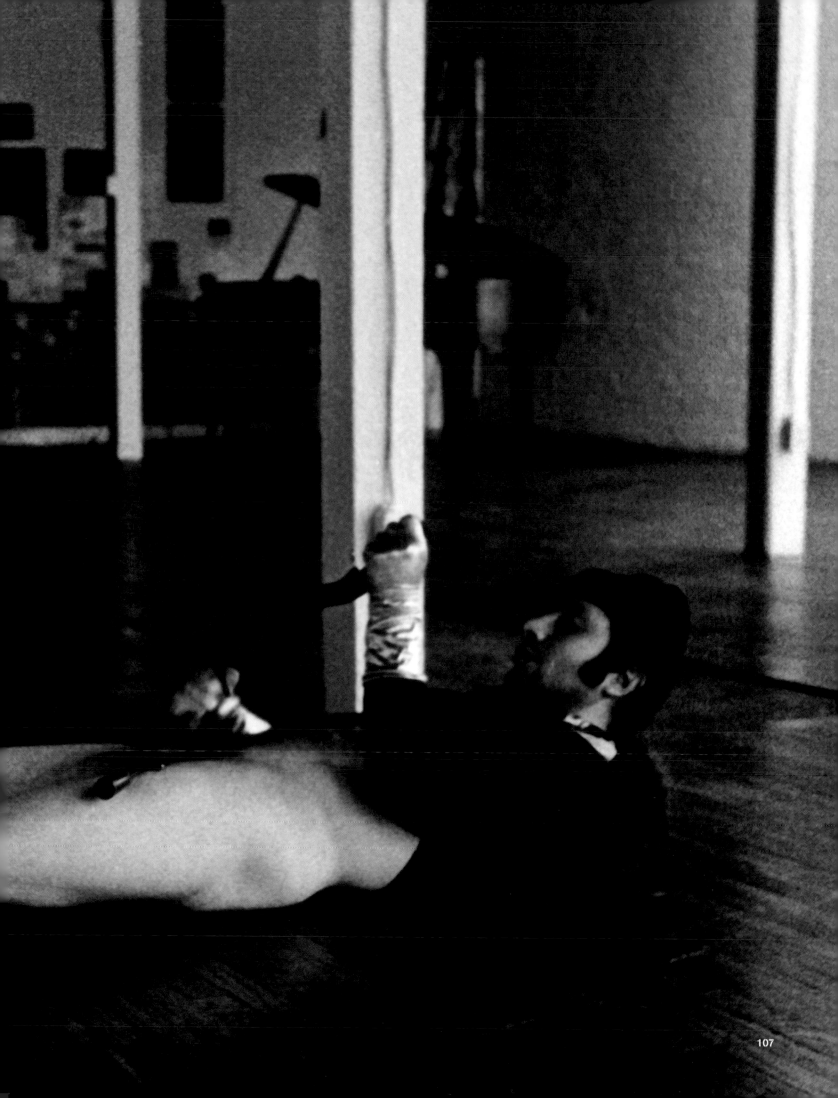

or Barbie dolls—all contemporary glories servicing the whole planet—that we find the ravages of American ideology, at once perverse and puerile, in the way it manages both the notion of childhood and the reality of children (hypocritically 'sacred' and 'presumed innocent' but also the perfect consumers). Palestine's childhood universe turns that upside down: it is uncomfortable, deliberately rudimentary, and tightly interwoven with the family history of a young Russian Jew from Brooklyn who, at eight years old, sang for hours at the neighbourhood synagogue, and a few years later rang the bells at an Episcopal church beside MOMA, the place where he first discovered art. This does not explain everything, and may clarify absolutely nothing, but it does establish a sort of intimate archeology, the foundation not of an explicit biography but of a system of tensions comparable to that which constitutes American culture in all its oppositions. (In a nutshell, this is what I mean when I talk about Palestine being inscribed in American culture.)

This
infantile state (a childhood we prolong and do not disconnect from or rediscover; an infantilism contrary to any idea of infantilisation or regression) is one key to Charlemagne Palestine's work. It 'links' him to others (I'm thinking obviously of Paul McCarthy and Mike Kelley) who are also committed to revealing the very nature of childhood—its rites and beliefs, enigmatic rhymes and stirring refrains, hidden dramas and quiet pleasures, revealing disguises and cruel games, desperate separations and quests for happiness—in a world where these concerns belong in fact to so-called popular culture, engaged in perpetual conflict with the adult power of the other incarnated by school and parents. It is here that the nature of childhood exiles the child himself to his corner: not knowing where to put head or body, harangued with questions, submerged by images, inhabited by consoling monsters. Certainly, everything has value to a child, but a value detached from the value system (moral, social, religious, aesthetic) conveyed by the *responsible* world, which indeed knowingly takes the opposite course. How does he perceive the sacred? "At heart, the sacred inspires in the believer exactly the same sentiments that fire inspires in the child-the same desire for ignition, the same fear of being burned, the same shiver when faced with the forbidden, the same belief that conquest brings strength and prestige."[3]

What access route to the sacred does Charlemagne Palestine follow? Ganesh, the Smurfs, and a thousand and one more or less defined animal creatures.... Voices of depth, of totemised stuffed animals.... Fervour, excess, vertigo.... All proceed from the same drive to exist. To be listened to. To be heard.... No, there's nothing especially narcissistic

about it. It's the hope and desire of art. Or the infantile state. We could define one or the other according to this formula of Nietzche's: "Man houses as many spirits as there are animals in the ocean—they battle against each other for the spirit of 'me'."

1. De facto reactivation, even if Beuys asserts the opposite.

2. I used this citation before in a text on Elvis Presley, which may be surprising since I used it to evoke the Americanness of the Elvis phenomenon. Just another side of the same coin....

3. Roger Caillois, *L'homme et le sacré*, 1950, Paris: Idées/Gallimard, 1963.

109

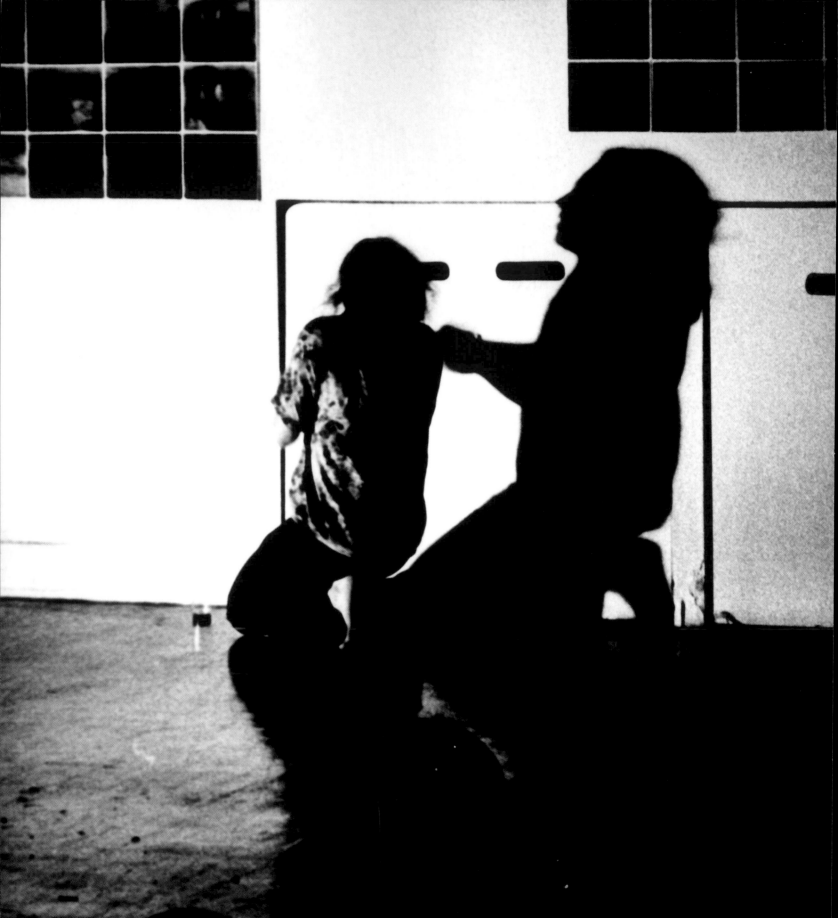

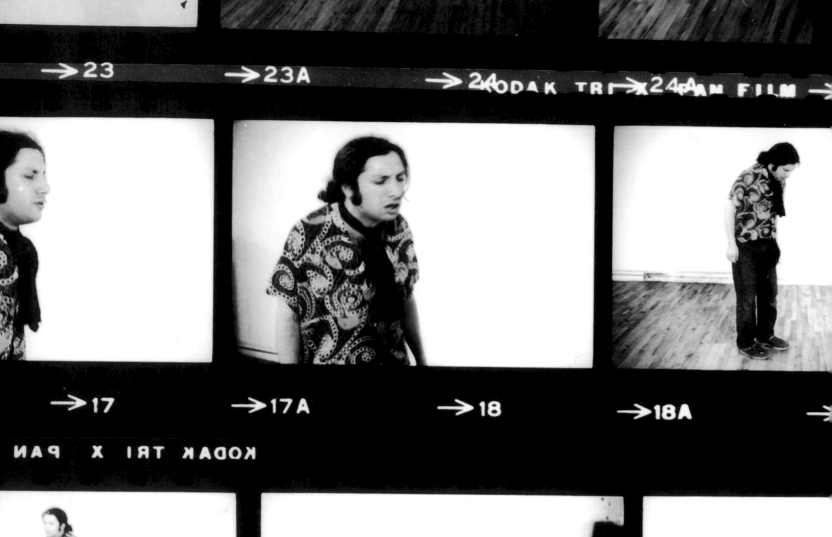

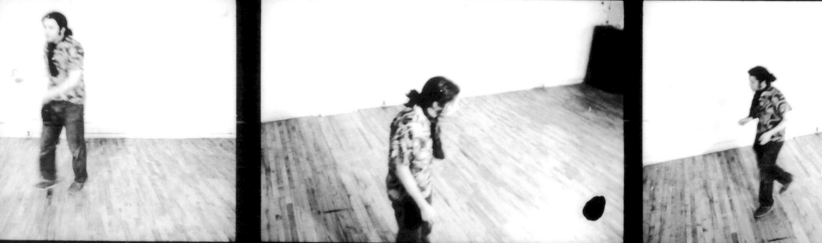

114

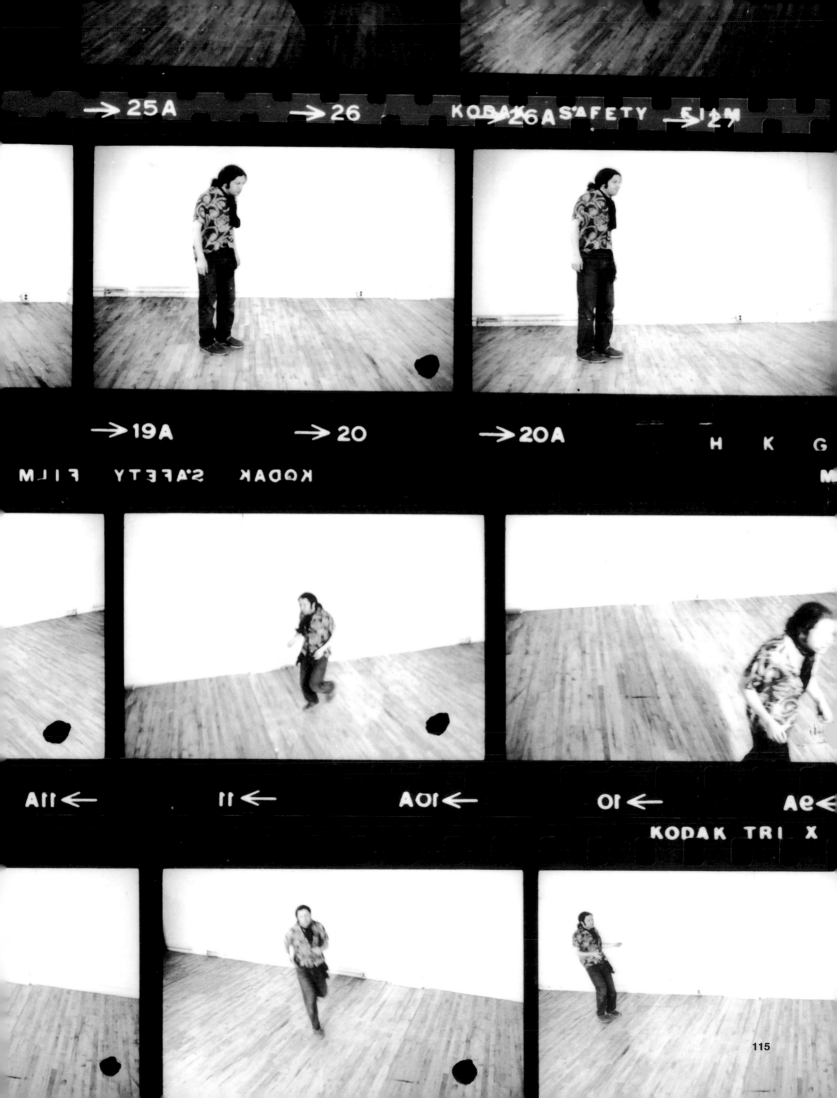

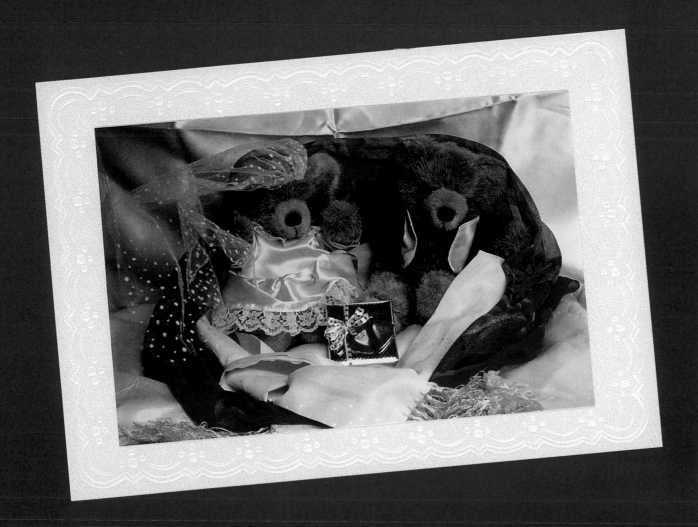

SPONGES AND MAGNETS: THE SHAMANIC ART

EDWIN POUNCEY

L'ART CHAMANIQUE DE CHARLEMAGNE PALESTINE

On his recording *Music for Big Ears*, Palestine (alongside carillonneur Jeffrey Bossin) returns to the instrument of his youth which, as he explains in the sleeve notes, contributed to the development of his later electronic music and "helped my search for 'sonority versus energy', a signature of my sonic investigations".

Since his comeback in the late 1990s, it has been these sonic investigations into open form drones, overtone structures, extended sacred chants and complex repetitive musical patterns that those who have heard his name instantly associate him with–together with the iconic image of Palestine in action behind his Bösendorfer Imperial grand piano, surrounded by a protective army of stuffed toy animals. Thanks to several dedicated connoisseurs of 60s minimalist music, the majority of Palestine's recorded performances have been made available; but to assume that his work is solely based around the manipulation of sound is ignoring an immense body of work that is highly intelligent, spiritually uplifting and infused with primitive magic and ancient and modern symbolism.

The groups of animals that are gathered around his keyboard are more than just cuddly looking props. Although they seem frozen in time and unable to communicate feelings, they have a hidden power and a secret language that slowly reveals them to be their guardian's constant companions, and the real driving force behind his 'sacred art' and music. Together they have forged an intense, personal relationship which began in the early years of Palestine's life, when he was living with his parents, and has continued to develop and intensify until the present day.

In my childhood I wasn't greatly connected with my parents and the world. Like all children I found little friends who were more sympathetic to me. Children love these companions that are always there, and that's their most important transitional object between themselves and their society during infancy. Between the ages of 12 and 18 I was suddenly bombarded with a lot of ethnological material about cultures from all over the world. I watched them on television and read about them in *National Geographic*. I suddenly began to see that in many parts of the world there were adults who had 'toys', and masks, and invisible friends that were animated but inanimate. I began to see a solution to my problem. I couldn't imagine abandoning this connection with my childhood companions for the rest of my life: what would eventually become the centre of my adult life. It was through this transition, from childhood to primitivism, which I integrated into my American-Jewish urban background to create me. What I've done is to continue this transition and become a shaman.

When did you decide to use stuffed toy animals as a medium?
My first relationship with the outside world as an artist came more from the daily interaction that was either with the body or with the voice. From my childhood I was already doing a kind of theatre work with my parents using some of my stuffed animals as intermediaries when I couldn't talk to my mother and father. I would invent a voice for each of my animals and they would talk; they would even talk to me. I would invent a voice and then have a dialogue with them, where I would ask them a question and they answered using another voice, as though we were doing a puppet show. That's my earliest life connection using these animals.

What were these early animals?
The first one was a bear. Maybe there was also a dog and a rabbit, but the bear was the chief animal. There were a couple of bears, I think my mother got rid of one because he was too old and I had hugged him too much, I don't remember.

There was a time in the 70s when I was invited to the University of Buffalo to talk about my performances and different things, and they asked me about my first installation. I remembered that when I was about eight years old I had made a tent around my bed using a sheet, so it was like a teepee. I was inside with my favourite bear and we were watching television. Around the bed, and all around the room, I had smaller stuffed animals who were part of my entourage, and I had given each of them a weapon—a fork, or a knife, or a plastic cowboy pistol—and all their weapons were pointed towards the door in my room. I had constructed a barricade; my parents wouldn't come in and I would be protected by this army of stuffed animals while I was with my bear watching television in this teepee. I reconstructed this at the University of Buffalo as my first installation. I gave the date of 1955 for the piece, which is when I would have been eight years old.

So this physical contact with stuffed animals goes way back to your childhood?
Eventually my mother began to get worried when, at the age of 13, I still had these animals around. Sometimes I'd even hide them under the bed when friends came; I began to feel embarrassed

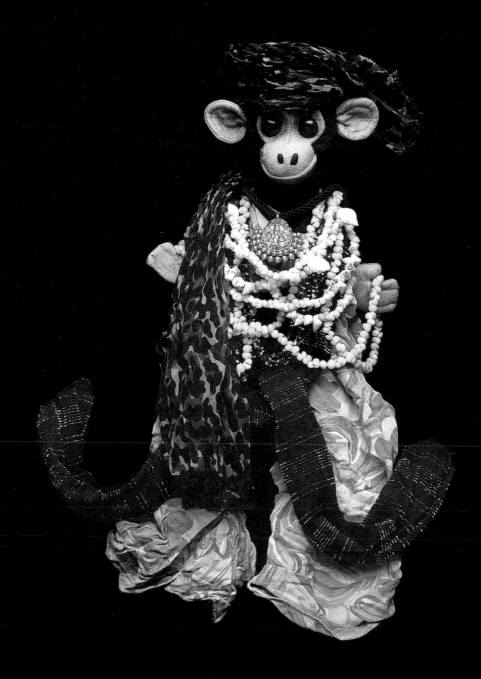

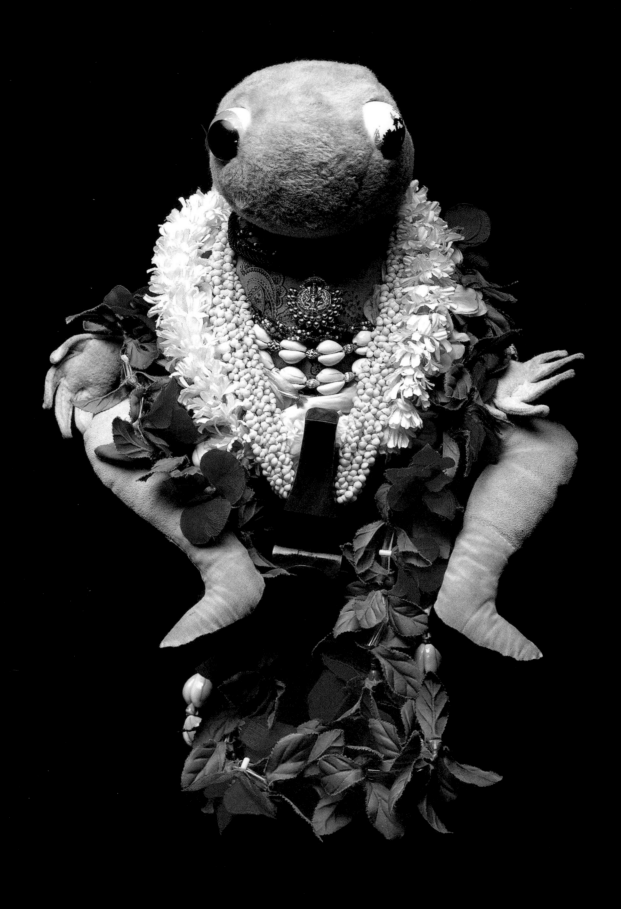

that I still had all of these stuffed 'friends'. It became more and more difficult for me to deal with my adolescence and my adolescent friends with these toys. Finally my mother threw some of them out.

I left home at 15 to live in Manhattan and began attending the High School of Music and Art. My mother found me a little studio apartment close to the school and I was living there alone. By then all the animals had disappeared, because of this problem with age—when does a Western child give up their toys? There was a lapse, and then, strangely enough, just several years later, somebody offered me a bear; a little bear that they had found somewhere which had blue eyes like mine. They gave it to me as a gift, as a sort of joke, and that immediately exploded into the second chapter of my life; an almost 38 year old passion for toys and animals which transcended the problem I had during childhood.

In our society, the objects that I use in my work come from this period of childhood. Then you enter adulthood, and the only time you return to this period of childhood is when you have a child. You begin to live as the adult parent with the child and their toys. As I never had children I became this artist who uses children's toys as his raw material.

When was the first time you shared this new language with the outside world?
At first it was more or less easy because I was already known as a multi-media artist. There were already a lot of artists, such as Joseph Beuys and Hermann Nitsch, who were integrating a physical ritual using objects around them to create a form of art installation.

I did what I needed to do, but I wasn't really sure why I was doing it, except to survive. I had a great many problems about how to make work that was also a financial tool. The initial idea that my works were linked to performance continued, but as I didn't have a country, a generation, or a following behind me to elevate the value of these things they were received very poorly in the financial art community and remained, more or less, unsellable. The moment they began to be objects to buy and ceased to be living installations I had a big problem. In this art game they didn't easily translate as things that gain in value.

How were you and your works viewed by the art scene in general and your immediate contemporaries at this time?
At the very beginning they were considered interesting and eccentric. Some people thought of them as Art Brut or Outsider Art, because my works didn't follow Pop Art, Op Art, Minimal Art, Conceptual Art, or American Postmodernism. Instead, here I am decorating stuffed toy bears, putting them on a little red background and showing them. They said, "This guy's out of his mind, but we really like him because he's such an interesting person. Even though we're not sure we like these things that he does, he's doing it." So my works came out of this very rigid 60s modern art tradition that was already linked to the financial community. It was Outsider Art, but I was an outsider of the insider group. I'm officially a member of the 'art club', but my artistic expression is always seen, certainly at the beginning, as being outside. I was buddies with the famous theatre, dance, music and visual art heroes of my generation, and I'm making these things that were 'outsider' from their point of view.

Shortly after this, a new generation of younger artists, like Mike Kelley and Tony Ousler, appeared who start to do things that strangely resemble the crazy 'outsider' look of my work. But they arrive as a serious team with a new language and a business savvy, and find a way to incorporate this kind of work into the next chapter of modern art's history. The art world was also in the mood for a change because it had gotten tired of all this Minimalism; they wanted something more. Which is exactly what I wanted, but I didn't know how to feed it into the business machine. I suddenly found myself going from being the outsider to funky crazy uncle imitator.

So, you were being accused of imitating this next generation of artists who were using your methods in their own work?

When we talk about painting, for example, how many different kinds of painters can we imagine? Like I feel about Minimalist music, there was something in the air. Using fetish objects is something I didn't invent; and using drones that resemble a refrigerator or a tamboura was certainly not dreamed up in New York during the 1960s. All of these things were invented thousands of years ago some place else. But there are these Western robbers of antiquity who use them to make modern things that are expensive and important. I have to take responsibility that I am a poor card carrying member of this group of colonial imbeciles and, in that sense, I was not an outsider. Maybe I'm just a person who blows the whistle more often than others to explain that we didn't create this. We are imitators, but we did it for a certain time and place.

You mentioned the word "fetish" to describe your stuffed animals. When did you first begin to seriously use this term?

They were often part of a voodoo ceremony or something. I first started to do this in France and Italy. I was travelling with a red suitcase that was just for my animals. People used the word "fetish", and I remember everyone using this word when I started to put these things around me. I would prepare a space for my performances with all these little objects and animals and people would ask me, "Are these your mascots?" I didn't know, I had no answer in those days, I just did it. I used to hear these words that other people would put on these things and that became my first clarification of what they were. You don't say fetish or mascot when you're a child; these are adult words that have been put into the language to explain the use of certain objects and elements that have a special, personal relationship with somebody. They're usually inanimate, meaning that they're not a living being, but they are given living qualities. That points to some kind of Oriental, African or primitive experience; this 'animism' which is a word I begin to use later on.

It was very difficult to integrate my work into society because it's always had this problem of being viewed as toys or a joke. I know what they are, because I use them and they physically felt right; they made perfect sense to me.

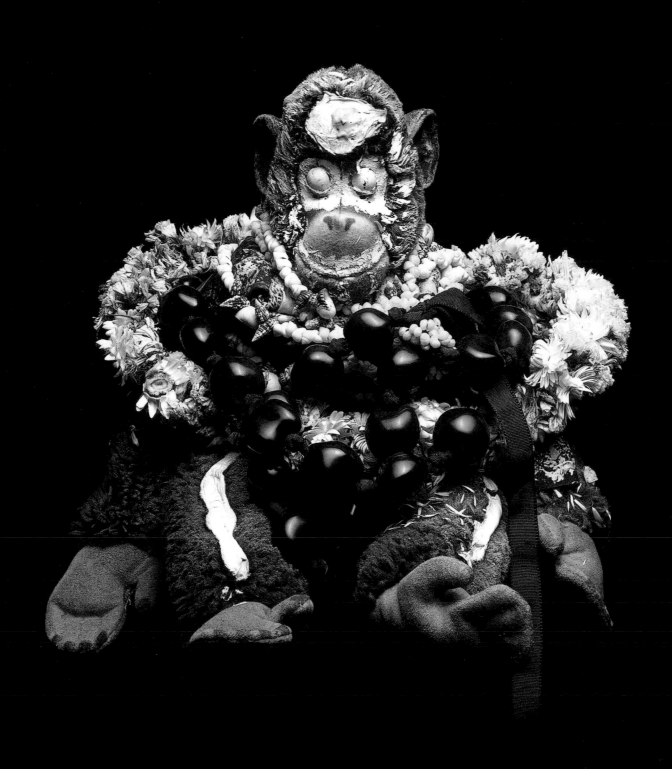

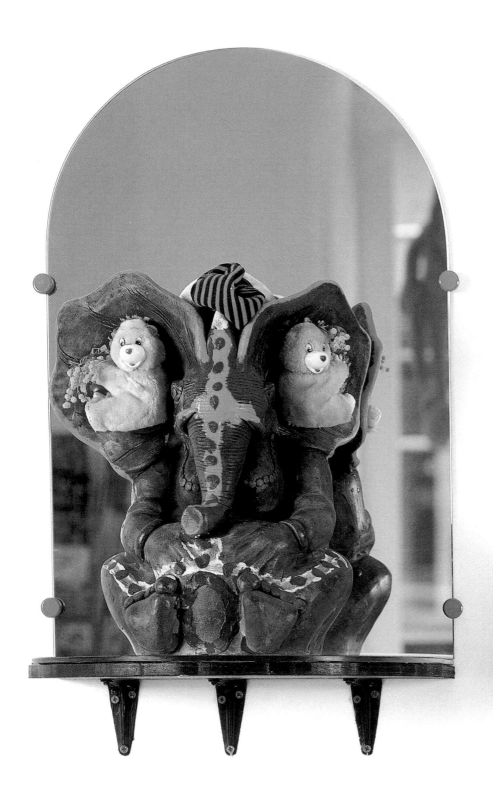

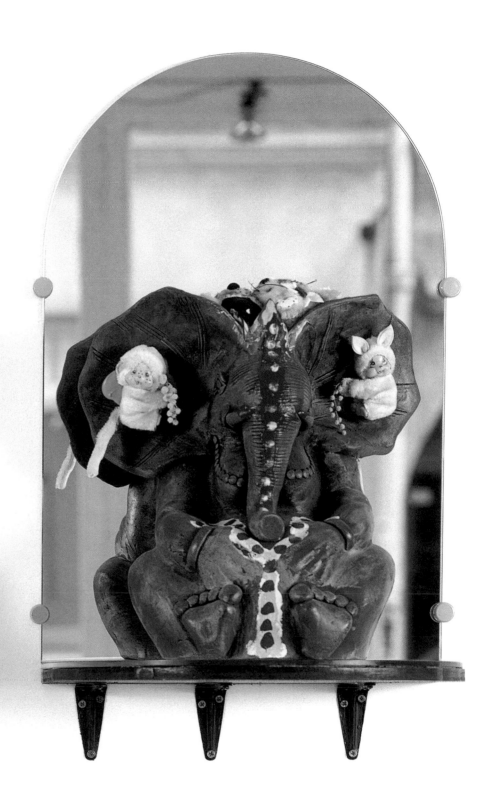

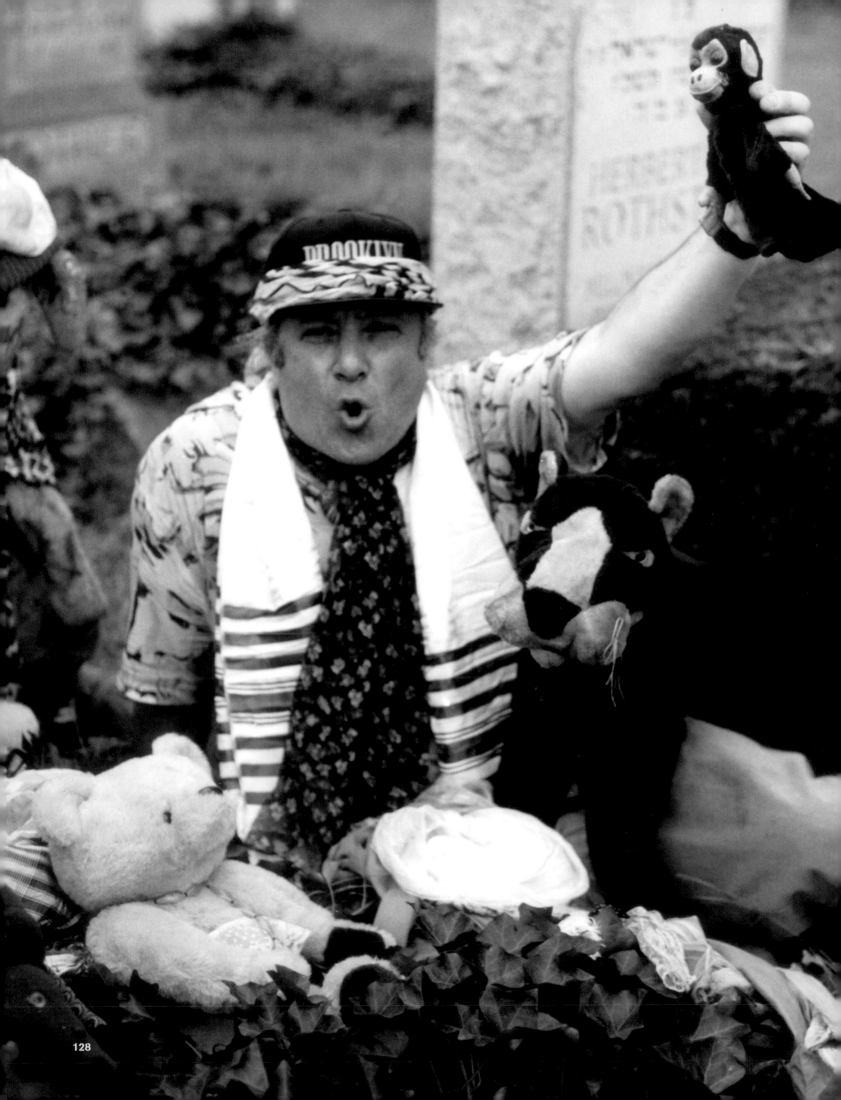

Some of your animals wear scarves of torn printed cloth, is this an extension of the fetish, voodoo altar idea that exists in your work?

They have always been prepared with several of my scarves. I also started to wear scarves at a very young age, because I had an enlarged thymus gland and was given too much radiation in my neck when I was one year old. From the time I was a young child until today, I always covered my neck with ties, shirts with very stiff collars, and later on, scarves. I wear scarves all the time. I rarely sleep without a scarf. There's always something protecting my neck, which probably comes from this radiation experience.

Can you tell me something about the rituals which you used in many of your performance works? Especially those that involved you playing your Bösendorfer piano for a certain length of time.

I have been heavily ritualistic from the very beginning. I come from a Russian-Jewish community and there's ritual everywhere. Early on in my works when I was doing my performance pieces, people began to use the word 'shaman' around me. I'd always have a special scarf. There would be special numbers and colours, a special alcohol, a special shirt, a special hat. Whether it was performance, playing music, or constructing objects, I'd often do it in a state of trance. When I'm not in this trance everything feels very difficult to me. To choose, to decide, to even begin is very difficult. I have a tendency to be lazy and resistant, I become stubborn, like a donkey, and I don't want to do anything. Then, at a certain moment, I get into this state where I transcend and loosen this burden, and at that moment things start to happen.

So people around me had begun to consider me in a shamanic way, meaning that I seemed to be in touch with the energy of a moment.

Describe how you feel when you enter this trance state. Are your animals with you?

They're always there. In my early performances with piano, the piano was totally covered with a group of my favourite companions. The reason being that, when I would enter the trance, their presence would give me the energy and wisdom to live in this sense of the present. The people around me who were watching and listening began to become a blur of energy to me. The things that looked at me straight in the eye with this sense of constant 'presentness' were these creatures that were sitting or hanging from my instrument. We would go on this journey together, like Rod Taylor in the film *The Time Machine*—where everything around him starts to move quickly and becomes blurred, and finally he stops and tunes into whatever century he has arrived in—it felt exactly the same way to me. All of a sudden, all the things around me become a blur, except that I became very conscious of space itself. The air became more important than the room or the things in it; and together with my animals we would experience this eternity of air.

At times it felt like I was on a roller coaster with them, the sounds that I was producing would make me totally stoned. I would begin to get scared because I was losing myself. Then, zoom! Right there! I look at them and they look back at me. They're my seat belt, my anchor to a constant present.

Were you aware of your audience while all this was going on?

I would be aware of my audience's energy, of their respiration. They were like this enormous elephant that has lots of nostrils, armpits, groins and sweat. They would turn into this one enormous amoebic organism with multiple things going on at the same time. Afterwards, when I'm just beginning to return, people would try to talk to me normally. I'd have long conversations with them where we would enter all kinds of realms. The next morning, however, when I'm back to normal, I would have no memory that these conversations took place. I would still be in this state of the present, and that's also what my work's about. It's about being totally in the present.

I started to produce works that were more and more crazy at the end of the 70s. Works that even the new generation of performers and musicians were coming to watch and listen to. They are amazed by this crazy man who's bleeding from his fingers and getting deeper into a violent abyss. My only protection are these animals, and at a certain point I decided to give up this past life and allow the animals to take me to another dimension where I began a new art form based totally on them.

SOFT SCULPTURE AS DIVINITY

In 1987, at the Documenta 8 exhibition in Kassel, Palestine presented his most important sculpture to date; an enormous triple headed stuffed bear with two bodies called *God Bear*. The sculpture was primarily based on the universal recognition and emotional pull of the famous children's toy which Palestine had elevated to the status of a supreme being—a veritable god of childhood memory. The evolution of the teddy bear (as it became known), together with the story behind those who were responsible for its creation, was also a crucial element of the finished piece. Thanks to an introduction from an influential friend, Palestine was given the opportunity to sell his idea to Steiff, the renowned German toy company who were among the first to manufacture a stuffed toy bear.

Palestine's eventual creative relationship with the Steiff Company and their chief designer Jorg Junginger produced one of his most monumental pieces—together with a friendship that lasted until Junginger's death in 2001.

When I decided to create my big bear for Documenta I realised that I had to raise 60,000 dollars. I went to visit Claus Oldenburg, because we had both been with the Sonnanbend Gallery in New York during the early 70s and he had been to some of my performances. I went to his house one Saturday morning, totally bombed on a bottle of vodka for courage. He lets me upstairs, offers me a cup of coffee, and I tell him the problem. He said, "My wife will never let me give you any money, but I do have a coat that Doug Christmas gave me." He shows me this coat which is full of holes, and smells like a bison, and says, "Take this coat and you can tell people that I gave it to you. Use it to raise the money and then bring it back to me. That's the best I can do."

It was a very hot weekend and I decided I wasn't going to take the coat, which resembled the kind of coat which rabbis wore in Eastern Europe. But he insists and puts this big, smelly coat on my shoulders as in some rabbinical ritual. So I wander around Soho on this hot weekend, wearing this coat, telling people about my project, and trying to find the money to fund it. Suddenly, people start giving me

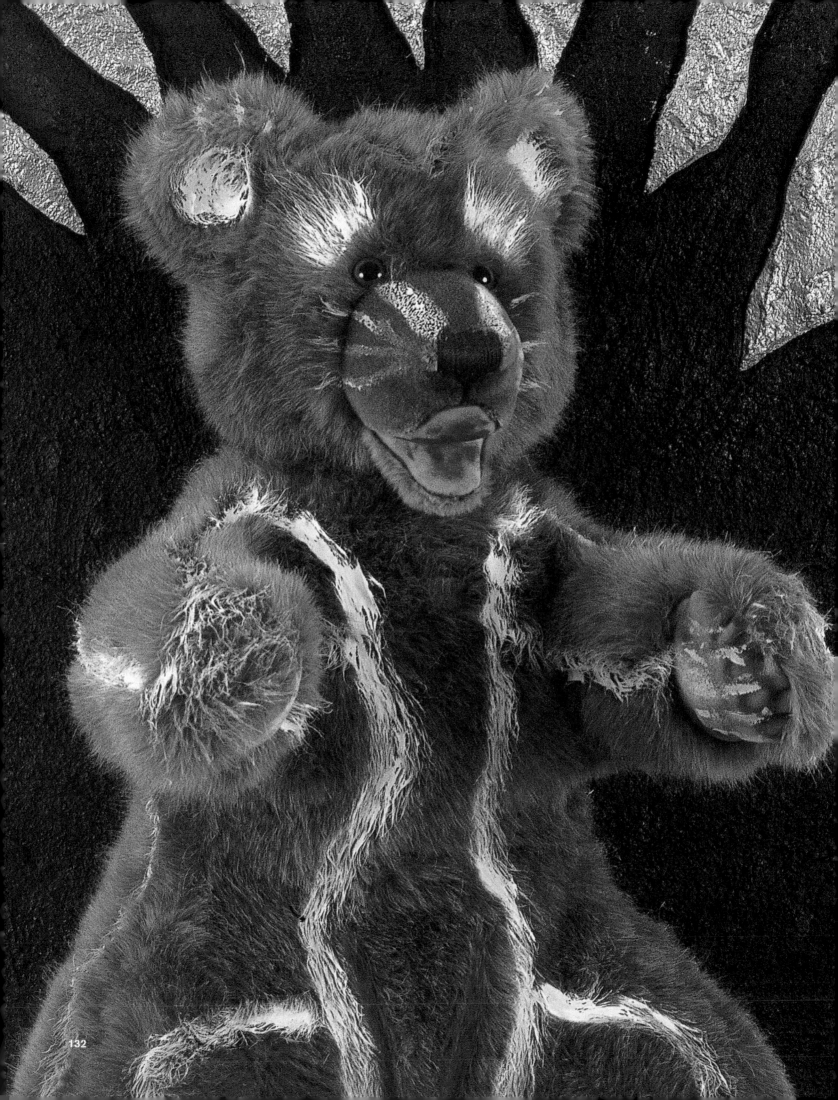

money for the project. I sat in front of art dealer Leo Castelli's building on 5th Avenue for six hours and finally, when he left his house, I followed and shared a taxi with him. He was trying to get out of the taxi. He said, "The smell of this coat is terrible!" I said, "But Leo it's the coat of one of your most important artists, Claus Oldenburg." The next thing I knew he gave me a cheque for 5,000 dollars. The funny part of the story is that, many years later, he was in Paris when my *God Bear* was in front of the Grande Palais. He passed by while I was standing there and I said, "Hello Leo. You see this bear!" He said, "You know Charlemagne, when you came to see me that day, I just gave you the 5,000 dollars to get rid of you. I would have never believed that this bear would be made. It's an amazing bear."

Once you raised the funding to build *God Bear*, what were the circumstances that led up to you working with the Steiff toy company in Germany?

At the real beginning point of my finding and building these animals I was living in Geneva. There I met Adelina von Furstenberg who ran the Centre d'art Contemporain in Geneva. One day she told me that the teddy bear was invented by a German company called Steiff and, if I was interested, she would call them up on my behalf and arrange for me to visit them. The idea sort of shocked me, but she explained that "These are old aristocratic companies, and since I have this aristocratic name maybe it will open a door for you." I said, "Yeah, why not?" So she called them up and it worked!

I went to Steiff and met the great nephew of Margarete Steiff, Jorg Junginger who was the company's director of design. He made a small prototype of *God Bear* for me. He liked the idea too; he always called it the "Buddha Bear". He was not a religious man, but he could live with that. The idea that he had helped create a divinity was something too difficult for him to absorb. Certainly in my religion it's totally forbidden to use that word out of context, and I sometimes got scared that a bolt of lightning would hit me. I once considered calling it "God's Bear". I thought that, even our God, who doesn't permit idols, even he must be permitted to have a toy.

How did you work out the original design for God Bear with Steiff? Apart from the teddy bear, what other elements were involved?

Several years before I went to Steiff, I passed a Persian rug shop in Cologne and saw a very beautiful wooden Ganesha with three heads in the window. It was very expensive, but I didn't care. I used my last money to buy that Ganesha, and, I think, directly from that moment, he developed into the *God Bear*. Ganesha was already a divinity. He had three heads you could see at the same time. I altered this on my bear so that you could only see two heads at the same time. The third would always be invisible, like in a circle. That was the concept of the *God Bear*.

Jorg Junginger had all the plans for all the bears that had ever been created since the beginning of Steiff and they were all in little drawers. We went through them to find a face that would work well for this project. We found a bear's face that dated from around 1912, along with a body from 1917, and we merged them together. Strangely, what happened is that when Documenta finally found a park to display the bear in, it was next to two retirement homes and all the people who lived there had been children from around 1912 to 1917. During the entire three months that *God Bear* was in that park, you

would see old people looking at the bear with tears in their eyes. It became, not their God, but a memorial of their lifetime. It was incredible.

When I was invited to contribute a work to Documenta 8, I came as sort of a Trojan horse because I wasn't invited as a sculptor. It was the first Documenta that decided to have an official film, video and performance section, which the organisers said would be equally as important as painting and sculpture. The theme that year was 'invisible conceptual sculpture', which was certainly the opposite of what I would finally do. The art world didn't recognise me as a sculptor.

What you came up with, though, was a sculpture. What made you decide to present a three-dimensional work rather than a performance?
A sculptor in the 1987 Documenta got between 20 and 50,000 deutsch marks for their sculpture, and I was given 2,000 deutsch marks because my piece was supposed to be a performance. I then had to find 98,000 deutsch marks to complete the project, so I had to invent ways to get it done. I had already told the people from Steiff that we were going to make this bear for Documenta. I told the people at Documenta that I was going to come with an object that I would use in my performance. A bear weighing 2,000 pounds, made out of 13 separate pieces, which would take two enormous trucks to transport it. I sort of told a ruse, but not a lie, because I told them what it was; only I didn't put it in their context. I took the idea from my earlier works where a performance consisted of a piano with many of my mascot, fetish, and voodoo altar friends. I then asked myself, what is a performance? A performance is whatever I decide I want it to be, and I have decided that my performance is to be an enormous Steiff bear that has three heads and two bodies. He will be a divinity, like a kind of Ganesha, and if I'm arriving with it then that's a performance.

I got to Documenta with my nearly six metre high *God Bear* made out of real mohair, after finally raising the money to build it. The day I arrived with a team of people to assemble it was the day when the national German television station was there to do the publicity for the grand opening. Manfred Schneckenburger was the curator, and he had chosen 'invisible conceptual sculpture' as the theme. There was a one kilometre pipe made out of brass that Walter De Maria had put into the ground, so all you could see was a little circle. Scott Burton had some furniture that was hidden in bushes. So the television station was all ready to do a big story on Documenta 8 and there's nothing to see except my enormous bear. That night every television channel shows my bear which becomes the unofficial symbol for Documenta 8; and the curator goes out of his mind. He didn't want the bear there, he didn't invite it, he didn't know I was going to come with a bear, I was supposed to do a performance. That was the birth of my *God Bear*, which became the most important symbol of that year's Documenta.

What happened to God Bear?
God Bear died like Joan of Arc, he died like a saint: he was burned at the stake. He was destroyed in Germany and so he died in the country where he was born. Nobody knows how *God Bear* was destroyed. The gallery I was with in Switzerland went bankrupt and the work was in storage in Germany.

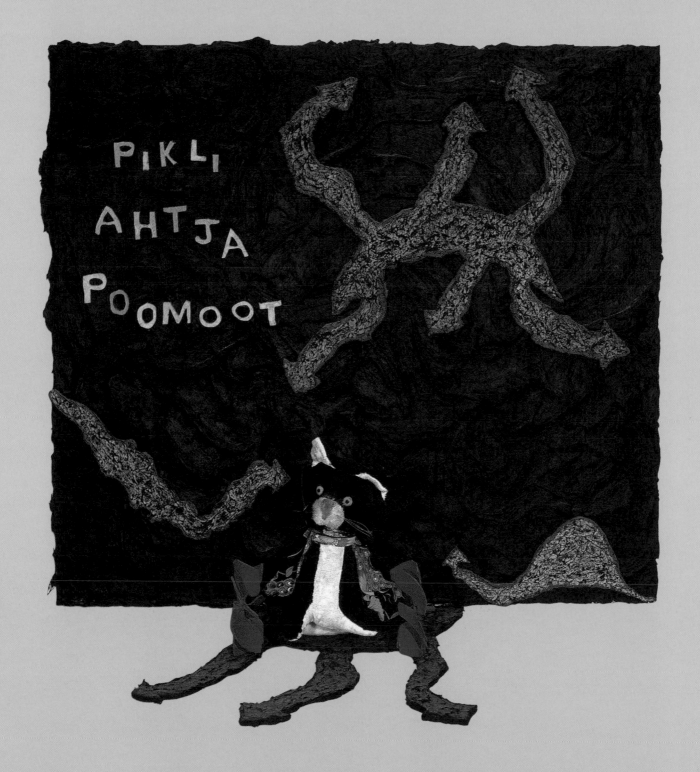

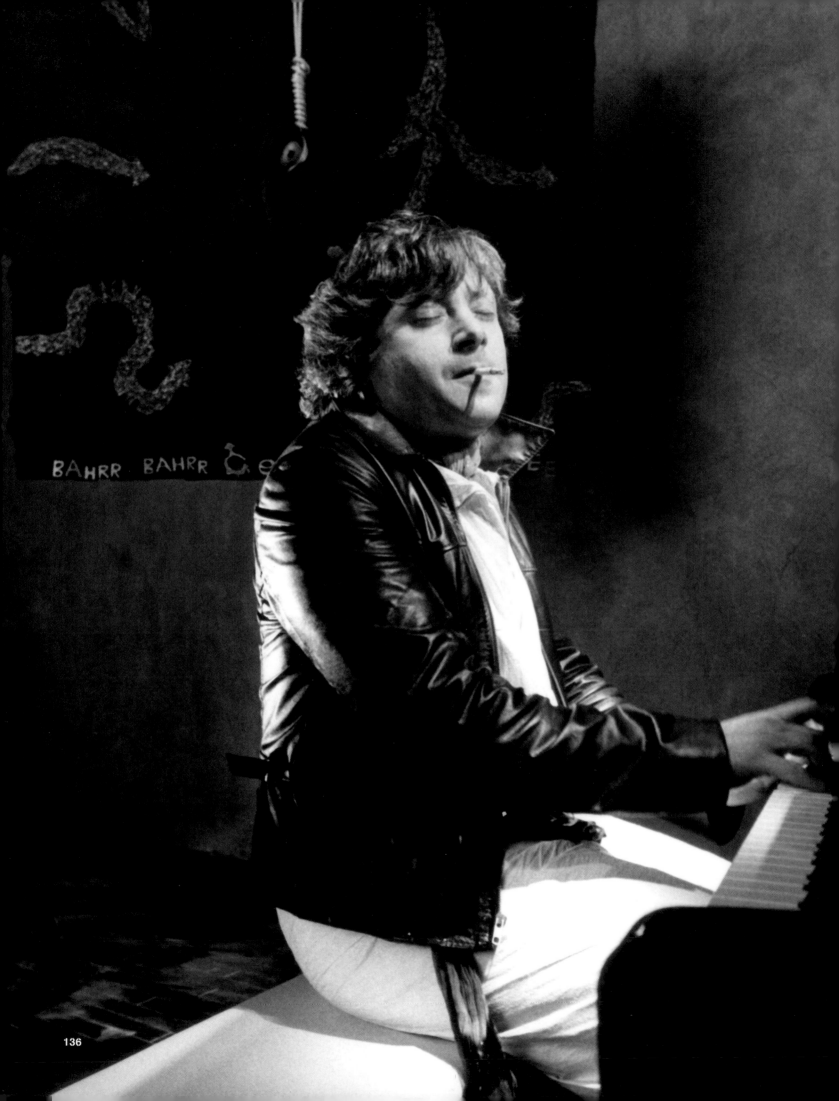

All of a sudden, one day it burned down, and nobody knows how or why it happened. Because I didn't have a power base, what muscle I had behind my career could not sustain objects and expressions of such magnitude. All of my major large pieces were destroyed, because they weren't taken care of. There needs to be some responsibility when you do monumental things in our society. They can't just be done, they need a structure around them, and I didn't have one.

Have you ever considered constructing a second *God Bear*?
We've been talking about it now for several years. He would certainly have to have a structure around him, because you can't have a God that doesn't have a home. It would be nice too if he could travel, because that was the original idea, that he would be a universal symbol.

Looking back at the *God Bear* project, what do you feel you achieved?
When I originally went to Claus Oldenburg and showed him the plans he said to me, "You know Charlemagne; I don't really like this project." I said, why? He said, "Because it's so sentimental, it's so subjective, and I don't believe epic sculpture should be sentimental or subjective."

Returning to the park I mentioned earlier, where there were all these old German people looking at *God Bear* and weeping—I realised that Claus was absolutely right. But what a magnificent sentimental and subjective form. I took epic soft sculpture, and created a sentimental and subjective object of heroic proportions. I had done exactly what Oldenburg criticised me for. It was a magical piece, and it's still a magical form.

THE CHOSEN ONES

God Bear was a major part of Palestine's development as an artist, spurring him on from performance art to creating sculptural works that were equally powerful, albeit less physically confrontational. Installation pieces such as *La Caravane en peluche*, 1990—where the outside of a touring caravan was completely covered with stuffed animals—and the more recent *D-Day P-Day*, 2001—which featured 130 stuffed animals suspended from the ceiling of the exhibition space wearing parachutes, in a re-enactment of the World War II Normandy landings—evoke strong memories of childhood and life experience. More importantly, though, they dig deep into the recesses of human history and excavate elements of tribalism and primitivism from the collective unconscious. To the casual onlooker Palestine's sculptures are probably nothing but a bundle of old toys that might be a humorous swipe at our modern day, throw-away society. In the world of Charlemagne Palestine, however, these man-made creatures possess individual personalities that provide vital inspiration for his work.

For the photographs taken at the Beth David Cemetery in Elmont, Long Island as part of his *Photo's Flotsam-Tombs of Bliss* exhibition, 1997, Palestine sits among the tombstones circled by his stuffed animal companions. In one shot he is holding aloft *Pepperoni*, the monkey puppet which is one of his 'special animals', together with the all seeing *Blind Monkey* who sits propped against the memorial of one Philip Palestine (Charlemagne's father). Despite the surroundings, the scene has more to do with joyous celebration than

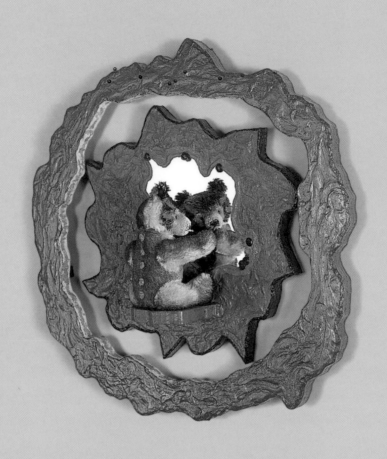

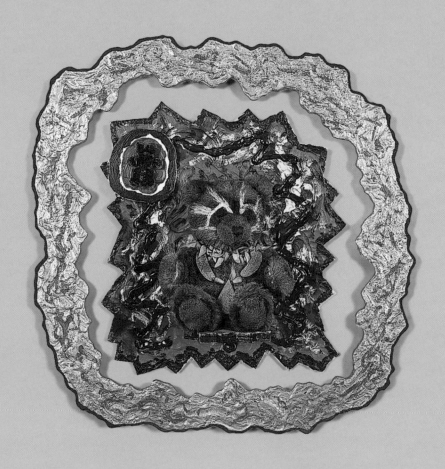

solemn remembrance. It suggests that Palestine has been reborn spiritually and artistically. Upon waking from his troubled past life, he discovers that his family of friends have been watching over him and preparing to welcome him back to the land of the living, to a magical utopian kingdom called *Charleworld* where he has deemed himself emperor.

There are key animals in my group. There's *King Teddy*, there's *Pepperoni* and there's *Blind Monkey*. *King Teddy* is very old. Unfortunately I travelled a lot with him and he's really disintegrated over the years. I didn't take good enough care of him. He was in the famous red suitcase which I took all around the world with me.

There's a funny story about this. In 1976 I was invited to a festival in Rome and I arrived at Rome airport with all of my luggage, including my famous red suitcase. So I'm getting onto the airplane, my bags go up this little escalator, and there are two German Shepherd dogs which sniff the red suitcase and they go crazy. In those days they had German Shepherds sniffing luggage for drugs and weapons. Of course the police open the suitcase and find 25 or 30 stuffed animals. The dogs are going crazy, they want to sniff at them, they're totally taken over by my animals. The police now want to cut open the animals to see what's inside them, and I have an anxiety attack. I start screaming. I start fighting. They have to send for more police. I'm screaming, "YOU'RE NOT GOING TO CUT OPEN MY ANIMALS! THEY'RE MY FRIENDS!" Finally the Director of Rome Airport comes down to see, what has now become an incredible scene. He looks at the dogs who are going crazy over these stuffed animals; he sees all these puppets outside of their red suitcase; he sees me going out of my mind; and he sees all of these policemen who are totally confused and not knowing what to do. He quickly puts all the animals back into the red suitcase; he closes it and carries it himself to the luggage ramp, and I'm allowed to get onto the plane.

Pepperoni is a monkey who was given to me in 1973 by the avant-garde dancer Simone Forti. We were performing together in Halifax, Nova Scotia where I was working and teaching at the College of Art and Design. *Pepperoni* was just a puppet that we found in a shop. She saw that I liked him, and bought him for me. I used to play a plastic clarinet as part of a work that we did together. It's a work for performance and dance music, and the animals were always a part of that piece. *King Teddy* was in that piece, at the very beginning, when he was younger. As *Pepperoni* has a hole in his body where a hand should go, he began to live on the plastic clarinet; which is where he lives today.

Blind Monkey was given to me by Jorg Junginger at Steiff. He resembles a blind Indian fakir. He's blind but he has a third eye. He has beads that come from the Hawaiian Islands where I used to live and his body is painted like somebody from Papua New Guinea. He could be part voodoo or part Indian, but he's the incarnation of all primitive beings. He resembles both the magician or the shaman himself, and also the kind of African statues that depict the shaman. He is all those things in my version; although he's actually a Steiff monkey circa 1977 or 1978 who has been transformed into a great priest. He got blind very quickly. I'm not sure why, but the idea behind his blindness was that it takes someone to lose their eyes before they can fully see. He immediately became one of my transcendental companions. *King*

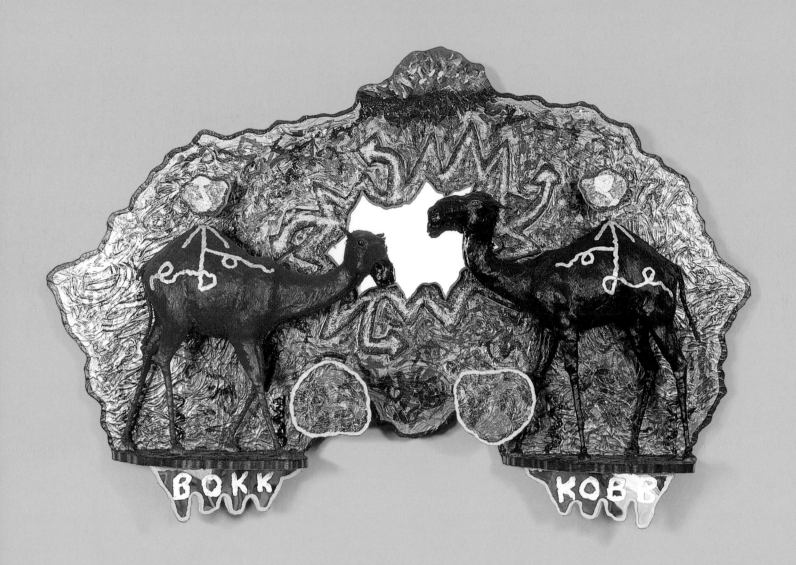

Teddy gives orders, he's a pain in the ass, he's a bully, he's a king; but *Blind Monkey* never talks. As he's blind you really become aware of his look, like seeing the strange movements of blind people's eyes. Then he has this third eye, which is very important. The monkey is the closest thing to our evolution. He's not a 'blind bear'; he's a 'blind monkey', because a monkey is our direct ancient cousin. I could never imagine a bear having such an important role in my story.

Do you somehow identify yourself with *Blind Monkey*?
One has to understand that I came to all of this ass backwards. I didn't have a concept like John Cage, which I could immediately present, and then spend my life showing the permutations and combinations of all that can be done with this approach. I came 'blind' like *Blind Monkey*, bumping into everything. After a lifetime of bumping into things I began to understand, like blind people do, how the planets are placed in my solar system, so I don't continually bang into them all the time. I began to understand through my blind mind's eye this strange phenomenon which now seems so natural, easy, and primal to me. I just rediscovered this primitivism that I sensed from the very beginning; but as a blind person. As a blind monkey.

How do you decide which animals to use in your works?
It's a very simple process. If any sort of object that resembles a creature enters my solar system, it gives off an essence, a presence, a personality. What happens is that, when I look at these animals for a certain period of time, they seem to present themselves in this inanimate, but animated world of sponges and magnets. Like a sunflower, when the sun shines they open up, and by doing so they reveal who they are. They become characters in this strange, continuous theatre of inanimate animism. It happens all the time. If they've been neglected for a long time, nothing is happening around them. There are no electrodes moving around them, it's dead air. When you give them energy with your attention they absorb this energy and later exude it. Once you see them in an installation or an exhibition they start to wake up, because there is all this energy happening. People looking at them, people talking about them; the air is moving and they start to come alive. It's crazy what I'm saying, but they are like sponges and magnets. They absorb a certain kind of energy and then they transmit it into the space.

Many of the animals that I use in my work have been thrown away by society because of the consumer ethic which demands that you use something until it's no longer apparently useful, or you're tired of it, and then you throw it out and get another one. The difference with toys is that you buy them to give to your children who play with them for several years. Then, when the child grows up, these toys or objects are abandoned and eventually discarded. Because of this close relationship between the child and his inanimate companion they are always disposed of in places where the child will not see them again. They're often donated to Salvation Army stores. It's into this abandoned, garbage can of society that I've arrived during the last 30 years. I breathe energy into these forgotten sponges which become magnets.

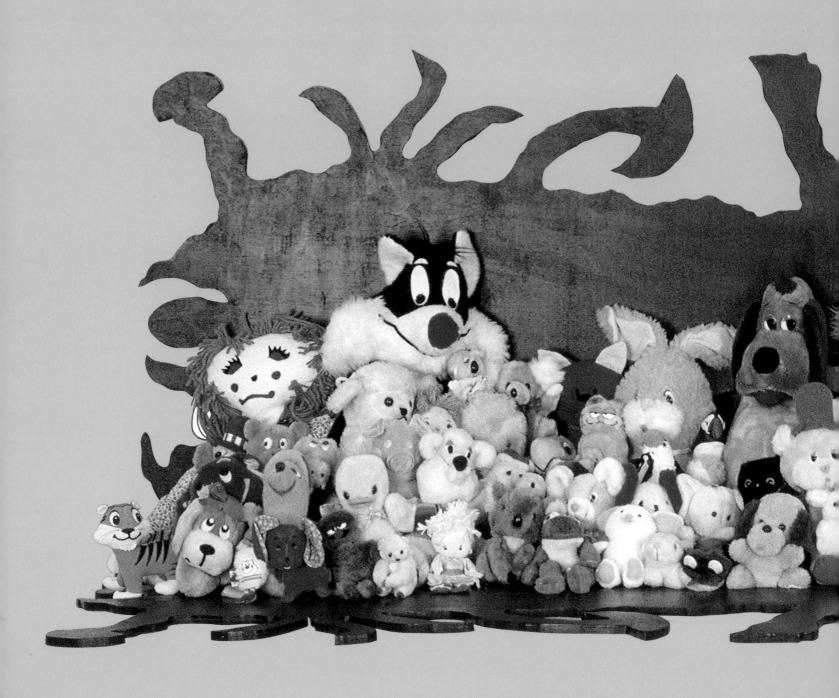

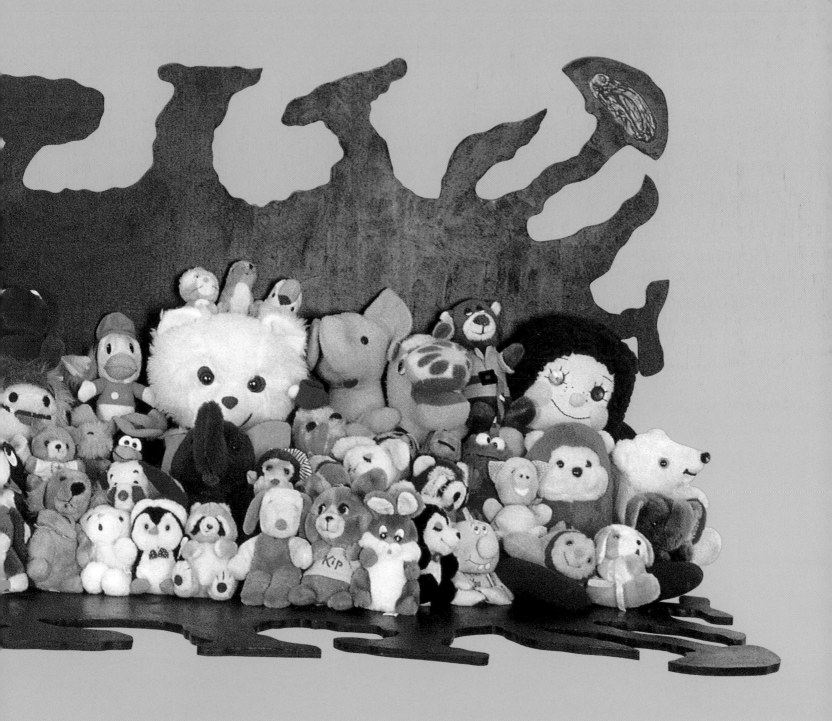

ORPHANS IN LIMBO

I n the roof space of Palestine's Brussels home (which he shares with his partner Aude Stoclet) several rows of children's playpens are lined up against the walls, each one is brimming with stuffed animals of all shapes and sizes which have been collected from thrift stores (or 'orphanages' as he prefers to call them) over the years. Some of these objects have already been used in sculptures, before being dismantled and put into storage; while others still await their turn to become a part of some upcoming project. Despite their comfortable accommodation they seem to look somehow lost, as though they are still shouldering the burden of their guardian's previous nomadic lifestyle and are unsure about the permanency of their present surroundings. The majority of this multitude of toys is unremarkable, but scattered amongst them are various celebrities that have been based on popular cartoon characters. None of them on this level, however, have any special status, they are all equal. "Some have no personalities," sighs Palestine. "There are certain little bears that are made in China which have very little personality because they made too many of them, they're very sad."

Across town, in another house belonging to Stoclet, important works are stored that Palestine has managed to buy back from the receiver who was holding them after the gallery representing him went bankrupt. These include the impressive Steiff studio animals of a lion, a dromedary and a couple of penguins that Jorg Junginger presented to the artist, which he then decorated with magic symbols to intensify their power. Palestine is clearly delighted and relieved to be re-united with them again, together with his other seemingly lost works.

Are the animals in the playpens upstairs in a state of limbo?

Seeing them like that sometimes reminds me of Alain Resnais' film *Night and Fog* where he shows the piles of bodies in the Nazi concentration camps. Except my animals are all smiling; even though none of them are capable of pissing and shitting on each other or being hungry, they're in limbo; but it's the best limbo that I've devised so far. Before they used to live in bags, and I hate bags. Now that my life has stabilised after all this wandering that lasted more than 30 years, I would like all these creatures to be in a healthy, light, friendly limbo. They're out of work; they're waiting for a job, that's how I see them.

Some of the animals upstairs are representations of celebrity cartoon characters like Mickey Mouse, Sylvester the cat, Snoopy and Bugs Bunny. By choosing them are you asking your audience to recognise their own childhood memories in your works?

I don't choose them, they're thrown away. I go to the orphanage and there they are the poor unwanted ones. What am I supposed to do? I'm going to ignore them because they were once stars? They're has-beens, I'm sorry for them. I often don't see them as the characters they once were. Because they've been thrown out already, for me they give off a whole other aura. I'm using the throw-aways of our society to make sacred altars. In this group of orphans there are characters that people remember. There have been rare times when I have excluded a character like that, because I felt that the piece was about something else and I didn't want him in the way.

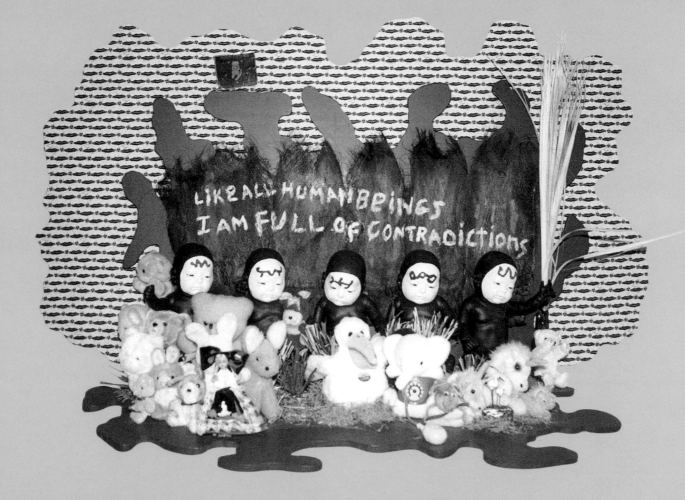

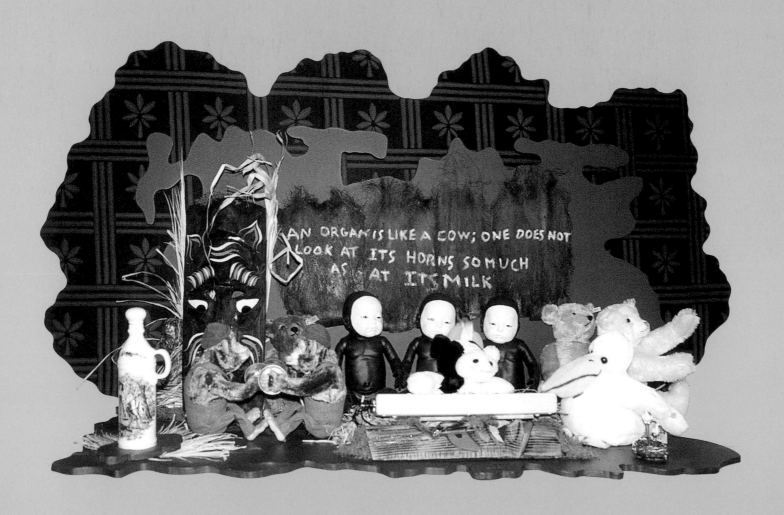

I've never done a piece that includes only celebrities. There was a period during the early 90s when I did a series with the same kind of animal; and a piece where all the animals were red. I've done that sometimes, but I've never done a mountain of Mickeys.

A recurring character is that of a Smurf. What's the fascination?
There are several favourites that I have and Smurfs are one. I saw them when I was younger. I don't know if they had a great impression upon me at the time, but then I went to live in Polynesia and studied Oceanic history and mythology in every way. I then realised that these aren't really Smurfs, these are Polynesian kings. The headdress of a Smurf is almost identical to that of the King of Hawaii. For centuries he wore a headdress that is this feathered crest, and there were special birds attached to these crests that could only be worn by the king. They were considered the most sacred object in Polynesia. When I rediscovered these Smurfs in orphanages, I was shocked to find Polynesian kings.

When you use paint to decorate some of your larger animals are you giving them a magical status?
That's right, especially during the time I was doing this the most. Those pieces are almost 20 years old, but my absolute desire then was to iconify and sacrify an object by painting it with sacred magic symbols. These are very important animals and I used paints to decorate them like Africans and Indians do, or other kinds of ancient peoples would. I used paint on them as a kind of a magic device.

On some of your works from the 1980s you have painted words. Is this somehow connected with your desire to produce magical objects?
They are incantations, but I've often used words in my works; and especially words that are incomprehensible. They don't mean anything especially. I like to play with words that I have invented, but these could possibly mean something incredible to someone else. I always hoped that one day somebody from a strange island would come to see one of my shows. He'd be wearing a turban, or a peculiar earring, or something, and he would look from work to work and say, "Ahhhh... ZEEGAHH!!!!" Each of my words would mean something profound to him. One day my prince will come and he will understand exactly what these words mean.

ETERNAL NOW

Not all of the animals that inhabit *Charleworld* are shadows of childhood; there are also several preserved specimens of real animals there too. The principal stuffed animals that hang on the walls of the house Charlemagne occupies are a bison's head; two wild boar heads called *Balthazar* and *Agrippa*; and a stag's head which goes by the name of *Orlando*. All four of them lived in the wild before they were hunted down and shot for sport. Stuffed and mounted, they were put on display in some baronial hall as proof of the owner's shooting prowess—silent subjects for an after dinner adventure yarn as cigars were smoked and the port was being passed around. Under Palestine and

Stoclet's protection, though, these four animal heads are treated as revered friends rather than decorative hunting trophies, each with their individual characteristics. *Orlando*, for instance, appears to be constantly singing operatic arias; while the two boars are seemingly deep in conversation with each other in the recreation room.

There's something about taxidermy, about the idea of making an eternal object that attracts me. When I look at *Blind Monkey* and little *Marseilles*, well kept in a decent atmosphere they will survive one hundred times longer than I will. That difference of temporal and eternal is a very powerful thing, and it's encompassed in this ritual which determines either letting an animal decompose after death and become a skeleton or immortalising it forever using taxidermy.

Although he has yet to fully take the plunge in this direction, if he did decide to resurrect a dead animal through taxidermy, Palestine's approach would be reverential. Unlike the work of an artist like Annette Messager, for example, whose flayed and crucified soft toy and taxidermied animal mutations tend to dramatically resemble the horrifying genetic experiments of some mad scientist. Instead of pulling them apart for art's sake Palestine prefers to breathe new life into his charges, and by doing so he manages to make contact with his audience through the ever expanding and evolving menagerie of rescued orphans and eternal creatures that make up his magic kingdom.

When I first saw a preserved animal I noticed that they live in the constant present. It's like time has not passed for them. They are frozen in the same position; they're in a state of anger, surprise, joy or confusion all the time. The connection between a preserved animal and my objects is that, when you present them, they exist as an essence that's always in the present. They have no memory—although one can't be sure—but these are definitely objects which have animal features and bodies which resemble certain species that we can recognise as creatures in our universe. They don't move on their own, but we can animate them. I can look into their eyes and see them come alive, but they're always in the present. I've just had works that came back from Switzerland after ten years of being in storage. I look into the eyes of one of the pieces and there it is. It's looking back at me saying, "Yeah, ten years have past, but I'm still here." THAT certainly is magic!

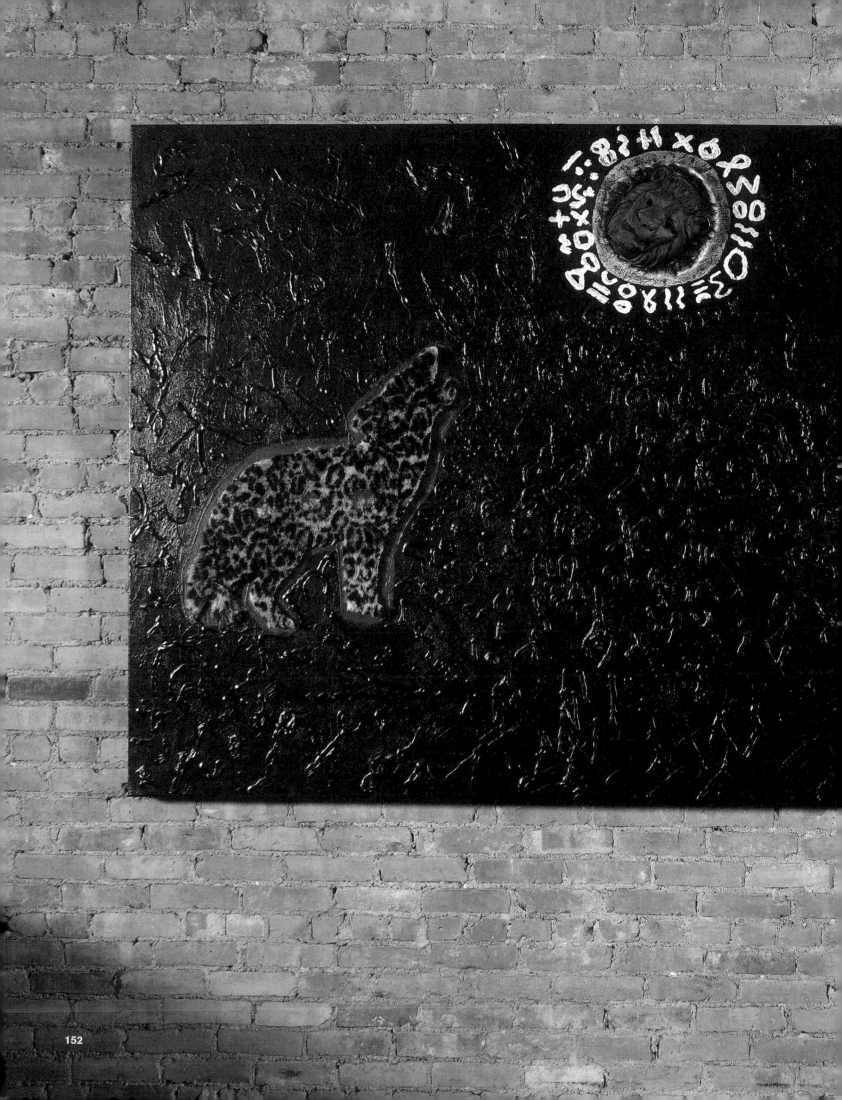

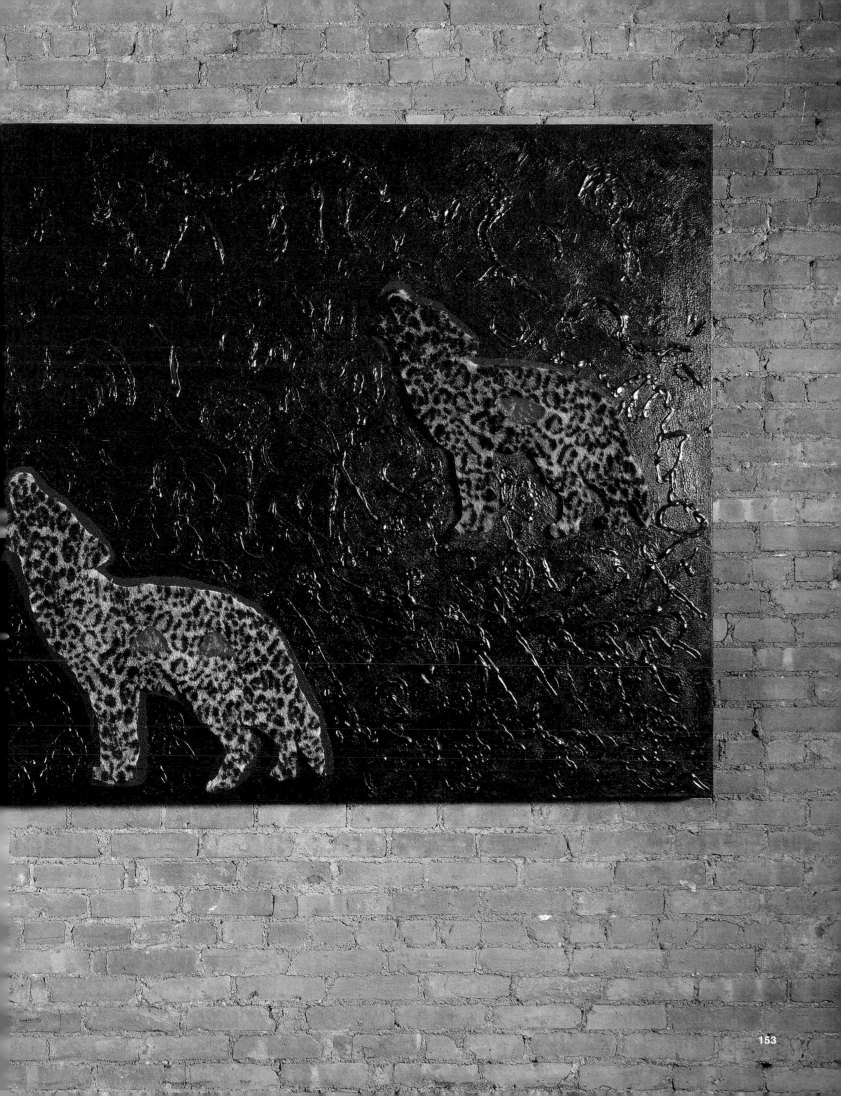

85

CI

arlemagne

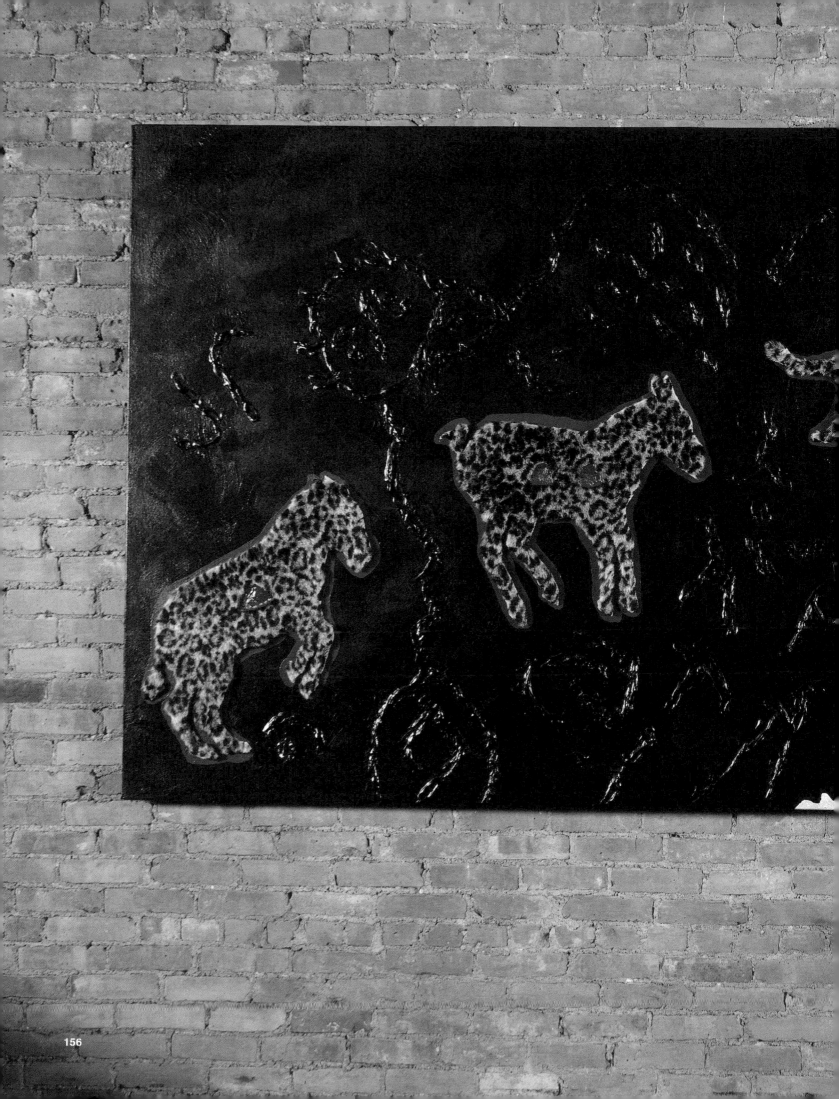

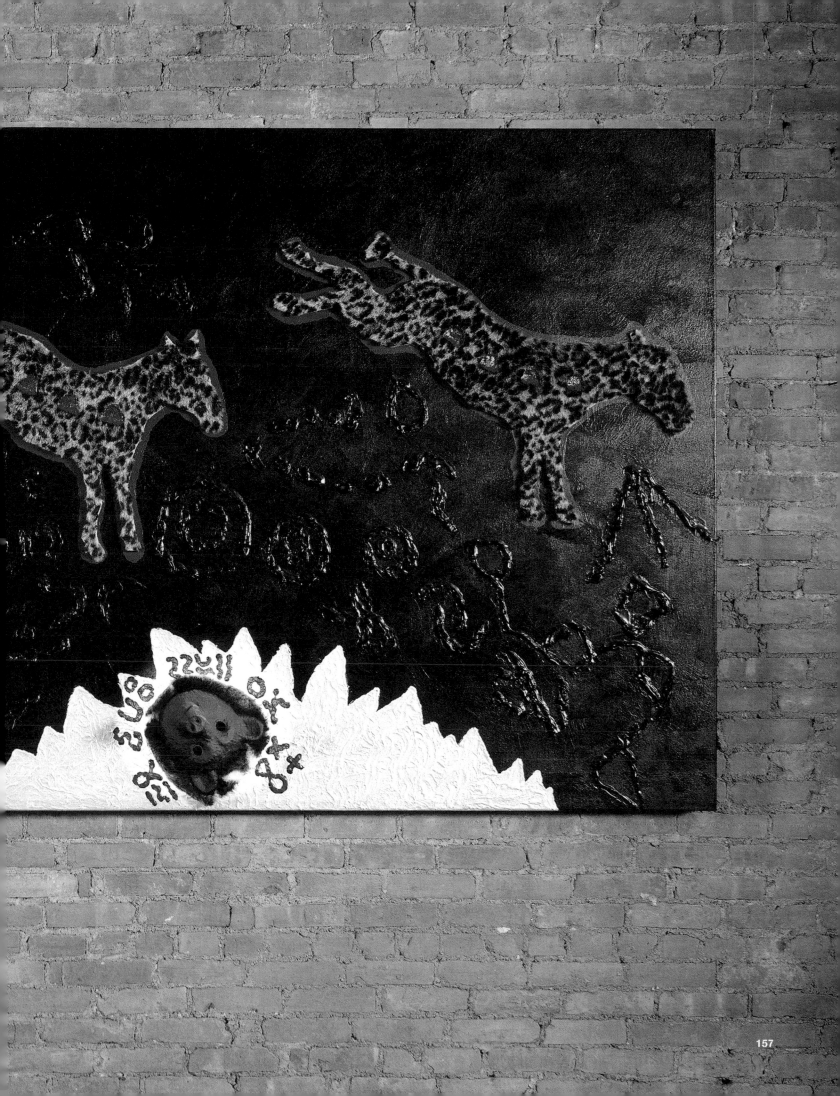

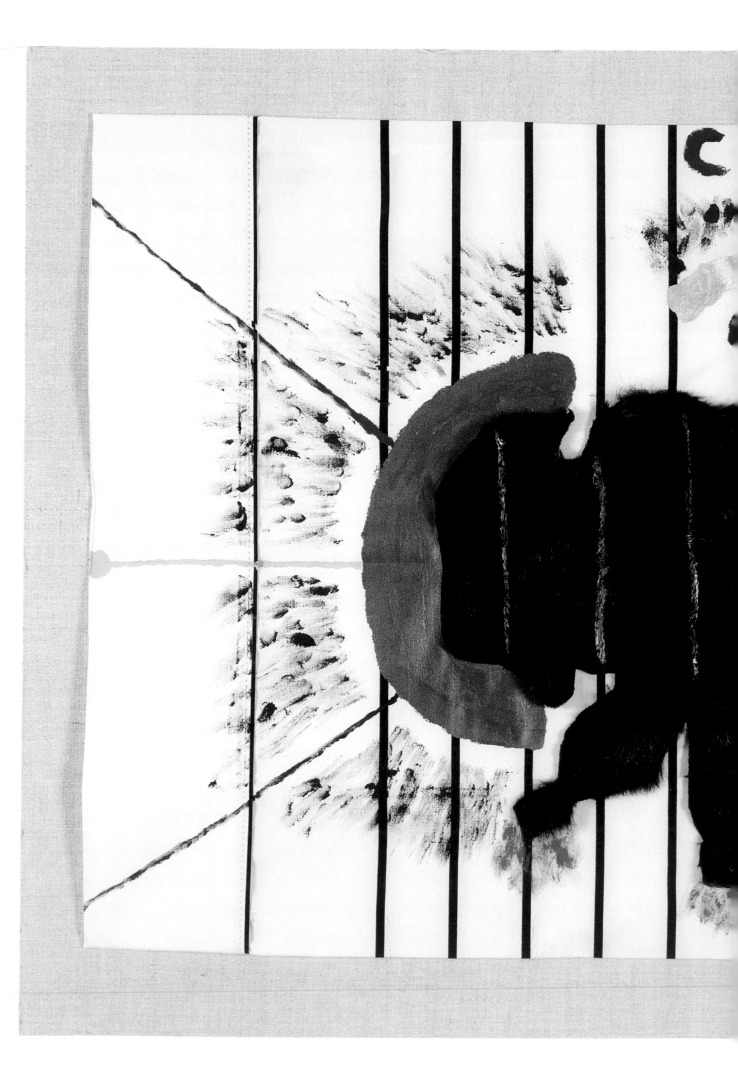

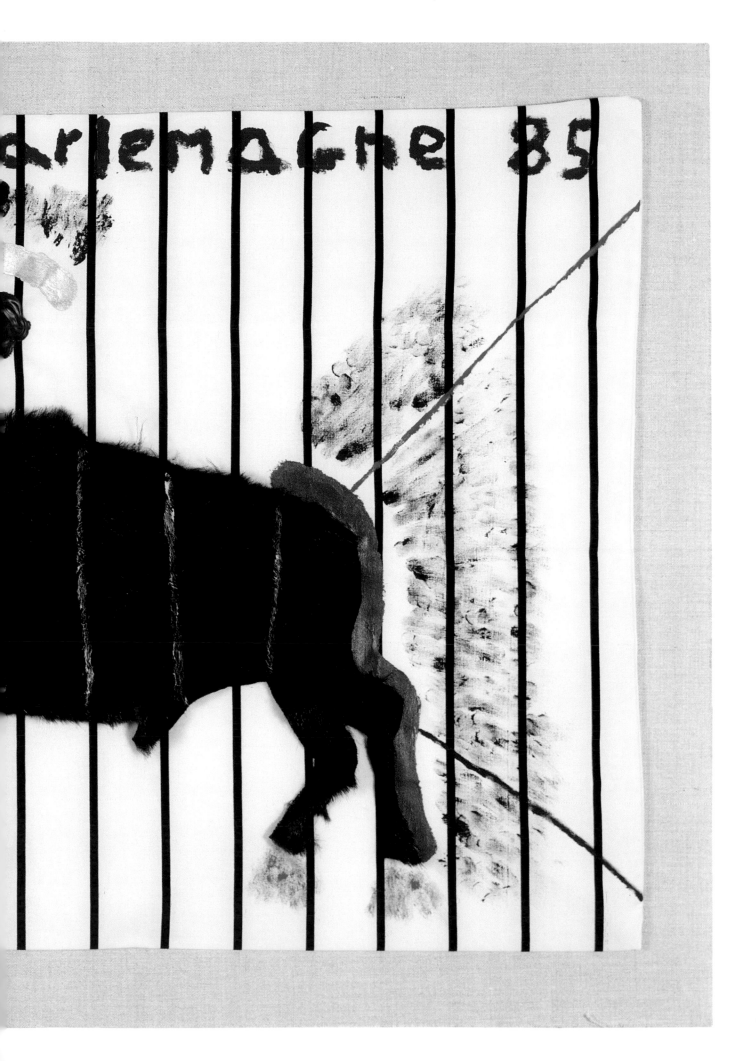

SELECT
EXHIBITIONS
CONCERTS
PERFORMANCES
RECORDINGS
VIDEOS
BIBLIOGRAPHY

162

INDIVIDUAL EXHIBITIONS

2003 *Charleblitz*, L'Atomium, Brussels
2002 *Spectral continuum*, Petit Théâtre Mercelis, Brussels
Raga Todi, Galerie Damasquine, Brussels
Pingmingding, Galerie Lara Vincy, Paris
Je suis le photographe de vos rêves–Blitzkrieg, Musée Nicéphore Niepce, Châlon sur Saône
2001 *D-Day P-Day*, Le Pavé in la mare, Besançon
Galeria Toselli, Milan
Gang Urine 8, Gallery Gangurinn, Reykjavik
2000 Galeries du Cloître, Ecole des Beaux-arts, Rennes
1999 *La beauté et la bête*, Galerie J&J Donguy, Paris (with Dorothée Selz)
Galerie Satellite, Paris
Kepalah & Kuuliah, Galerie l'Aquarium, Ecole des Beaux-arts, Valenciennes
1998 Galerie Gerald Piltzer, Paris
1997 *Bordel Sacré*, galerie l'Aquarium, Ecole des Beaux-arts, Valenciennes
Transmutation des reliquaires sonores, Galerie J&J Donguy, Paris
Photo's Flotsam–Tombs of Bliss, Torch Gallery, Amsterdam
1996 *Bordel sacré*, Duende, Rotterdam
1994 Galerie Calart, Geneva
12ᵉ Foire Internationale d'Art Actuel, Brussels (Wassermann Gallery, Munich)
1993 Fondazione Katinca Prini, Genoa
Are we a family?, Wassermann Gallery, Munich
1992 *Matrimonio di Luisa e Carlo*

Orsacchiotti, Galeria Toselli, Milan
Dubinsky Fine Arts, Zurich
Centre d'arts plastiques, Saint-Fons
1991 *Pianicôns en peluche*, Galerie du Génie, Paris
Hommage à Albert Schweitzer, Galerie Jade, Colmar
Peut-on élever un monument à la douleur?, Musée des Beaux-arts, Dôle
1990 *Temple en peluche*, Boîte Noire, Montpellier
Sacred Toys, Preservation of Old Souls, Torch Gallery, Amsterdam
1989 *Ruah Nefesh: the preservation of old souls at the end of a forgetful century*, Galerie Eric Franck, Geneva; MonteVidéo, Amsterdam
Retour à nos racines, Salon d'Euromedecine, Palais des Congrès, Montpellier
Let's go back to the caves, to hell with white walls, Galerie du Génie, Paris
1986 Gallery Rolf Wernicke, Stuttgart
1985 Gallery Zolla Liebermann, Chicago
1984 *Icônes-Bestiaire*, Galerie Graff, Montréal
1982 *Beastrol icônes*, Galerie Eric Franck, Geneva
Peluch-o-grams, Galerie Eric Franck, Geneva
1981 *Animal Pictogrammes and Musashi Rotors*, Galerie Farideh Cadot, Paris
1980 Galerie France Morin, Montreal
Sound in Mid-air, Galeria Ugo Ferranti, Rome
Plan K, Brussels

1979 *Paper versus Cloth*, the Clocktower, New York
Lapp Drawings, Paint on Cloth, Gallery Engstrom, Stockholm
De Vleeshal, Middelburg
1977 *Drawing versus Book*, 112 Green Street Gallery, New York
1976 Sonnabend Gallery, New York
Galeria l'Attico, Rome
1975 *Une installation sonore*, Galerie Sonnabend, Paris
Stefanotty Gallery, New York
Galerie Gérard Piltzer, Paris
1974 Galerie Sonnabend, Paris
Gallery Oppenheim, Cologne
Galerie D, Brussels
1973 Modern Art Gallery-Lucio Amelio, Naples
1972 Galeria l'Attico, Rome

GROUP EXHIBITIONS

2003 *X-tract sculpture musicale*, Podewil, Berlin
2002 *100 artistes pour les 100 ans de la Ligue des Droits de l'Homme*, Palais de Justice, Brussels
Porto Franco, O'artoteca, Milan
L'art est un jeu?, La Venerie, Brussels
Mu-sique en vue, atelier de l'Union régionale pour le développement de la lithographie d'art (URDLA), Villeurbanne
Outer and Inner Space, Virginia Museum of Fine Art, Richmond
2001 *Belgian System*, Tour & Taxis–Ancien Entrepôt Royal, Brussels
La Fabrique d'anges/The Making of Angels, Atelier 340 Museum, Brussels
2000 *La vérité*, Galerie Hors Lieux, Strasbourg
Canular, INSA, Villeurbanne
Charlemagne 2000, Ludwig Forum Für Internationale Kunst, Aix-la Chapelle
1999 *L'enfance de l'art*, Galerie Piltzer, Paris
Art contemporain, vidéo et cinéma : un choix du Frac Nord/Pas de Calais, Centre culturel Noroit, Arras
Musiques en Scène 99, Musée d'art contemporain, Lyon
Circa 1968, Museu de Serralves, Porto
Illuminations, Castello di Rivoli, Turin
Animal, Musée Bourdelle, Paris
Cream Gallery, New York
1998 *Acquisitions récentes, une sélection d'installations et de vidéos*,

Frac Nord/Pas de Calais, Dunkirk
Dialogues, Galerie Piltzer, Paris
Acts of Faith, Abraham Lubelski Gallery, New York
80 artistes autour du Mondial, Galerie Enrico Navarra, *Paris*
1997 *Animalities*, MonteVidéo, Amsterdam
Espaces Romanesques, Grands bains-douches de la plaine, Marseille et Ancien entrepôt Uniroyal, Brussels
Centrum Beeldende Kunst, Rotterdam
1996 *Klangkunst*, Akademie der Künste, Berlin
1994 *Babies and Bambis*, Foundation Arti&Amecitiae, Amsterdam
Paul McCarthy, Mike Kelley, Charlemagne Palestine, Dirk Larsen, Torch Gallery, Amsterdam
1992 Kunsthistorisches/Naturalhistorisches Museum, Vienna
1991 Atelier Urdla, Villeurbanne
Les artistes décident de jouer, Association Campredon Art et Culture, L'Isle-sur-la-Sorgue
Künsthalle Palazzo Liestal, Bâle
Musée d'art contemporain, Nice
Gallery Barbara Toll, New York
Musée Ruhrland, Essen
Dénonciation, Usine Fromage, Darnétal, Rouen
1990 *La Caravane en peluche*, from Dunkerque to Sète
Propos d'artistes contre le racisme, Art Jonction International, Nice (Galerie Enrico Navarra, Paris)
1989 *Noah's ark*, Fluxusmuseum, Weisbaden

1987 *Nightfire*, De Appel, Amsterdam
Documenta 8, Kassel
1986 *The Brutal Figure: Visceral Images*, Robeson Center Gallery, Rutgers University, Newark
Graff 1966-1986, Musée d'art contemporain, Montréal
1985 *Ripe Fruit*, PS1, New York
1984 Halle Sud, Geneva
Totem, 420 West Broadway
Video: a retrospective 1974-1984, Museum of Modern Art, Long Beach
1982 *60-80*, Stedelijk Museum, Amsterdam
1980 Institute of Contemporary Art, Cincinatti
1979 *New Video (John Caldwell, Peter d'Agostino, Charlemagne Palestine)*, Museum of Art, Long Beach
1978 Moderna Museet, Stockholm
1977 112 Green Street Gallery, New York
10th Biennale, Paris
1976 39th Biennial, Venice
Soho in Berlin, Berlin
1974 *Project 74*, Cologne
Contemporanea, Villa Borghese, Rome

CONCERTS AND PERFORMANCES

2002 Kaaitheater, Brussels
Soirées nomades: Illuminations (with Simone Forti), Fondation Cartier, Paris
2001 *The Gil & Moti Wedding Project*, Hôtel de Ville, Rotterdam
Strumming Music for Bösendorfer, Lantaren Venster, Rotterdam
Charlemagne Palestine et Michael Snow: Concert à deux pianos, Chapelle des Petits-Augustins, ENSBA, Paris
Ertz Festival, Bera
Old Souls Wearing New Clothes, Earational Festival, Het Musiekcentrum, 's-Hertogenbosch
2000 *Electrohappening*, Ecole des Beaux-arts, Rennes
Festival de musique contemporaine pour carillon, Tiergarten, Berlin
Charlemagne at Sonnabend, Sonnabend Gallery, New York
Charlemagne par Charlemagne, The Unhyped History, Belgie Kultuur & Dienstencentrum, Hasselt
Lem Festival, 4th International experimental music festival, L'Espai, Barcelona
Dom Cathedral, Utrecht
Ten Weyngaert, Brussels
Charlemagne 2000, Ludwig Forum, Aix-la-Chapelle
1999 *Musiques en scène*, Musée d'art contemporain, Lyon
Were you there?, Safe Ruimteverhuur, 's-Hertogenbosch et Teschnische Universiteit, Eindhoven
Pan Sonic/Charlemagne Palestine,

Club Roxy, Amsterdam
Circa 1968, Museu de Serralves, Porto
Meltdown Festival, Purcell Room, London
Festival *Freunde Gutte Musik*, Berlin
Toot Festival, Ferens Art Gallery, Hull School of Art and Design, Hull
4 pianoforti, Palazzo delle Esposizione, Rome
1998 Galerie Piltzer, Paris
Festival of Drifting, St. John's Church, London
Concerts miniatures, FRAC Basse-Normandie, Caen
Beyond the PinK Festival, Hollywood Methodist Church, Los Angeles
Atelier Eustachy & Anka Kossakowski, Paris
London Musicians' Collective, Purcell Room, London
L'Apparence des cieux, Auditorium du Louvre, Paris
Rencontre internationale et colloque interactif. Art Action 1958-1998, Le Lieu, Quebec
Night Town, Rotterdam
1997 *L'Aquarium*, Ecole des Beaux-arts, Valenciennes
Festival *Trafic*, Lieu unique, Nantes
Perish Performance-video Festival, Duende, Rotterdam
Center for Electronic Music Studio, Amsterdam
Hommage à Fakir Pandit Pran Nath, Galerie J&J Donguy, Paris
Le Fait du Prince, les représentations

du pouvoir au cinéma, Auditorium du Louvre, Paris
Soirées nomades (The Phoenix slowly rises), Fondation Cartier, Paris
Scratch Projection, autour de Charlemagne Palestine, L'Entrepôt, Paris
1996 Kunst-Station, Sankt Peter, Cologne
Sauschdall, Ulm
Festival *Sonambiente*, Berlin
Festival *Impakt*, Utrecht
1993 *Visioni di sculture musicali in movimento*, Fondazione Katinca Prini, Genoa
1990 *Nounours & cotillons*, Galerie du Génie, Paris
1988 *Performance in NRW*, Bonn, Essen, Cologne
1983 Eonta Space, New York
Institut Franco-Américain, Rennes
1980 *Tickets to Nowhere*, 80 Langton Street, San Francisco
1979 *Forum Audiovisueel 2*, Vleeshal, Middelburg
Hallwalls Gallery, Buffalo University
New Music America, Chicago
New Music-New York, the Kitchen, New York
NHK, Farmsum
Gemeentemuseum, Arnhem
Lontaren Venster, Rotterdam
Stedelijk Museum, Amsterdam
Corps de Garde, Groningen
Belgrade University
1978 Seattle Institute of Art
De Appel, Amsterdam
Corps de Garde, Groningen

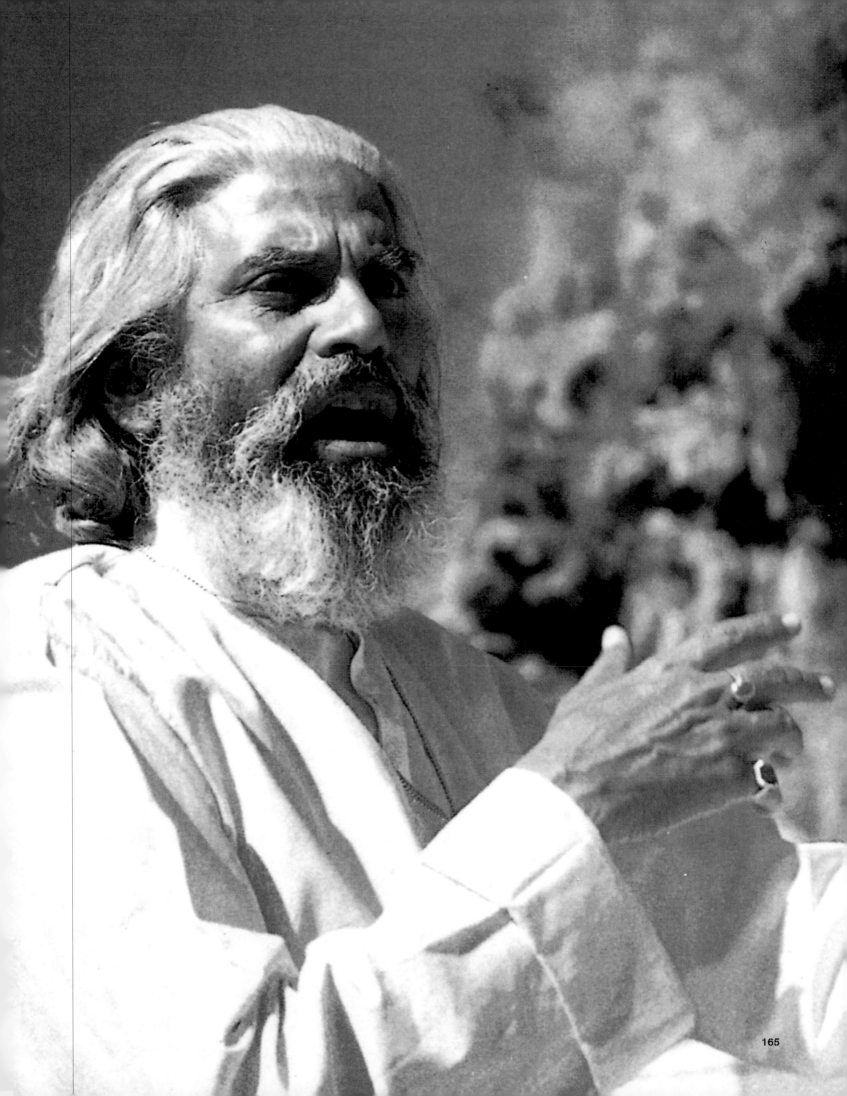

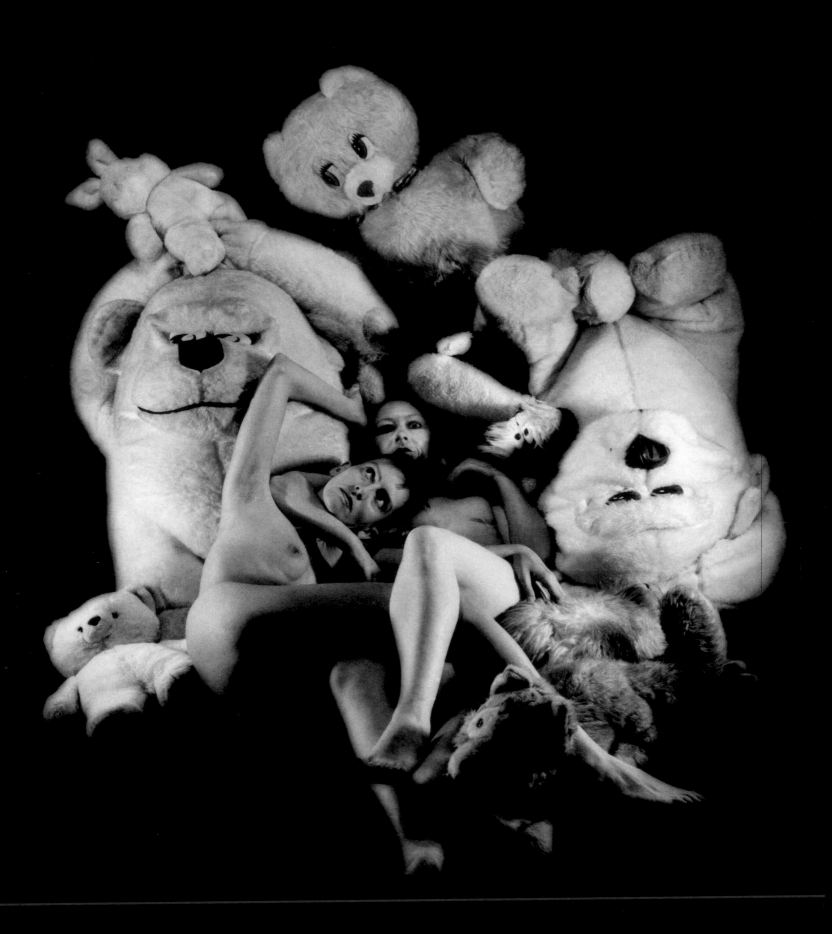

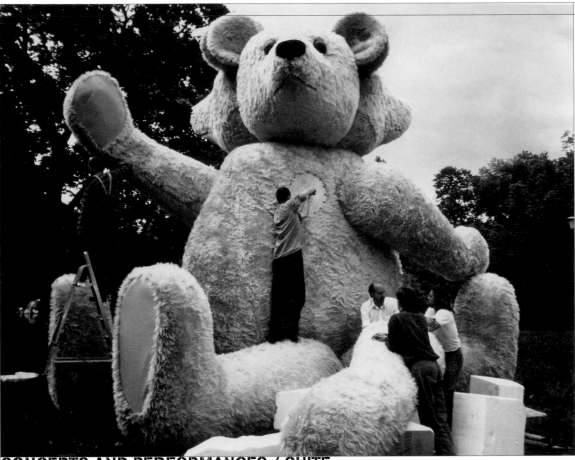

CONCERTS AND PERFORMANCES / SUITE

Performance Workshop, Tweed
Courthouse, New York
Performance Festival, Graz University
Belgrade University
International Performance Festival,
Österreichisscher Kunstverein, Vienna
1977 *03 23 03*, Premières rencontres
internationales d'art contemporain,
Montreal
Galleria Communale d'Arte Moderna,
Bologna
Documenta 6, Kassel
Chant a Capella, Judson Church,
New York
San Fransisco Conservatory of Music
Portland Art Center
Sonnabend Gallery, New York
Westertoren, Amsterdam
De Appel, Amsterdam
Stedelijk Museum, Amsterdam
Corps de Garde, Groningen
1976 Venice Biennial
Pro Musica Nova, Bremen
Walker Art Center, Minneapolis
Soho in Berlin, Academie der Kunste,
Berlin
A Space, Toronto
York University, Toronto
Belvedere Festival, Florence
Festivale Parcheggio, Rome
Kunstmesse, Cologne
Louisiana Museum, Humlebaek
Grommets, 537 Broadway, New York
Bösendorfer Festival, New York
University
1975 Modern Art Agency, Naples

Galerie Gérald Piltzer, Paris
Festival d'*Art à la Bastille*, Paris
CAPC, Bordeaux
Musée d'Art Moderne de la Ville de Paris
Oberlin College, Cleveland
Idea Warehouse, New York
Sonnabend Gallery, New York
Oppenheim Gallery, Cologne
ICC, Anvers
Saint Mark's Church, New York
Judson Church, New York
Merce Cunningham Studio, New York
New Music, The Kitchen, New York
Houston Museum of Art
Dalhousie University, Halifax
Nova Scotia College of Art and Design,
Halifax
1973 Mills College, Oakland
Vanguard Theater, Los Angeles
San Francisco Art Institute
Festival d'Automne, Musée Galliera, Paris
California Institute of the Arts, Valencia
Grand Union Dance Gallery, New York
Stefanotty Gallery, New York
Palais des Beaux-arts, Brussels
East/West Festival, Rome
Galeria L'Attico, Rome
Stefanotty Gallery, New York
Palais des Beaux-arts, Brussels
FIAC, Paris
Project 74, Kunstverein, Cologne
Oppenheim Gallery, Cologne
Byrd Hoffman Foundation, New York
Sonnabend Gallery, New York
Idea Warehouse, New York
New Music, the Kitchen, New York

Nova Scotia College of Art and Design,
Halifax
1972 Buchla Associates, Oakland
Ann Halperin Dancer's Workshop,
San Fransisco
American Arts Festival, Rome
Galeria L'Attico, Rome
University of Southern California, Irvine
University of Southern California,
San Diego
California Institute of the Arts, Valencia
Free Music Store, WBAI, New York
1971 *Electronic Music Marathon*,
Los Angeles
Radio Station KPFK, Los Angeles
Unitarian Church of North Hollywood,
Los Angeles
California Institute of the Arts, Valencia
Acme, New York
Pasadena Art Museum, Pasadena
Galeria L'Attico, Rome
1970 McMillan Theater, Columbia University,
New York
Free Music Store, WBAI, New York
California Institute of the Arts, Valencia
Unitarian Church of North Hollywood,
Los Angeles
1969 *Free Music Store*, WBAI, New York
Manhattan School of Music, New York
American Dance Festival, New York
NY University DanceTheater, New York
1968 McGill University, Montréal
1967 Pratt Institute, Brooklyn, New York
Mannes College of Music, New York
McGill University, Montréal
1965 NY University DanceTheater, New York

VIDÉOS

2001 *Rituels dans le vide*, Centre International de Création Vidéo-Pierre Schaeffer, Hérimoncourt, 44:40 min., colour, stereo

2000 *Sacré Asnières*, CICV-Pierre Schaeffer, Hérimoncourt, 19:00 min, colour, stereo
Satyre du parking, production CICV-Pierre Schaeffer, Hérimoncourt, 3:00 min, colour, stereo

1989 *Retour à nos racines*, Monades Light, Montpellier, 480:00 min, colour, stereo
Preservation of old souls at the end of a forgetful century, Netherlands media art institute-MonteVidéo, Amsterdam, 60:00 min, colour, stereo

1979 *Dark into Dark*, Jude Quintiere & Composers Forum, New York, 19:28 min, colour, stereo

1977 *Where It's Coming From*, with Wies Smals, De Appel, Amsterdam, 56:50 min, black and white, stereo

1976 *Island Monologue*, Castelli-Sonnabend, New York, 15:05 min, black and white, sound
Island Song, Castelli-Sonnabend, New York, 16:29 min, black and white, sound

75-76 *Andros; an escapist primer*, Castelli-Sonnabend, New York, 57:13 min, black and white, sound

1975 *Internal Tantrum*, Castelli-Sonnabend, New York, 7:35 min, black and white, sound
Running Outburst, Castelli-Sonnabend, 5:56 min, black and white, sound
St. Vitas Dance, Oppenheim Studio, Cologne, 8:50 min, colour, sound
You Should Never Forget the Jungle, Oppenheim Studio, Cologne, 11:09 min, colour, sound

1974 *Body Music II*, Art/Tapes/22, Florence, 7:51 min, black and white, sound
Four Motion Studies, Castelli-Sonnabend, New York, 13:24 min, black and white, sound
Snake, Castelli-Sonnabend, New York, 10:43 min, black and white, sound

1973 *Body Music I*, Art/Tapes/22, Florence, 12:39 min, black and white, sound

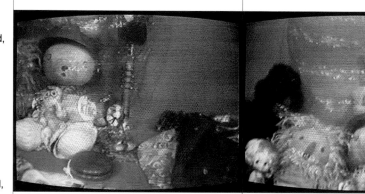

DISCOGRAPHY FILM SOUNDTRACKS MULTIPLES

DISCOGRAPHY

2003 *Golden 3 (in mid air)*, Alga Marghen, Milan

2002 *Maximin* (remix of David Coultier and Jean-Marie Mathoul), Young God Records, Brooklyn, New York
Negative Sound Studies, Alga Marghen, Milan (vinyl, limited edition)

2001 *Music for Big Ears*, Staalplaat, Amsterdam
Karenina, Durtro, London
Charlemagne at Sonnabend, Sonnabend Gallery, New York

2000 *Golden 2 (Continuous Sound Forms)*, Alga Marghen, Milan
Erratum #3, Erratum Musical, Besançon (compilation)
Jamaica Heinekens in Brooklyn, Barooni Records, Utrecht
Golden 1 (Alloy), Alga Marghen, Milan
Holy 1 & Holy 2, Alga Marghen, Milan (vinyl, limited edition)
Schlongo! daLUVdrone, Cortical Foundation, Malibu
Mort aux vaches (with Pan Sonic), Staalplaat, Amsterdam (limited edition)

1999 *Schlingen-Blängen*, New World Records, New York
Hommage à Faquir Pandit Pran Nath, ADLM, Paris (limited edition)
La Beauté et la Bête, J&J Donguy, Paris (limited edition)
Because tommorrow comes #2, Cologne (compilation)

1997 *God Bear*, Barooni Records, Utrecht
Three compositions for machines, Staalplaat, Amsterdam

1996 *Four Manifestations on Six Elements*, Barooni Records, Utrecht
Halana, Cortical Foundation, Malibu (compilation)

1995 *Strumming Music*, Felmay Records, San Germano

1976 *Strumming Music*, Shandar, Paris (vinyl)

1973 *Four Manifestations on Six Elements*, Sonnabend Gallery, New York (vinyl)

FILM SOUNDTRACKS

2002 Pip Chodorov, *Charlemagne 2: piltzer*, 16 mm, 22:00 min, optical sound

2001 Moira Tierney, *American Dreams #3*, 16 mm, 5:00 min, optical sound

MULTIPLES

1996 *Kepalah & Kuuliah*, silk screen printing on glossy paper, 60x80 cm, edition of 30, in wooden box 62x82x6 cm, Editions de l'Aquarium agnostique, Valenciennes

1991 *00*Atah*, lithograph on vellum, 65x50 cm, edition of 19 copies, atelier de l'Union Régionale pour le Développement de la Lithographie d'Art (URDLA), Villeurbanne

Soup and Tart

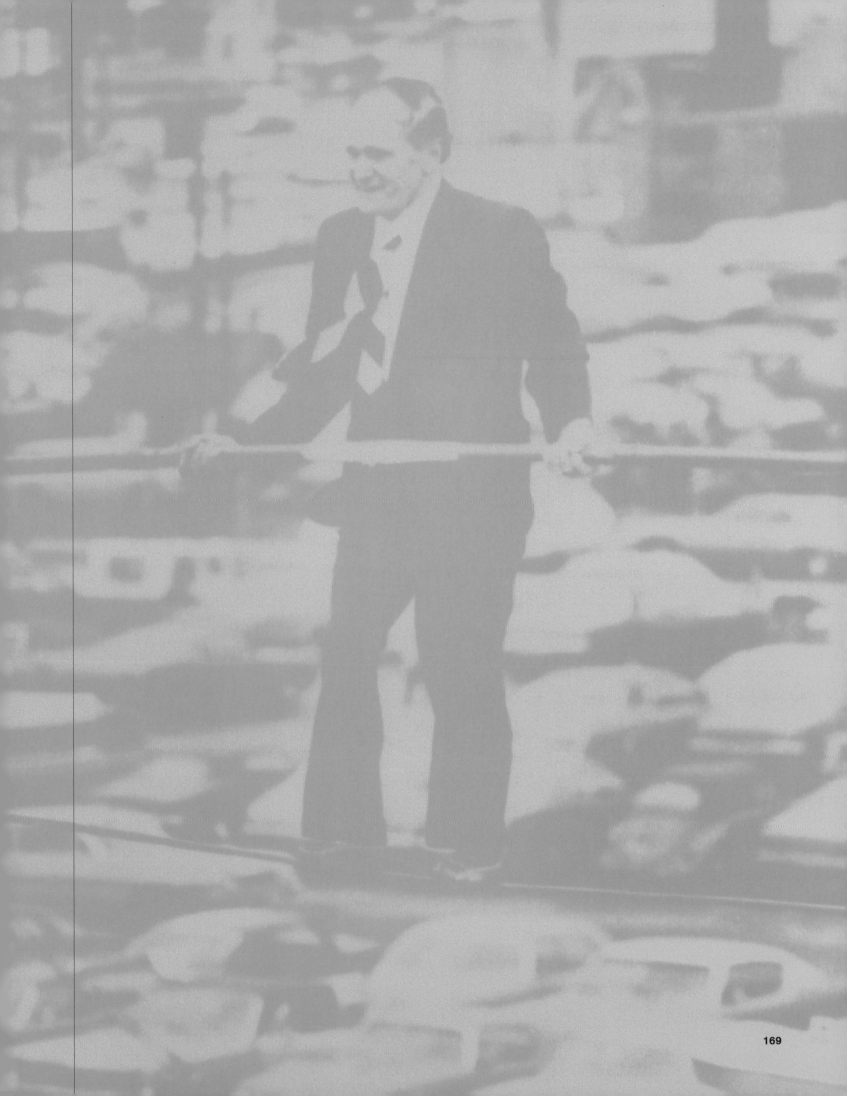

BIBLIOGRAPHY

PRESS

2002 FRANCK Philippe, "Palestine, l'enfant terrible des maxi-minimalistes", in *DDO*, Roubaix, no. 48, July-August
PONTEGNIE Anne, "Exposition à la galerie Damasquine, Brussels", in *ART-FORUM*, New York, no.1, September
GRAY Louise, "Invisible Jukebox: Charlemagne Palestine", in *The Wire*, London, no. 223, September
RÜELL Niels, "Hergés Favoriete Klokkenluider", in *De Standaard*, Brussels, 31 August
GRAY Louise, "Charlemagne Palestine, Music for Big Ears", in *The Wire*, London, no. 221, July

2001 DIEDERICHSEN Diedrich, "Minimalisten und alter Cognac", in *Der Tagesspiegel*, Berlin, 6 January
GHOSN Joseph, "La Ruée vers l'oreille", in *Les Inrockuptibles*, Paris, January
FRANCK Philippe, "Sampler de muta-tions Electro-soniques", in *Mouvement*, Paris, no. 14, October-December
BOON Marcus, "Pandit Pran Nath: Infinity's Pathfinder", in *The Wire*, London, no. 221, September
"Charlemagne Palestine, The Golden Research 1: Alloy; The Golden Research 2: Continuous Sound Forms", in *The Wire*, London, Summer

2000 DAL SOLER Gino, "The God Bear", in *Blow Up*, Bologna, no. 28, September
ZAGORSKI William, "Schlingen-Blängen", in *Fanfare*, Tenafly, January-February
KOETHER Jutta, "Music: Figure of Note. Charlemagne Palestine", in *ARTFORUM*, New York, no. 8, April
MALLET, Franck, "Schlingen-Blängen", in *Le Monde de la musique*, Paris, no. 239, January
GRAY Louise, "Schlingen-Blängen", in *The Wire*, London, no. 190/191
GANN Kyle, "Blast from the Past: History, a/k/a Charlemagne Palestine, Returns", in *The Village Voice*, New York, October

1999 DUGRE Françoise, "Art-action, entrevue de Charlemagne Palestine", in *Inter Art Actuel*, Québec, no. 73, Spring-Summer
MARTEL Richard, "Art-action, le perfor-matif", in *Inter Art Actuel*, Quebec, no. 73, Spring-Summer
VAN HOOF Marine, "Rencontre interna-tionale et colloque interactif. Art Action 1958-1998", in *Parachute*, Montreal, no. 93, January-February-March
LASTELLA Aldi, "Il piano di Palestine oltre il muro del suono", in *La Repubblica*, Rome, 19 November

1988 PINSET Ed, "London Musicians' Collective's Seventh Annual Festival of Experimental Music", in *Resonance Magazine*, London, June
SWED Mark, "Wishing He Would Just Drone On and On", in *The Los Angeles Times*, Los Angeles, 16 February
GIOVANELLI Jean-Pierre, "Tous les jours je me demande ce qu'il y a d'important dans ma vie", in *Flux News*, Liège, no. 15, February
MARSHALL Ingram, "Who's Afraid of Charlemagne Palestine", in *Schwann Opus*, Santa Fé, summer
ALBERTS Armeno, "The poet of Minimalism", interview in *Centre for Elektronic Music Bulletin*, vol. 13, no. 3, Amsterdam, December
SHAPIRO Peter, *The Wire*, in *Halana Magazine*, Ardmore, no. 3, October

1997 SUZUKI Dean, "Four Manifestations on Six Elements", in *Wired*, New York, May
MALLET Eric, "Strumming Music", in *Le Monde de la musique*, Paris, no. 213, September
JURGA Antoine, "Et tout le monde il est bordeliste", in *DDO*, Roubaix, July-August
LICHT Alan, "Minimalism: The Next Ten", in *Halana*, Ardmore, vol. 1, no. 3, winter
MALAM Jeanette, "Charlemagne Palestine: Bordel sacré", in *Nord Eclair*, Valenciennes, 25 May
MALAM Jeanette, "Vidéo, Arts Plastiques, Musique se côtoient", in *Nord Eclair*, Valenciennes, 29 and 30 June
NOGENT Christian, "Charlemagne est parti, l'école est finie", in *La Feuille d'Annonces*, Valenciennes, 1 August
PALESTINE Charlemagne, "Schlingen Blängen", in *Halana*, Ardmore, vol. 1, no. 3, Winter
PLICHON Jean-Paul, "Le Bordel sacré à l'Aquarium. Tout un programme", in *La Voix du Nord*, Valenciennes, 31 May
"Bordel sacré", in *La Voix du Nord–Evasions*, Lille, 4 June
PLICHON Jean-Paul, "L'enfance de l'art de Charlemagne Palestine", in *La Voix du Nord*, Valenciennes, 18 June
"Charlemagne Palestine", in *Regards*, Valenciennes, no. 4, June-August

1996 DELLES Thierry & NOETINGER Jérôme, "Peluche", in *Revue corrigée*, Grenoble, March
DUGUID Brian, "Charlemagne Palestine", in *Est 7*, London, April
LORRAI Marcello, "Strumming Music, Il disco di Charlemagne Palestine edito da New Tone", in *Flash Art*, no. 189, Milan, June-July
POUNCEY Edwin, "Four Manifestations on Six Elements (Barooni)", in *The Wire*, London, August
POUNCEY Edwin, "Divine Insurrection", in *The Wire*, London, December
SMITH Ben, "Four Manifestations on Six Elements (Barooni)", in *Magic Feet*, London, July
SPEKLE Roland, "Charlemagne Palestine", in *Sonic Death*, San Francisco, no. 7, 15 January
"Four Manifestations on Six Elements (Barooni)", in *Muzik*, London, July
"Four Manifestations on Six Elements (Barooni)", in *Top*, London, September
"Four Manifestations on Six Elements (Barooni)", in *Mojo*, London, November
CERNOTTO, Andrea "Charlemagne Palestine, lo sciamano ritrovato", in *Oltre il silenzio*, October, no. 2, Rome

1993 SCIACCALUGA Maurizio, "Charlemagne Palestine", in *Segno*, Pescara, March, no. 122

1992 AINARDI Dolène, "Charlemagne Palestine", in *artpress*, no. 175, Paris, December
BOST Bernadette, "En attendant God Bear, le dieu des ours", in *Le Monde*, Paris, 24 October
GABRIEL Nelly, "La tribu des peluches", in *Le Figaro*, Lyon, 9 October
GUEHENNEUX Lise, "Charlemagne Palestine", in *Révolution*, Paris, November
MULLER Elisabeth, "Pluschweit gegen die rohe Aktualität: Palestine, Jan Worst und Martin Fengl", in *Abendzeitung*, Münich, 5 November

1991 LERRANT Jean-Jacques, "Jouets d'artistes", in *Le Monde*, Paris, 28 August
VAUTIER Ben, "Charlemagne Palestine", in *La Revue de Presse de Ben*, Nice, March

1990 CAZARD Xavier, "Le déraciné de Brooklyn", in *L'Image Vidéo*, Montpellier, February-March
CORBOU Michel, "Ethnologie Cinema Project", in *Pixel*, Paris, April
CORBOU Michel, "Video-Surprise, Montpellier", in *Contemporanea*, New York, March
DREYFUS Charles, "Vidéo viscères", in *Kanal Magazine*, Paris, no. 4, January
OTT Lise, "Charlemagne Palestine: L'art et l'humain", in *Calades*, Nîmes, January
"Culture de racines", in *Reflex*, Paris, March-April
"L'anti-clip de nos racines", in *Video Camera*, Montpellier, January
"Monades light en vidéo art majeur", in *Midi-Libre*, Montpellier, July
"L'art mimile attaque !", in *NewLook*, Paris, September

1989 AINARDI Dolène, "Charlemagne Palestine à la galerie Eric Franck, Genève", in *artpress*, Paris, no. 134, March

1987 SCHWARZE Dirk, "Im Schutze des Bären", in *Stadt Kassel*, Kassel, 19 June
"Riesenteddybär als Symbol des Friedens", in *Heidenheimer Zeitung*, Heidenheim, 2 July
"Für Palestine's Teddy kein ehrenhafter Platz", in *HNA*, Kassel, 3 July
"Der Teddybär wird fast zu Tode geliebt", in *HNA*, Kassel, 8 July
"documenta-Macher wollen Teddy verschwinden lassen", in *HNA*, 26 July
BABIAS Marius, "Der Bär ist los", in *taz*, Kassel, 16 September

1985 STALDER Anselm, "Charlemagne Palestine", in *Flash Art*, International Edition, Milan, no. 121, March
BEAUDET Pascale, "Charlemagne Palestine, Galerie Graff", in *Vanguard*, Vancouver, February

1983 PALESTINE Charlemagne, "Palestine par Palestine: Oolahgaboo", in *Halle Sud*, Genève, no. 1
"Shlingen beastra blängen", in *Perfo Festival*, Rotterdam
MORTIFOGLIO Richard, "Charlemagne Palestine's Badass Formalism", in *The Village Voice*, New York

1982 STRASSER Catherine "Palestine à la galerie Farideh Cadot, Paris", in *Flash Art*, Milan, no. 105, December-January
VON SCHIER Bonnie, "Charlemagne Palestine, galerie Eric Francke", in

BIBLIOGRAPHIE

artpress, Paris, no. 59

1979 PALMER Robert, "Piano: Palestine Shows his Massed Harmonics", in The New York Times, New York, 26 February
"Multimedia-installatie Charlemagne Palestine", in PZC/kunst/binnen-buitenland, Middelburg
MASSIN Brigitte, "Les pianos-cloches de Charlemagne Palestine", in Le Matin, Paris, 6 November
BOS Eric, "Minimal music op orgel in Farmsum", in Nieuwsblad van het Noorden, Groningen, 24 October

1979 "Charlemagne Palestine", in Genève 7 jours, 13-14-15 May

1977 JOHNSON Tom, "Charlemagne Palestine Ascends", in The Village Voice, New York, 18 April
HEG Hans, "Charlemagne Palestine bezeten fenomeen", in De Volkskrant, Amsterdam, 23 May

1976 TRINI Tommaso, "Charlemagne Palestine", in Data, Milan, May-June
BELL Jane, "Charlemagne Palestine", in Arts Magazine, New York, March
GERVAIS Raymond & PONTBRIAND Chantal, "Charlemagne Palestine", in Parachute, Montréal, no. 5, winter
ROCKWELL John, "Charlemagne Palestine at Bösendorfer fête", in The New York Times, New York, 8 November
JOHNSON Tom, "Music", in High Fidelity/Musical America, New York, February
JOHNSON Tom, "Experimental Music Takes a Trip to the Art World", in The New York Times, New York, 5 December

1975 FINN Robert, "Palestine Sounds are Chemistry of Tone", in Cleveland Plain Dealer, Cleveland

1974 BORDEN Lizzie, "The New Dialectic", in ARTFORUM, New York, March
JOHNSON Tom, "Meditating on the Run", in The Village Voice, New York, 31 January
ROCKWELL John, "Music: Aborted Recital", in The New York Times, New York, 29 January

1973 "Simone Forti & Charlemagne Palestine", in L'art vivant, Paris, no. 43, October
MARSHALL Ingram, "Charlemagne Palestine, Proselyte of the New Harmony", in Sounding Magazine, Saugus

1972 BARBER Nancy, "After a Charlemagne Palestine Experience", in The Soho Week News, New York
HITTNER Amy, "Entretien avec Palestine", in arTitudes, Paris

1970 MARSHALL Ingram, "Charlemagne's Environnements", in The Free Press, Los Angeles, 20 November

CATALOGUES/PUBLICATIONS

Les années 70. L'art en cause, Maurice Fréchuret, Bordeaux: Editions du CAPC Musée d'art contemporain/RHN, 2002

Mu–sique en vue, Jean-Yves Bosseur, Pierre Alain Jaffrenou, James Giroudon, et al, Villeurbanne: URDLA, 2002

Vidéo, un art contemporain, Françoise Parfait, Paris: Regard, 2001

Jeune, pure et dure, une histoire du cinéma d'avant-garde et expérimental en France, Cinémathèque Française, 2001

La performance du futurisme à nos jours, Roselee Goldberg, Paris/London: Thames & Hudson, 2001

Charlemagne Palestine, Franco Toselli, Milan: Editions Toselli, 2001

L'enfance de l'art, Paris: Galerie Piltzer, 2000

Animal, Jean Albou et Pascal Bonafoux, Paris: Paris musées et Somogy, 1999

4 pianoforti, Fabio Sargentini et Paolo Coteni, Rome: Palazzo delle Esposizione, 1999

Musiques en scène, Thierry Raspail, Richard Robert, Lyon: Musée d'art contemporain et GRAME, 1999

80 artistes autour du Mondial, Nicolas Bourriaud, Henri-François Debailleux, Pierre Restany, et al, Paris: Galerie Enrico Navarra, 1998

Cloches et Carillons, Pierre Berthet, Brussels:Tradition Wallonie, 1998

Acquisitions récentes, text by Catherine Legallais, Frac Nord/Pas de Calais, Dunkerque, 1998.

Klangkunst, Berlin: Prestel–Verlag, Munich and Akademie der Künste, 1996

Charlemagne Palestine, Josselyne Naef, Saint-Fons: Centre d'arts plastiques, 1992

Kitsch-Art, Wie Kitsch zur Kunst wird, Gregory Fuller, Cologne: DuMont Buchverlag, 1992

Les artistes décident de jouer, Marie-Victoire Poliakoff, Bertrand Lorquin and Pascal Bonafoux, L'Isle-sur-la-Sorg ue: Association Campredon Art et Culture, 1991

Agathe Coutemoine, Alfred Wirz, Charlemagne Palestine, Hedy Graber, Niggi Messerli, Philip Ursprung, Liestal: Kunsthalle Palazzo, 1991

Sacred Toys, The preservation of old souls, Charlemagne Palestine and Hendel Teicher, Geneva: Galerie Torch, Amsterdam and Galerie Eric Franck, 1990

The Voice of New Music: New York City 1972-1982, Tom Johnson, Eindhoven: Het Apollohuis, 1989

The Brutal Figure: Visceral Images, Alison Weld, New Jersey: Robeson Center Gallery, 1986

Graff 1966-1986, Montreal: Musée d'art contemporain

Video: a retrospective, 1974-1984, Kathy Rae Huffman, Bill Viola, Barbara Hendrick, Long Beach: Long Beach Museum of Art, 1984

80 Langton Street Residence Program, San Francisco: Ingram Marshall, 1981

Scores: an Anthology of New Music, Roger Johnson, New York: Schirmer Books, 1981

Collective Consciousness, Art Performances in the Seventies, ed. Jean Dupuy, New York: Performing Arts Journal Publications, 1980

Performance by Artists, ed. AA Bronson and Peggy Gale, Chantal Pontbriand, France Morin, et al, Toronto: Art Metropole, 1979

03 23 03, Normand Thériault, Chantal Pontbriand, Jean-Christophe Amman, Germano Celant, Thierry de Duve, et al, Montreal: Médiart et Parachute, 1977

Desert Plants-Conversations with 23 American Musicans, Walter Zimmerman, Vancouver: Aesthetic Research Center of Canada Publications, 1976

East-West Music: La Monte Young, Phil Glass, T R Mahalingam, Charlemagne Palestine, Pandit Pran Nath, T N Ramachandra Iyer, Terry Riley, Daniel Caux, David Reck, Mahalingam, Charlemagne Palestine, Rome: L'Attico, 1974

Charlemas

L.A.

Sonecous

Palestine
1971

NYC

Book Ends

174

THE QUEST FOR THE SONOROUS ABSOLUTE

GUY DE BIÈVRE

THE

American composer/performer Charlemagne Palestine is one of the exponents of what was known in New York City in the late 1960s and 70s as "the downtown new music scene". Along with colleagues Phill Niblock, Jon Gibson, La Monte Young, Bill Hellermann, Tony Conrad, RIP Hayman, Yoshi Wada and Phil Corner—each in their own way—he followed the minimalist road into territories much more adventurous than those charted by composers such as Steve Reich or Philip Glass. He chose to subject minimalist concepts to extreme physical endurance and intense acoustic explorations; blurring the border between concert and performance and ultimately disembodying the sonorous event from the performer and his instrument.

The main chronicler of the downtown music scene, composer Tom Johnson, wrote in 1977 in the *Village Voice* after a Charlemagne Palestine concert: "The piece is, admittedly, not a pretty thing to witness, and I'm not even sure that I like it myself. It is more frightening than anything else. But it seems important because it goes so far." [1] And Palestine's music usually goes as far as he can lead it, reaching for that elusive golden sound. The only true Palestine experience is, without a doubt the live concert; for recordings, however perfect, remain surrogates when it comes to acoustic events. Still, they exist and can be heard as privileged moments in Palestine's quest. Considering the often monomorphic character of his works, it is challenging to subject them to some sort of formal musical analysis.

... in California I came up with the feeling that I was like an alchemist, and I was searching for the golden sound. And like every year it becomes another way of doing it. [2]

New York City, 1967: A C# sawtooth wave strolls along with some other approximately tuned electronic tones; never further from each other than a major second; tense, but always at a safe distance. Together, they form an apparently steady cluster named *Holy 1*; but, actually, a lot is happening and what we hear is more like a swarm of microscopic action. 30 minutes later, *Holy 1* has transmuted into *Holy 2* and the same C# from the beginning—it's been there all the time—is now rubbing shoulders with a dissonant gang of minor seconds, as close a one can get in the well-tempered world.

Brussels, 2002: When asked about what he considers as having changed in his music between the early 70s and now, Charlemagne Palestine, illustrating the evolution on his Bösendorfer Imperial, says that he's become more comfortable with dissonance. The 35 year span from *Holy 1* to *Holy 2* on the piano keyboard seems like a very long time, but then very long times are a key parameter in Charlemagne's music.

Reducing Charlemagne's musical history to a gradual narrowing of intervals would be oversimplifying—missing the point(s). Besides, there was always dissonance in his work. During a 1975 conversation with the German composer Walter Zimmermann he says, "Actually, my music is becoming more dissonant. It was very dissonant around 1968 and 1969. In 1970 it became more sonorous... and now again it's getting into more dissonance."[3] So, it seems to be an ongoing story: reaching out for dissonance, as the place where it all happens, where music turns into some sort of energy, becoming something bigger than the sum of the parts. Each time he would either burn his fingers or come very close to turning lead into gold, but not yet.

Another work from the late 60s has some of the same ingredients. Its score reads like a recipe that does not exactly give away what the performer is supposed to end up with. This score, (*Sonority A vs. Sonority B*, 1968), tells the performer to play three notes (*Sonority A*)—each a whole step apart—simultaneously in a pattern of continuous eighth notes for approximately five minutes at a tempo of 116 bpm.[4] The natural momentum of the body should decide whether the tempo speeds up or slows down. After the decay and a silent break, the same instructions are applied to *Sonority B* (a major 7th higher) and then, finally, for ten minutes both 'sonorities' are played twice as fast in an alternating pattern. The score also indicates that the sustain pedal should be depressed all the way. It is all very simple, in a true minimalist vein. The third part, with the alternating 'sonorities', is where it all happens; where dissonance and resonance reach a complexity that is not mentioned in the score.

In *Holy 1* and *2* we merely see the prototype (or its recorded trace) of a possible frame. Some of them are already there, but a number of essential characteristics are missing, the main one being physicality. The only physicality we get is that of the interaction in space of electronic sounds. Pitches are separated over the two stereo channels, with a lot of acoustic interaction happening away from the loudspeakers. It is quite crude and, even at high volume, weak, compared to what is to come: the physicality of acoustic sound almost to a point of tangibility, the liquefaction of solids (very solid concert grands) and the corporality of the performer. In *Holy 1* and *2* he is not really present, merely slowly turning knobs, while later, according to the legend, there'd be blood on the keys. We can, in retrospect, imagine *Sonority A vs. Sonority B* being performed by Palestine, with the closing sentence of the score "Dynamics and touch are up to the pianist,

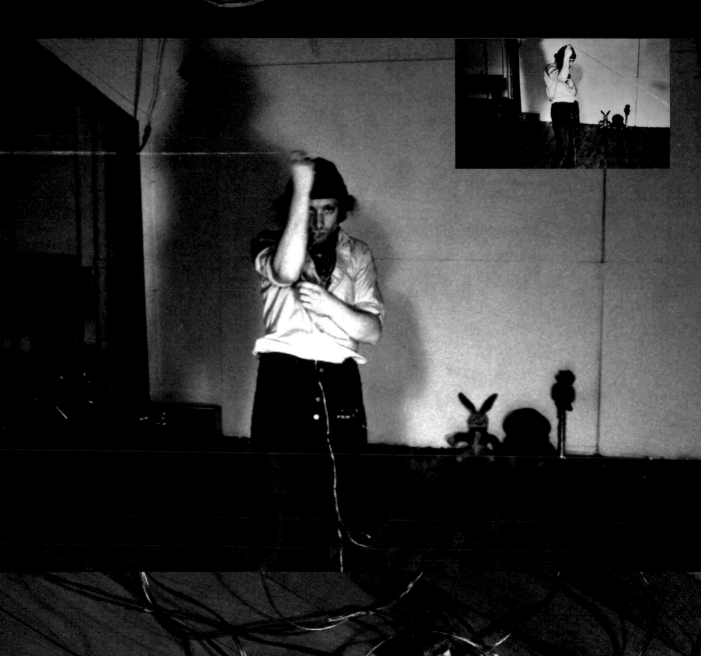

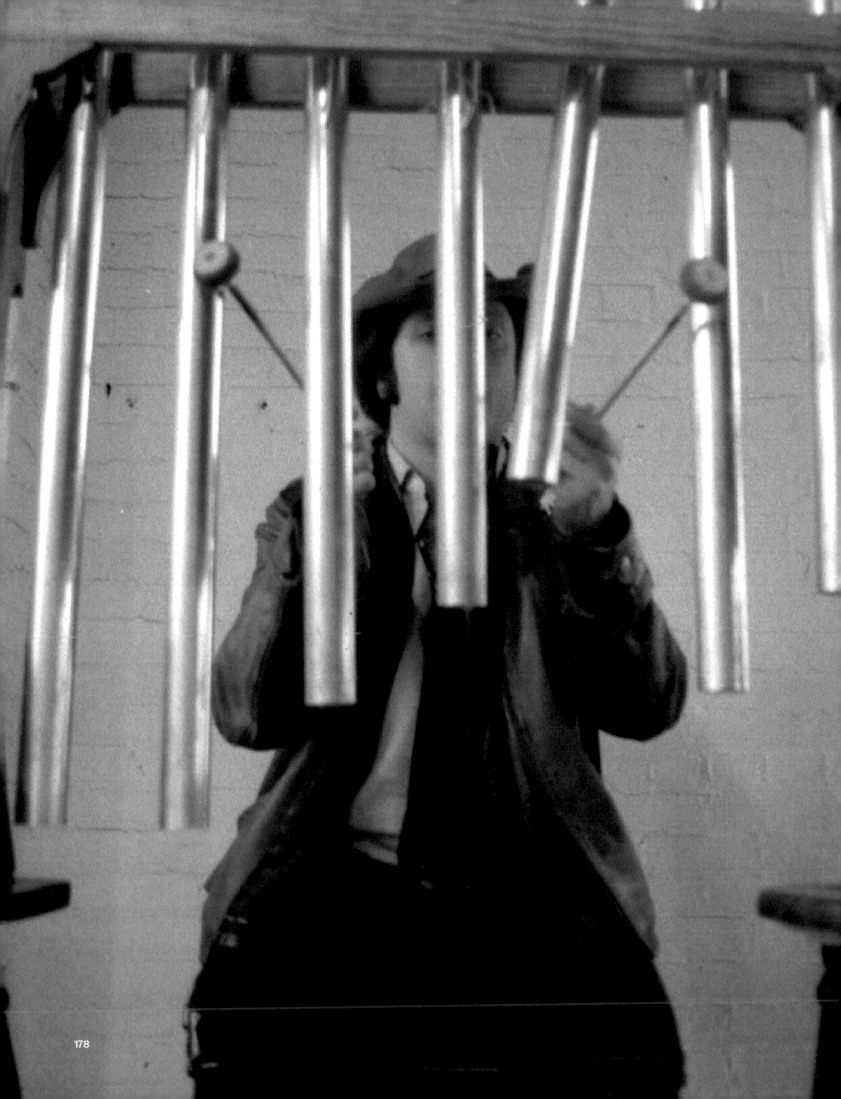

naturalness being preferred to contrivity throughout", guaranteeing some of the intensity required to 'make it happen'.

We find the composer further researching the tools needed for his quest in the vocal works from 1970: *Overtone Study for Voice* and *Overtone Study with Cigarette*. Upon reading the instructions: "Sing a sustained ah on one pitch, holding your breath as long as possible. While maintaining the same pitch begin exploring all the possible fluid changes of shape your mouth, tongue and lips can create..."we may be tempted to see the pieces as escapades into Fluxus territory, but some details are Charlemagne Palestine essentials: "Begin simply, becoming more complex later on.... For best results sing this study in a reverberant room.... This study is about endurance as well as sound."[5] Later on, the original *Overtone Study* is expanded in the compositions, *Singing on the Run*, 1972 and *Singing against the Wall*, 1974, which are both about physicality—"The more endured, the better."

We are able to find these elements of resonance, dissonance, and endurance in all of Charlemagne Palestine's later work. They are both the tools and the matter he uses to reach out for what he calls "the golden sound". We can easily link these elements to his early vocation as a carillonneur that began at the age of 16 and continued for six years, for a church next to the Museum of Modern Art in New York. The combination of resonance and dissonance are the main characteristic of the sound of bells. Bells may have a fundamental pitch, but they also have a unique, hard to control, universe of partials above the fundamental. And the element of endurance is particularly present in carillon playing for it is an instrument that demands great physicality through the use of the player's fists.

An encounter of major importance reflected in Charlemagne Palestine's musical oeuvre occurred in 1969 at Cal Arts. In an interview with Armeno Alberts, Palestine recalls the event as follows: At a certain moment I find myself in 1969 in California, in a building that's just made to be the California Institute of the Arts. There is an enormous piano there, the most beautiful piano I'd ever seen and I open it and I play and I touch a tone and the tone ring seems to ring on forever and all the overtones that I heard in oscillators I hear in this tone. It turns out to be a Bösendorfer Imperial piano made in Vienna. I said: "Wow... what an incredible instrument, it makes tones like an oscillator, but it responds to my hands and to wood and to the space." [6]

From then on the piano would become his main vehicle on the road to the golden sound. Among the first recorded traces that we find is the 1972 *Piano Drone*; played on that very first Bösendorfer Imperial. *Piano Drone* is nothing more than a single chord (D6) arpeggiated in a continuous mode with slow crescendi and decrescendi. Palestine sticks to the original chord all the way through the piece; holding the sustain pedal down and surfing on the waves of the overtone drone. Almost as if he knows what is out there, but is not prepared yet to go and get it.

Later, in the winter of 1973/1974, Palestine records a suite of pieces that are slightly offbeat in his production, though they may not appear to be so at first hearing. Commissioned by the Sonnabend Gallery in New York, the work, *Four Manifestations on Six Elements*, was meant to be a kind of sonorous exhibition on four walls.

The first and last pieces of the suite, *Two Fifths*, and *Three Fifths*, are both electronic works, and may seem related to the old *Holy 1* and *Holy 2*, except that they are more refined. They use smooth sine waves instead of crude sawtooth waves and are tonally kept within the strict boundaries of their titles; all at the cost of harmonic eventfulness. The same ideas appear in the two piano works of the suite; both of which also harmonically deal with fifths and unfold within rather strict rhythmic patterns. There were plenty of fifths and other consonant intervals hopping along rigorous rhythmic patterns in New York in those days, for example, Steve Reich and Philip Glass come to mind, and it is strange to find the much more radical and unrestrained Charlemagne Palestine in their musical company.

We soon find Palestine searching for the golden sound again, and coming much closer to it in what certainly is a milestone in his œuvre: *Strumming*. *Strumming* is also fifths, but fifths let loose, not entrapped in rhythmic frills but, rather, hammered fifths breathing life into the piano. It's also a big minor seventh chord and another big major seventh chord, with or without added sixth. Intervals are no longer what this work is about. They are there because the piano has a rigorous keyboard, and Palestine is searching for the road to get to the sound. He plays the keyboard in an almost unmusical, unpianistic way. We can easily imagine him as described by Tom Johnson at the time, "Most of the time Palestine sits eyes closed, his head turned to one side listening intently to the overtones."" All of his actions—they are extremely varied, especially considering the fact that most of the time he limits himself to the same keys for very long periods—are in sole function of these overtones. He speeds up to catch up with them or slows down not to outrun them. He industriously alters accentuation and dynamics, not to serve a compositional construction, but to shape the big sound. Of course, like a true alchemist he doesn't succeed, but he manages to give us a serious hint about what might be out there.

This strumming technique would become his main vehicle. It reappears over the years under various forms. One of these forms is a very interesting version for two harpsichords which Palestine performed together with Elisabeth Freeman. It is fascinating because of the choice of instrument. There is no way to make a harpsichord resonate like a grand piano, so it sounds like a model of the real thing; like a skyscraper built with matches. Listeners familiar with the piano versions of this work could easily imagine and maybe even psycho-acoustically recreate the sonic events that are never achieved. The relentless painstaking efforts of the two keyboardists never come anywhere close to the golden sound, but in their senseless abandonment they attain a very special poetic dimension.

Two other works: *The Lower Depths*, 1977 (originally subtitled *Descending/Ascending*) and *Timbral Assault*, 1978, sound like magnifications of *Strumming* details. *The Lower Depths* concentrates on the lower bass regions of the Bösendorfer (its range extends 9 notes lower in pitch than other concert grands); moving up (to the middle register) and down again in an irregular fashion but always at a high pace, thereby causing the upper registers to resonate. Starting and ending with E, it has no clear harmonic figures, but one gets the impression that Palestine is looking for the sonically most efficient combinations regardless of their musical form. He appears to be working

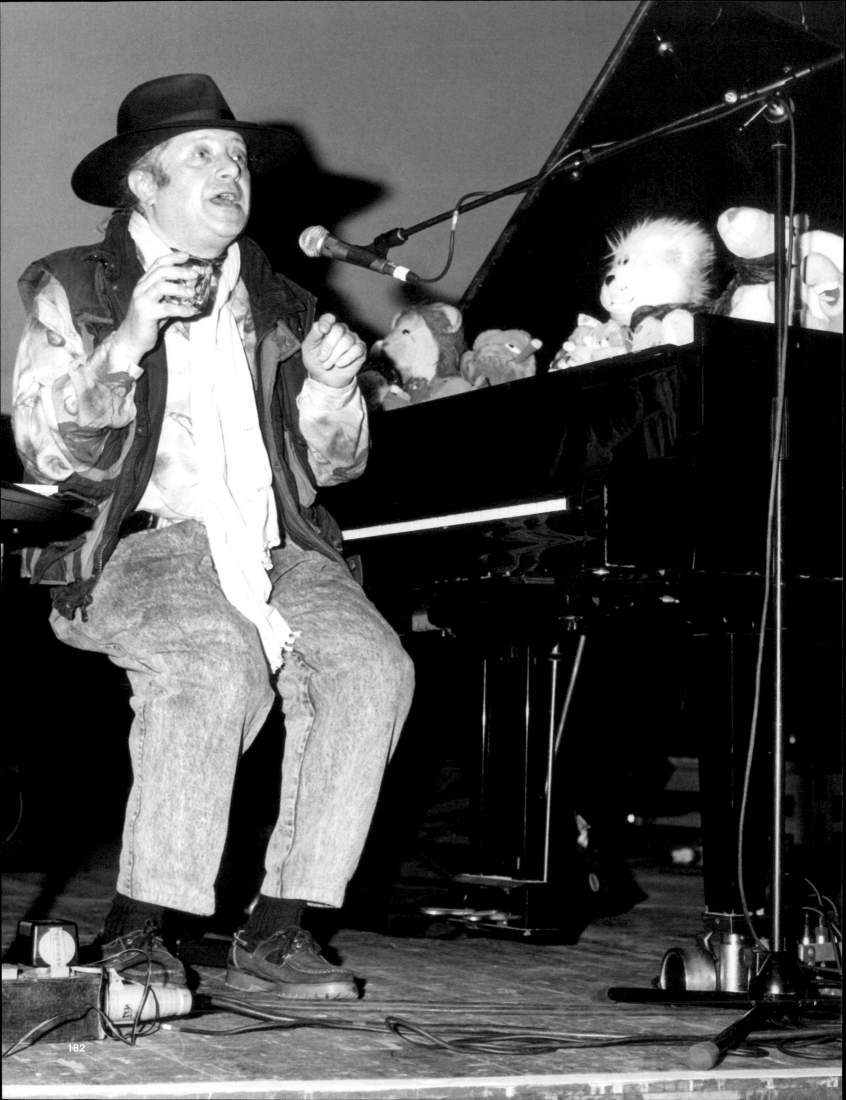

very hard at the keyboard rather than actually 'playing' it. Maybe more than most other variations of *Strumming*, it offers a clear separation between what is heard and the region where the action takes place. In a concert review of the work, Tom Johnson wrote, "The first thing I noticed on the night of the ascending was that the floor was shaking. It was hard to believe the thunderous power with which Palestine suddenly began hammering on two notes with a fast left-right-left alternation. The sound of these bass notes was equally hard to believe. Since he plays with the pedal down, one hears not only the notes he is actually playing but also a large complex of high- and middle-register tones ringing off the other strings." [8] *Timbral Assault* is faster, more dissonant, and irregular. Within his body of work, one could almost describe it as "experimental" in the sense of the "let's try this and see what we get" attitude. Hard and fast clusters alternate with trilled fourths and fifths. The trills, though faster than the other actions, sound almost like brief breathers, both for the pianist and the piano.

Up to this day, Palestine is still strumming and working on a way to notate the strumming so that it could be performed by others in a satisfying way. One of the techniques he intends to use is to perform it on a computer controlled piano, so that it could not only be reproduced by a robot (not unlike Debussy recording his music on a player piano), but also translated in detail into standard music notation. Ironically, this may very well result in highly complex scores, as hermetical as a treatise on alchemy.

Though the Bösendorfer remains his favourite tool, he relies on other instruments to address the subject from different sides. Thus in 1979, Palestine was invited by festival producer Leendert Van Lagestein to Holland to create an organ piece. This became *Schlingen-Blängen*, which he subsequently recorded in 1988. *Schlingen-Blängen* is a remarkable work, both because of its conceptual simplicity and its efficiency. On the recording—70 minutes long—we hear a wide continuous cluster (at the core of which is a Fsus7 chord). Palestine has depressed and blocked a number of keys and limits his actions to occasionally changing registers, but mainly allowing the organ to lead its own life and to enter a dialogue with the space and its resonant qualities without ever changing the original harmonic foundation. We hear natural tension (beatings between various harmonics, new ones probably meeting reverberated older ones) and release (suggesting melodic phrases), colour changes, dissonances and re-solutions. It is as if Palestine found a way to miniaturise us and lead us into the very heart of the sound. We hear all the resonances we might encounter in *Strumming* without the 'distraction' of the physical and mechanical action of the piano. Palestine writes about the work: "This is a work that traditionally organists prefer to discourage being done in their domain as it is anti-virtuosic and demands that listeners participate—they play their own ears and dazzle themselves, a sort of masturbation. But in the music world this sort of approch is still considered controversial. Minimalism is a word I only heard much later through music critics. My music is more a sensual, liquid, physical experience. When I built long long pieces it was to objectify its hearness and its hereness, I've always been more sculptor than composer or more a composer of sculpture than a composer of music."[9]

Hovering between mysticism and the science of the musical occult, it seems obvious that next to the organ, we find Palestine again sitting at the keyboard of the carillon, the instrument that, as stated earlier, played a determinant role in his musical life. A major recorded work for carillon is *Music for Big Ears*, and though the carillon

is at the extreme resonant opposite from the harpsichord, the piece shows similarities with the version of *Strumming* for two harpsichords. It resonates immensely, but seems unable to take off, and is awesomely beautiful in this inability. It is like an enormous airplane making small jumps on the runway. This may have to do with the fact that both works are performed by two people and that the score requires them to stick together, rather than individually reaching out whenever the illusion of sonorous absoluteness lurks in the distance. Another determining factor may be that the instruments don't allow for the almost liquid elasticity the grand piano offers. But one can see this implied failure as an essential aspect—if not, *the,* essential aspect of alchemy. Successful alchemy is mere passionless chemistry. Fortunately it is most probable that Charlemagne Palestine, in his current attempts at computer assisted notation of his work, will only achieve hermetic poetical discourse. In the lineage of Franz Liszt and Alexander Scriabin it is his very personal "golden sound" that he is after—who else knows what it is supposed to sound like?

1. Tom Johnson, *The Voice of New Music, New York City 1972-1982.*

2. Walter Zimmermann, *Desert Plants, Conversations with 23 American Musicians.*

3. Zimmermann, *Desert Plants.*

4. Roger Johnson, ed., *Scores, an anthology of new music.*

5. Johnson, *Scores.*

6. Armeno Alberts, "Charlemagne Palestine", *CEM Bulletin*, vol. 13, no. 3, December 1998.

7. Johnson, *The Voice of New Music.*

8. Johnson, *The Voice of New Music.*

9. Quoted in *Halana Magazine*, no. 3, 1998.

185

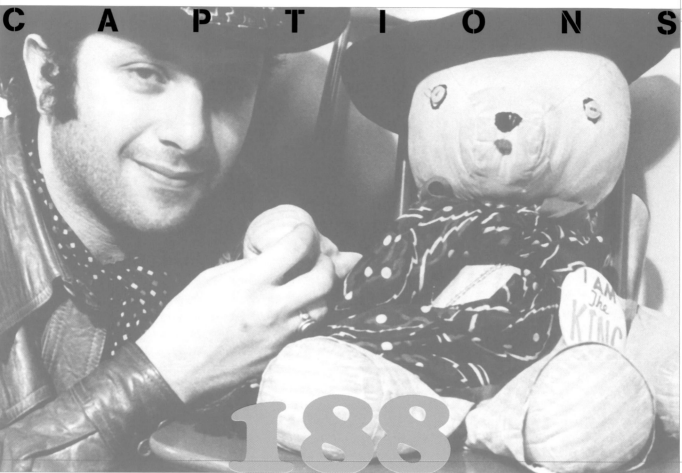

188

500x250x500 cm, Fiac, Grand Palais, Paris, 1990,
© Galerie Eric Franck, Geneva.

pp. 53-54
Exhibition "Todi Kamehameha",
details of the exhibition, galerie Damasquine, Bruxelles,
2002, © Galerie Damasquine, Bernard Prévot, Bruxelles.

p. 55
La danse du sabre, ca. 1979, © Jabarry.

pp. 56-58
Exhibition "La caravane des caravanes", 1990,
caravan, fluffy animals and mixed media,
© Marie-Aude Chardon ; (vignette: image taken from
NewLook, pp.32-33, n°86, sept. 1990, Paris,
© Sylvain Hitau).

pp. 59-61
Temple en peluche, 1990,
fluffy animals and mixed media, 450x350x150 cm,
La Boîte noire, Montpellier, © Christian Loan ;
(vignettes: views of the construction).

pp. 62-63
Igor Rogi, 1994,
fluffy animals and mixed media,
exhibition "Babies and Bambis",
Arti & Amicitiae Foundation, Amsterdam,
© Niels Denhaan.

pp. 64-65
Overtone study for voice, ca. 1970, © Elaine Hartnett.

pp.66-67
Exhibition "D-Day P-Day", 2001,
fluffy animals, sound and mixed media,
© Charlemagne Palestine.

pp. 68-69
God Bear, 1991,
mixed media, 540x500 cm,
installation in the market square of Dôle,
© Claude Huyghens.

pp. 70-71
Exhibiton "La Beauté et la Bête", 1999,
with Dorothée Selz, Galerie Jacques Donguy, Paris,
© Jean-Claude Planchet.

p. 72
Gold Room with Freddie Rabbit, 1975,
fluffy animal and mixed media, 160x100 cm approx.,
Galerie Sonnabend, N.Y.C., © Elaine Hartnett.

p. 73
Performance Living Drawing, ICA, Cincinnati, Ohio, 1980,
© James Rosenberg.

p. 74
A Plethora of Pussies, 1994,
fluffy animals and mixed media, 110x110x35 cm,
© Charlemagne Palestine.

p. 75
Running, 1976, © Kathy Agnoli.

p. 76
Fax from Luigi Ontani, 1999.

pp. 77-79
Paper versus cloth:Death of the Innocents-Earth Room,
Black Sun-Yellow Room, A Slaughter-Red Room, 1979,
mixed media and books, installation at the Clock Tower,
N.Y.C., © Charlemagne Palestine.

p. 80
Danger Artists (Houdini), 1985,
silkscreen print, 40x60 cm.

p. 81
Aaeeaaoottaa, 1985,
fluffy animal and mixed media, 142x147x63 cm.

pp. 82-83
Paper versus Book, 1978, mixed media,
installation at the 112 Green Street Gallery, N.Y.C.

pp. 84-85
Installation, mixed media, De Vleeshal, Middelburg, 1979,
© Wim Riemens.

p. 86
Running, 1976, © Kathy Agnoli.

p. 87
Hunter's Alter Ego, 1985,
fluffy animal and mixed media, 130x75x45 cm,
© Galerie Eric Franck, Geneva.

pp. 88-89
Lapp paintings-Mirror Arrows, 1980,
paint and pigment on canvas, Galerie France Morin,
Montréal, © Charlemagne Palestine.

p. 90
Prima Puma, 1982,
fluffy animal and mixed media, 130x150x122 cm,
© Galerie Eric Franck, Geneva.

p. 91
Brown Bear and his Dwarf Friends, 1992,
installation, mixed media,
Katinca Prini Foundation, Genoa,
© Galerie Eric Franck, Geneva.

pp. 92-93
Raakhk, 1982,
fluffy animal and mixed media, 170x122x93 cm;
Issachi, 1982,
fluffy animal and mixed media, 285x370x110 cm;
© Galerie Eric Franck, Geneva.

p. 94
Project for Fuck You Bear, 1991, fax.

p. 95
Kawr Kahr, 1982,
fluffy animal and mixed media, 215x266x110 cm,
© Galerie Eric Franck, Geneva.

pp. 96-97
Singing against the floor, 1973,

Festival d'Automne, Musée Galliera, Paris,
© Elaine Hartnett.

p. 98
Running, 1976, © Kathy Agnoli.

p. 99
Internal Tantrum, ca. 1980.

p. 101
Battling the Invisible, 1976, Toronto, © Kathy Agnoli.

pp. 102-103
Filming the video Where it's Coming From,
with Wies Smals, 1977, © DR.

p. 104
Running, 1976, © Kathy Agnoli.

pp. 106-107
Battling the invisible, 1976, Toronto, © Kathy Agnoli.

p. 109
Running, 1976, © Kathy Agnoli.

p. 110
Singing against the wall, 1974, Nova Scotia College
of Art & Design, Halifax, © Elaine Hartnett.

p. 111
Video still, Internal Tantrum, 1975,
7'30", black & white, © Gwenn Thomas.

pp. 112-113
Illuminations, with Simone Forti, 1973,
Musée Galliera, Paris, © Elaine Hartnett.

pp. 114-115
Singing against the floor, 1973,
Musée Galliera, Paris, © Elaine Hartnett.

p. 116
Running, 1976, © Kathy Agnoli.

p. 117
Al matrimonio di Luisa e Carlo Orsacchiotti, 1992,
© Galerie Franco Toselli, Milan.

p. 118
Running, 1976, © Kathy Agnoli.

p. 121
Peperoni, ca. 1984, © Kevin Clarke.

p. 122
Raga Todi, ca. 1984, © Kevin Clarke.

p. 125
Blind Monkey, ca. 1984, © Kevin Clarke.

pp. 126-127
Ping Ming Ding, 2002,
fluffy animals and mixed media, 70x160x28 cm each,
Galerie Lara Vincy, Paris, © Daniel Pype.

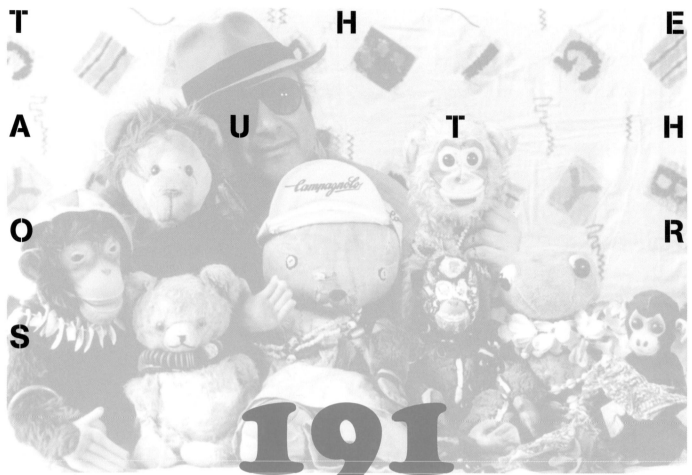

191

GUY DE BIÈVRE is a Belgian composer, musician, arranger, sound designer, sound art curator and sound engineer. As a composer/performer he focuses on experiments which combine computer, live electronics, acoustics and standard arrangement formats. He has had works commissioned and/or performed by musicians such as Guy Klucevsek, Seth Josel, Anne La Berge, The Bozza Mansion Project, Annette Sachs, The Zivatar Trio, as well as various Belgian and international organisations. In addition to his own compositions, he has collaborated as performer with various composers and musicians such as Phill Niblock, Tom Hamilton, The Ensemble Champ d'Action, and Peter Zummo. He curates the *Earwitness sound art series* at the Centre for Contemporary Non-Objective Art in Brussels, and, after working for diverse contemporary and experimental music related organisations (e.g. the Logos Foundation and the Institute for Psycho-acoustics and Electronic Music, (both in Gent), he is currently a researcher at the Jan Van Eyck Academy in Maastricht.

EDWIN POUNCEY has been writing about music and art since the early 80s for a variety of publications. As a visual artist he goes under the name *Savage Pencil* under which he has produced numerous illustrations, some of which have been used on record covers by Sonic Youth, Big Black, Nurse With Wound, Current 93, Skullflower and many more. He currently writes and draws for UK independent experimental music magazine *The Wire* and has recently become engrossed in learning the ancient art of etching.

If he first was known as a performer, ARNAUD LABELLE-ROJOUX later became a historian of performance as an artistic expression with his book *L'Acte pour l'art* (Editeurs Evidents, Paris, 1988). Since then, he has done the best he could, mixing, manipulating and multiplying media in his work, without neglecting his writing (*Junot B. Goode, Java, Paris, 1997; Twist dans le studio de Velasquez, L'Evidence, Fontenay sous Bois, 1999; Leçons de scandale, Yellow Now, Liege, 2000*) and curating events calling upon the participation of numerous artists, events such as, in 2001, the *Nonose Club* at the Palais de Tokyo or, in 2003, the *7 sets* at the Plateau art centre. His recent exhibitions include: 2001, *On dirait que ce serait une exposition*, École des Beaux-arts, Dunkerque; 2002, *La vie au fond se rit du vrai*, CAPC, Bordeaux; Biennale de Cetinje (Monténégro); 2003, *Rien à branler des chiens*, Loevenbruck Gallery, Paris.

Since 1991, ANTONIO GUZMAN is director of l'Ecole des Beaux-arts of Valenciennes, where he founded the Aquarium contemporary art gallery in 1993 and the éditions de l'Aquarium agnostique in 1994. Critic and art historian born in Colombia, he has curated numerous exhibitions in France as well as abroad, and his frequent texts on contemporary art have been published in Europe and in North America.

Graphic designer DANIEL PERRIER regularly works with the leading contemporary art institutions and organisations in France. He has recently finished the graphic design for a monograph on the artist Saâdane Afif for the Michel Rein Gallery in Paris. He is also the author and producer of *Les Trésors publics*, a series of silk-screened multiples confronting graphics and the fine arts that includes limited editions dedicated to Piet Mondrian, Stéphane Mallarmé, Claude Debussy and Bruce Nauman, among other artists. He co-founded the trimestrial magazine *Le Travail de l'art* in 1997 (Paris), to which he has since then been a regular contributor.

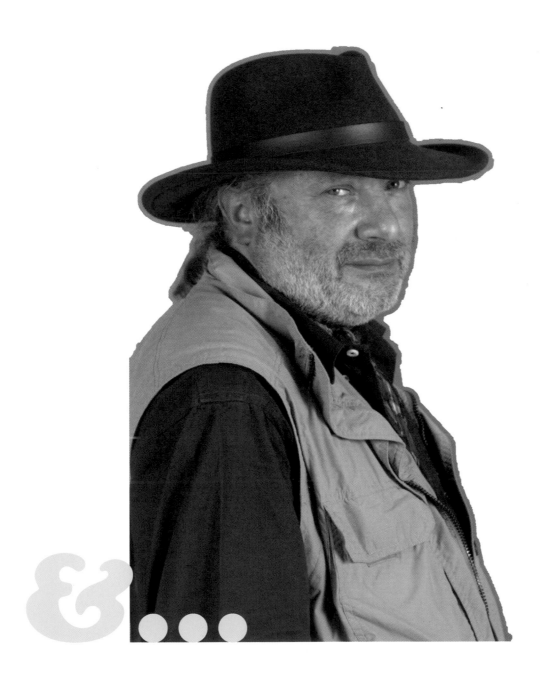